THE MIRACLES OF OUR LORD

THE MIRACLES OF OUR LORD

CHARLES CALDWELL RYRIE

THOMAS NELSON PUBLISHERS

Nashville • Camden • New York

Copyright © 1984 by Charles Caldwell Ryrie

Published in Nashville, Tennessee, by Thomas Nelson, Inc., and distributed in Canada by Lawson Falle, Ltd., Cambridge, Ontario.

Printed in the United States of America.

design by Thelma Whitworth

All Scripture quotations are from the NEW KING JAMES VERSION. Copyright © 1979, 1980, 1982, Thomas Nelson, Inc., Publishers.

Library of Congress Cataloging in Publication Data

Ryrie, Charles Caldwell, 1925–
 The miracles of our Lord.

 1. Jesus Christ — Miracles. I. Title.
BT366.R97 1984 232.9'55 84-16608
ISBN 0-8407-5362-4

CONTENTS

PUBLISHER'S PREFACE

In A.D. 531, Justinian I, emperor of the eastern Roman Empire, began building *Hagia Sophia*, the great church in Constantinople dedicated to "the Holy Wisdom" of God Himself. In the next six years, Justinian employed ten thousand workmen and spent more than $100 million to build the world's finest example of Byzantine architecture — a church with a magnificent dome 100 feet in diameter, rising to 180 feet above the ground. At the building's dedication, Justinian gave "glory to God who has thought me worthy to accomplish so great a work."

In 1131, on the right bank of the river Wye in the rugged countryside of Wales, monks from Normandy founded an abbey at Tintern. During the next four hundred years they worshiped God, studied and copied manuscripts, taught novices, cared for the sick and elderly — and built a magnificent church in the shape of a cross.

For more than four years — from May 1508 to October 1512 — Michelangelo worked on the ceiling of the Sistine Chapel in Rome. He painted nine major panels picturing scenes from Genesis, including the creation of man, the temptation, and the flood of Noah. Here is the artistic strength of Michelangelo at its greatest, and it is said that after he had finished, Michelangelo had spent so much time on his back that he found it easier to read holding a book above, rather than beneath, his eyes.

Since the time of Christ, much of our artistic energy in architecture, painting, sculpture, and other art forms has been directed to the glory of God. To be sure, motives were not always pure. Justinian, for instance, after giving glory to God upon the completion of *Hagia Sophia*, added, "O Solomon! I have vanquished you!" But the artistic efforts of the past are in marked contrast to those of today, which are directed towards building monuments to commerce, government, and the human spirit apart from God. This shift in outlook is not unique to the arts; it merely reflects a radical reorientation of our civilization from a culture that claimed to believe that God exists, "and that He is a rewarder of those who diligently seek Him," to one preoccupied with humanity, one that questions the relevance of — if not the very existence of — supernatural reality.

Yet miracle — an evidence of supernatural reality — is at the heart of our Christian faith. The Apostle Paul said that if Christ's resurrection, the greatest miracle of all, did not occur, "then our preaching is vain and your faith is also vain." Throughout the last two thousand years, therefore, a multitude of artists have sought to glorify God through the depiction of the miracles of our Lord. It is in that tradition that Charles Caldwell Ryrie has written a strong, clear, and succinct study of each of Christ's thirty-five miracles and combined it with reproductions of important works of art. The art depicted throughout illustrates how artists have interpreted biblical scenes and gives a sense of history and continuity to our own worship and adoration of Jesus Christ.

Each individual sees the events of the Bible in terms of personal experience, as the pictures in *The Miracles of Our Lord* show. The Christ painted on the wall of a catacomb (p. 82) looks like a young Roman. In the illuminated manuscript prepared by the Limbourg brothers (p. 114), the Canaanite woman who pleads with Christ to heal her daughter does so in fifteenth century France. And Pieter Van Aelst's tapestry of the Miraculous Draught of Fishes (p. 28) includes the construction of St. Peter's Basilica in Rome in the background.

Just as the artists represented here pictured Christ in terms of their own experience, so too does Christ want to meet us in our own situations. His miracle-working power is not limited to the past. It is not to be found only in the first, twelfth, or sixteenth centuries. It is available today. To us.

The Publisher would like to give special thanks to Diane Tonkyn for her help in researching the works of art pictured herein, Lorraine Matties for her able editorial direction, and Jerry Mallick of the National Gallery of Art, Washington, D.C., for his consultation.

INTRODUCTION

This is a book about the miracles of our Lord. It does not attempt to vindicate them but rather to explain them, and in the explaining to show us more facets of the Person who performed them. The explanations combine exegesis of the passages involved with the themes that emerge therefrom. Not only is it important to know the facts about each miracle, but also to glean from those facts the insights they give us about the Lord. In addition, I have tried to outline each miracle in a way that will, so to speak, attractively gift wrap the material for you.

Nothing that any interpreter can say could ever be as important as what the Scripture itself records. I must urge you, therefore, as strongly as I can, to read the Scripture passage that begins each chapter. Many of the miracles, of course, are recorded in more than one Gospel, but only the most complete account is included at the beginning of each chapter in this book. If other accounts are referred to in the chapter, you will profit if you take the time to look up those other references in your own Bible. If you own a harmony of the Gospels where all the accounts are spread out side by side, then by all means use it. But at the very least, please do not skip over the biblical text printed at the head of each chapter.

May I also urge you to meditate on each miracle? Get the facts from the inspired biblical text. Interact with the interpretations and ideas I offer you. Then meditate and reflect on each story. Proper meditation will never create truth, but it may clarify and apply truth. You may want to study these miracles one at a time, with some time between each, so that you can think about each one more thoroughly. Meditate on them while you are driving or exercising or just doing nothing. Probe each miracle as fully as possible.

The chapters of this book were written over a number of years and not always in chronological order. But as I approached the end, a strong desire was developing to include artwork with the text if the material was ever published in a book. At first I thought only of photographs of the sites, but then of reproductions of great works of art. Such works are a part of our Christian heritage,

but a part that is often overlooked. To incorporate some of it into a study that focuses on the Lord seemed most appropriate, and I was delighted with the publisher's enthusiastic response and input to the concept.

A. What is a Miracle?

Many definitions are given, but one of the clearest is offered by C. S. Lewis in his book *Miracles* (London: The Centenary Press, 1947, p. 15). A miracle is more than something unusual (though in ordinary speech we often call such events miracles). A true miracle is something beyond man's intellectual or scientific ability to accomplish. It is not natural, even though it may be unusual; a miracle is supernatural (that is, from God or Satan). It is more than a highly improbable event; it injects a new element (the supernatural) into the natural order of things.

To the nontheist that element is alien, but to the theist it is part and parcel of his or her total world view. Therefore, the question of the possibility of miracles is inseparably connected with the existence of God. If He exists, then miracles are not only possible but plausible. Certainly, then, if Jesus of Nazareth was who He claimed to be—God—we should expect that He performed miracles.

Four Greek words are used in the Gospels to characterize our Lord's miracles. (1) *Dunamis* emphasizes that the mighty power of God has entered our world as displayed in Christ's miracles (see Matt. 11:21; Mark 6:2,5,14; 9:39; cf. Acts 13:10). (2) *Teras* means "wonder" and underscores the extraordinary character of the Lord's miracles. It is always used with some other word (such as "signs and wonders") so that we will not think of the miracles simply as dazzling demonstrations (see Mark 13:22; John 4:48; cf. Matt. 24:24). (3) *Ergon* means "works" and is used both for Christ's miracles and His ordinary deeds of mercy (see John 5:20,36; 7:3; 10:25). (4) *Sēmeion* means "sign" and indicates that Christ's miracles were to teach us spiritual truths (see John 2:11; 4:54; 6:2; 11:47). The miracles are historically true, but they also serve to teach us heavenly truths that go beyond the factual accounts themselves.

B. The Purpose of the Miracles

The main purpose of the miracles was to teach, to reveal. Christ used miracles to demonstrate His deity (see Mark 2:7), to support His claims to being the Messiah (see Matt. 9:27), and to serve as illustrations of deeper spiritual truths (see John 6:32–35). But the miracles also remind us of the consequences of sin—sickness, blindness, death—and of the power of the Lord to do something about those consequences. That is why many of His physical cures illustrate so well the spiritual salvation He secured when He died and rose from the dead.

C. Some Characteristics of Christ's Miracles

1. They were performed for high purposes. He did not use them for His personal convenience (remember His temptation) but to meet definite needs of others.
2. They were not confined to a single sphere of life, so they could never be considered trickery. They were done on nature (see Luke 5:4–7), on human beings (see Mark 1:29–31,40–42), and on demons (see Mark 5:12–13).
3. They were done openly in front of spectators and witnesses. When the Gospels were written, there would have been many persons living who had seen His miracles and who would have known and objected if the Gospel writers had not accurately recorded the stories.
4. They did not always involve the faith of the person healed but sometimes were done in spite of the lack of faith (see John 5:7).

D. The Number of Christ's Miracles

Thirty-five separate miracles done by Christ are recorded in the Gospels. Of these Matthew mentioned twenty; Mark, eighteen; Luke, twenty; and John, seven. But these are only a selection from among many that He did (see Matt. 4:23–24; 11:4–5; 21:14). In this book I follow the chronological order of the thirty-five as nearly as it can be determined.

I sincerely hope that all the features of this book will help reveal to each reader more of the glory and beauty of the Lord who performed them. If the book does that, it will have served its purpose.

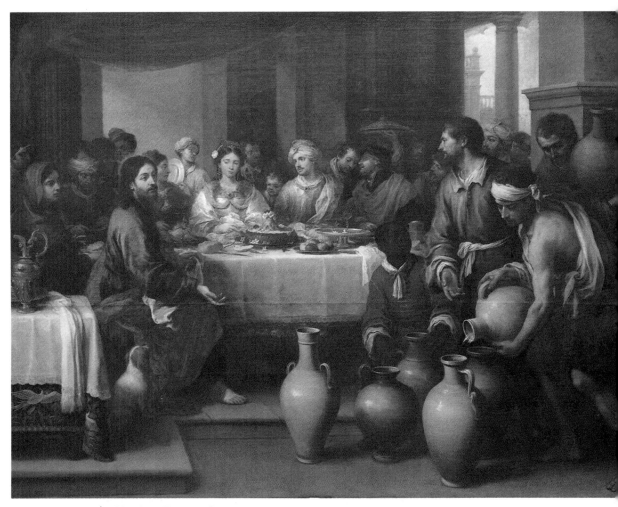

The Marriage Feast at Cana
Bartolome Esteban Murillo, ca. 1665–67; 70″ x 92½″; oil; The Barber Institute of Fine Arts, The University of Birmingham, England

Murillo, who was born in Spain in 1617 and died in 1682, was a realist, and his work, especially his religious compositions, were popular. His depiction here of the marriage feast at Cana is very human and warm. To point us to the main subject of the miracle, he employed a technique similar to that of Rembrandt — a strong diagonal light appears from the left, illuminating the married couple, Christ, the servants, and the jugs of water. The painting captures the moments after Christ has instructed the servants to pour the water into the jugs, just before the discovery that this wine was better than the first. One servant seems to be questioning the wisdom of the instructions, while the richly dressed newlyweds are absorbed in each other as they wait for the results.

HIS FIRST MIRACLE

Turning Water into Wine at Cana

On the third day there was a wedding in Cana of Galilee, and the mother of Jesus was there. Now both Jesus and His disciples were invited to the wedding. And when they ran out of wine, the mother of Jesus said to Him, "They have no wine." Jesus said to her, "Woman, what does your concern have to do with Me? My hour has not yet come." His mother said to the servants, "Whatever He says to you, do it." Now there were set there six waterpots of stone, according to the manner of purification of the Jews, containing twenty or thirty gallons apiece. Jesus said to them, "Fill the waterpots with water." And they filled them up to the brim. And He said to them, "Draw some out now, and take it to the master of the feast." And they took it. When the master of the feast had tasted the water that was made wine, and did not know where it came from (but the servants who had drawn the water knew), the master of the feast called the bridegroom. And he said to him, "Every man at the beginning sets out the good wine, and when the guests have well drunk, then that which is inferior; but you have kept the good wine until now." This beginning of signs Jesus did in Cana of Galilee, and manifested His glory; and His disciples believed in Him *(John 2:1–11)*.

The days of seclusion were at an end, and the period of public ministry was beginning. In this semiprivate and semipublic atmosphere of a wedding feast, our Lord's first miracle was performed. John 2:11 clearly states this miracle was the first, although the apocryphal Gospels record a number of miracles that Jesus supposedly did before His baptism. They are never "signs," nor do they have any high purpose. They consist of incidents where the Lord, as a boy, brought harm through use of a miracle to anyone who opposed or hurt Him. These records notwithstanding, the inspired text makes it clear that He did no miracle until this one at Cana in Galilee.

I. The Setting of the Miracle: Approbation

In doing His first miracle at a wedding, the Lord gave full approval to the institution of marriage. He foreknew that later some in the church would despise marriage (see 1 Tim. 4:3); indeed as early as the third century, Cyprian decried Christians' attending marriage festivities.

Jesus' presence also should negate any suggestion that an ascetic life is preferable for a believer. Actually, asceticism can be an escape, for it is often easier to decline contact with the world than to be involved in it while always behaving like the Son of God.

Furthermore, the Lord, by accepting the invitation to the feast, showed His approval of times of festivity and celebration for His followers. The lack of mention of Joseph in this account may mean he had died by this time (though John 6:42 might indicate otherwise).

Jewish weddings took place at the conclusion of a year-long engagement period. That time of betrothal was a much more serious matter than is our custom of engagement. It signified such a binding commitment that divorce was necessary to break it. At the time of the wedding, the bridegroom and his friends went in a procession, often at night, to the bride's house. Then the group returned with the bride to the groom's house where the wedding banquet took place. That feast might last as long as a week (see Gen. 29:27; Judg. 14:17).

II. The Story of the Miracle: Separation

One word can be written over the story of the miracle itself: *separation;* the separation of Jesus from His mother by virtue of His words to her, and the separation of Jesus from all other mortals by virtue of His miracle.

This incident at Cana was the second of four recorded public encounters Mary had with her Son during His ministry (see Luke 2:41–52; Mark 3:31–35; John 19:26–27). Seventeen years had elapsed since the boyhood incident at the temple. Now at this wedding banquet, the wine had run out. This was a serious matter that, had it not been remedied, might have opened the bridegroom's family to a lawsuit. At the very least it was a terrible breach of the requirements of hospitality. Mary appealed to Jesus to do something, and she obviously trusted that He could. But whatever she expected of Him undoubtedly did not include what He did when He said, "Woman, what does your concern have to do with Me?" (John 2:4).

The term *woman* was not a cold, disrespectful way to address a person (see John 4:21; 19:26; 20:13,15), but it was surely unusual that Jesus did not use the term *mother.* His speech began to bring about a new relationship between Him and His mother. And the words that follow indicate that change. No longer would the intimate and familial arrangements of the household at

14

Nazareth apply. Now He was beginning His public ministry, and the interests and demands of His ministry superseded those of His family. Though it must have been difficult for her, Mary's reaction to this reminder of new priorities was full of faith and good advice: "Whatever He says to you, do it" (John 2:5).

The events of the story also separate Jesus of Nazareth from all other men and single Him out as unique. Our Lord commanded that the six stone water-pots, which were in the house because of the purification rites of the Jews (see Mark 7:3; Luke 7:44), be filled with water. That they were filled to the brim rules out any possibility of a trick being done by adding some already existing wine to partially filled pots. They were completely filled with water; then all that water was changed to wine. Water went into the jars; wine came out. Each jar held at least twenty gallons, so together they held enough for something like twenty-four hundred servings of wine. Here was something no mere man could do.

III. The Secret of the Miracle: Creation

The miracle was a spectacular act of creation. It was not simply a matter of speeding up a process that had been going on. It was accomplished in a moment without grapes, sun, or time. Of course, it was a miracle that contained the appearance of age. The wine seemed to have come from grapes that grew and matured and were picked and pressed over a period of time. The actual age of the wine was only minutes; the apparent age was a season of growth and harvest.

The quality of the wine was attested to by the master of ceremonies. The words *well drunk* in verse 10 do not necessarily mean that the guests were drunk. Wine was diluted, usually with three parts water, which made it not as easy to become intoxicated by that beverage as by "strong drink" which was undiluted.

IV. The Significance of the Miracle: Attestation

It had been hundreds of years since the Jews had seen a bona fide miracle. Miracles in the Old Testament were often for judgment; miracles in the New were for blessing. But miracles in both were for the glory of God. Since this miracle at Cana revealed the glory of Jesus of Nazareth (see John 2:11), the people were being faced with the claim that Jesus is God. In this moment, His glory was revealed to attest to Him as the Creator who exercised His rightful

power over matter to create wine. The glory of God is the manifestation of any of God's attributes; here Jesus revealed His power to create.

V. The Symbolism of the Miracle: Illustration

Some commentators make so much of the symbolism of the miracle that the historical facts fade into nothing. We must not forget that it was not some "deep" symbolism that impressed the disciples; it was the astounding fact that water was actually changed into wine. It was not any supposed symbolism in the water or the wine, but the creation of the wine that impressed them. Nevertheless, wine is a symbol of joy (see Ps. 104:15), so the incident may also illustrate the joy that Christ brings (see Ps. 16:11). It may preview the fact that His new message to the world would replace Judaism (see Mark 2:22). Certainly the words of Mary in verse 5, "Whatever He says to you, do it," contain a basic principle of the Christian life.

Lest people today use this story as a license to use wine freely, let them also read verses such as Romans 14:21 and 1 Corinthians 8:13 and 10:31. Let them also remember that today's wine is not first boiled before storage, then reconstituted with three parts water before drinking, as was true in the time of Christ. Today's wine is 10 to 14 percent alcohol as it comes from the bottle. That is why one five-and-one-half ounce glass of wine (about the size of a punch cup) raises the level of alcohol in the blood as much as a cocktail or two bottles of beer. This miracle is not meant to justify drinking or to debate the abstinence question. It is meant to display the Creator-Lord in His glory. If we miss that, we have missed the purpose of the miracle.

Leave the Miracle to Him

"Whatsoever He bids you, do it!"
Though you may not understand,
Yield to Him complete obedience,
Then you'll see His mighty hand.
"Fill the waterpots with water"
Fill them to the very brim;
He will honor all your trusting —
Leave the miracle to Him.

Oh, ye Christians, learn the lesson;
Are you struggling all the way?
Cease your trying, change to trusting,
Then you'll triumph every day.
"Whatsoe'r He bids you, do it"
Fill the waterpots to the brim,
But remember, 'tis His battle —
Leave the miracle to Him.

—Author unknown

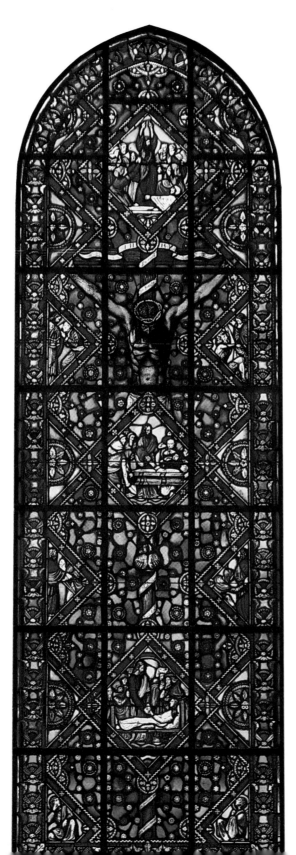

Christ of the Seven Miracles
Louis Rivier, 1921; 19′6″ x 24′4½″;
stained glass; Reformed Protestant
Church, St. Die, France

Placed above the church's altar as a focal
point, Rivier's window conveys the idea of a
suffering Christ from whose blood springs
seven miracles. Depicted in the medallions
are Christ's giving sight to a blind man, His
restoring the health of a paralytic, His heal-
ing of the woman who touched His garment,
His purifying of the lepers, His raising of
Lazarus, His restoring the widow of Nain's
son, and His raising of Jairus's daughter.
These last three miracles, involving individ-
uals raised from the dead, are placed above,
in the middle, and below the crucified Christ
as reminders that Christ conquered death
and lives. The translucent quality of stained
glass gives it its unique, reverential effect.
Glass panes of varied colors are joined by
a network of lead strips and inserted into a
metal frame. The glass, in effect, becomes a
painting of light. Widespread use of this art
form began during the twelfth century and
assumed the decorative functions once held
by mosaics.

TAKE HIM AT HIS WORD

Healing the Officer's Son

Now after the two days He departed from there and went to Galilee. For Jesus Himself testified that a prophet has no honor in his own country. So when He came to Galilee, the Galileans received Him, having seen all the things He did in Jerusalem at the feast; for they also had gone to the feast.

So Jesus came again to Cana of Galilee where He had made the water wine. And there was a certain nobleman whose son was sick at Capernaum. When he heard that Jesus had come out of Judea into Galilee, he went to Him and implored Him to come down and heal his son, for he was at the point of death. Then Jesus said to him, "Unless you people see signs and wonders, you will by no means believe." The nobleman said to Him, "Sir, come down before my child dies!" Jesus said to him, "Go your way; your son lives." So the man believed the word that Jesus spoke to him, and he went his way. And as he was now going down, his servants met him and told him, saying, "Your son lives!" Then he inquired of them the hour when he got better. And they said to him, "Yesterday at the seventh hour the fever left him." So the father knew that it was at the same hour in which Jesus said to him, "Your son lives." And he himself believed, and his whole household. This again is the second sign that Jesus did when He had come out of Judea into Galilee *(John 4:43–54)*.

Only John recorded our Lord's second miracle. Some writers equate it with the healing of the centurion's servant recorded in Matthew 8:5 and Luke 7:2, but too many differences between the two miracles make such a conclusion impossible. This miracle concerned a son, the other a servant. This one overcame fever, the other paralysis. Here the official pleaded with Christ to come with him, in the other the centurion asked Him not to come. Here is portrayed weak faith, there strong faith. The two miracles are undoubtedly distinct.

I. The Place

Jesus had traveled as far south as Jerusalem since the wedding at Cana (see John 2:13), and He returned to Galilee through Samaria (see John 4:3–4). The scene of the action thus shifts from Samaria to Cana in Galilee where the Lord had turned the water into wine. Though a prophet is not generally well received in his own home territory (a reference to Nazareth in contrast to what was about to happen in Cana, or possibly a reference to Judea in contrast to the

reception Jesus had received in Samaria), some Galileans welcomed Him. This proverbial saying was used by Christ also in Matthew 13:57 and Mark 6:4. Those who received Him had attended the Passover feast in Jerusalem, and had seen in person the miracles the Lord had done there (see John 2:23).

II. The Person

In Capernaum, about twenty miles from Cana, lived a nobleman whose son was at the point of death. The word *nobleman* does not mean he had royal blood but that he was a royal officer in the service of Herod Antipas, tetrarch of Galilee and Perea from 4 B.C. to A.D. 39. (Officially Herod was not a king although the title was used popularly of him, see Mark 6:14.) At Capernaum the Lord's grace extended to a variety of people: the son of this political officer, the daughter of a Jewish ruler of the synagogue (see Mark 5:41), and the servant of a Gentile soldier (see Luke 7:7). And it is still extended to all today, regardless of their national, political, or cultural backgrounds!

III. The Problem: John 4:47–48

The boy's condition was critical; he was at the point of death. The father's pleas to Jesus were persistent (the tense of the verb in v. 47 indicates that). In reality, however, the problem of the desperately sick son served to bring to the surface the more serious problem in the situation, the weak faith of the father that demanded a sign to shore it up. In response to that problem, the Lord rebuked the official and others (the *you* in v. 48 is plural) who looked to the spectacular and sensational to link them to Him. Of course, the Lord expected that His miracles would lead people to believe in Him, but His harsh remark to the official shows how much He longed for people to believe Him on the basis of what He said about Himself (see John 14:10–11). Faith that depends on the props of signs and wonders is never as deep or solid as that direct heart-to-heart relationship that simply takes a person at his or her word.

Shallow faith must have the assurance of the outstretched hand, the audible voice, the physical presence; it craved the assurance which the outward and physical, the sensuous and emotional, supply. And in the absence of these it was in danger of expiring. But faith like this hardly merits the name, though alas! it is too common with us all. We are brave at swimming so long as we are in our depth. We are grand soldiers so long as we stay within the castle enclosure. We believe so long as we can see or feel. (F. B. Meyer, *The Gospel of John* [London: Morgan and Scott, n.d.], p. 84.)

Later, in the same vein, the Lord said, "If they hear not Moses and the prophets, neither will they be persuaded, though one rose from the dead" (Luke 16:31).

IV. The Power: John 4:49–50

Without rationalizing or trying to defend himself, the official pleaded with the Lord to do something. (Capernaum on the Lake of Galilee was "down" from Cana which was on higher ground, v. 49, a nice touch of accuracy!) The Lord put the man to a most difficult test. By announcing that the boy was all right, Christ demanded that the father believe His word without the help of a visible sign or the personal presence of the Master at the boy's side. Was not His word as good as His presence? Was He not able to perform all that He promised?

The official answered clearly and affirmatively, for he "believed the word that Jesus spoke to him" (v. 50). Furthermore, he demonstrated that he believed the Lord's word, for he started for home, realizing that further pleas were unnecessary in view of Christ's statement.

V. The Products of Faith: John 4:51–54

The boy was cured; the father fully believed; and faith spread to his whole household. When the servants who had been caring for the sick lad saw what happened to him, they set out to meet their master with the good news. When they met, the father inquired at what time the boy had begun to get better (v. 52), revealing the fact that he had expected the cure to be gradual. But the servants' reply showed that the cure was immediate and complete. Then the father believed, that is, he put his whole faith in all that Jesus claimed to be, and his household also believed.

Faith is only as good as the object in which it is placed. Self-generated faith is only as good as the person who generates it. Sign-encouraged faith may evaporate in the rough routines of life. But faith in the eternal, living Word of God will never disappoint or dissipate. And faith increases not by looking at self or circumstances, but by learning more about the object in which it is placed. To increase our faith, then, we must continually increase our knowledge of our Lord, and that knowledge comes through His Word.

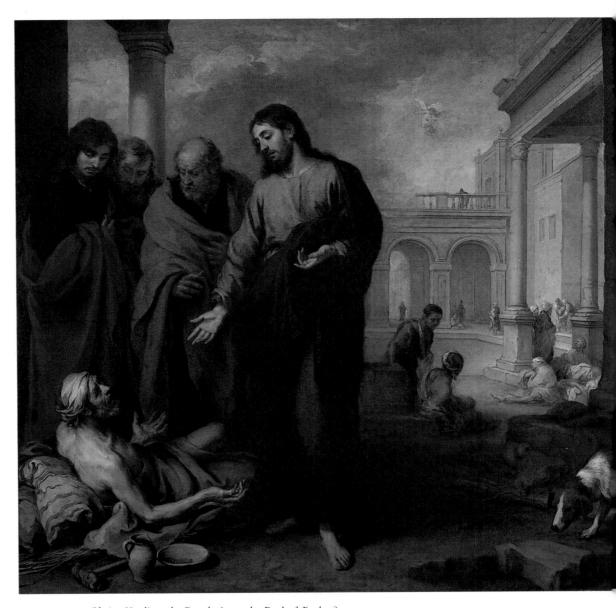

Christ Healing the Paralytic at the Pool of Bethesda
Bartolome Esteban Murillo, 1667–70; 93¼″ x 102¾″; oil; Reproduced by courtesy of the Trustees, The National Gallery, London, England

This painting is part of a series of six that Murillo painted, illustrating Christ's works of mercy, for the church at the Hospital de la Caridad in Seville. The left half of the painting is occupied by the central figures of the narrative — Christ, the paralytic, and three disciples — and the right half gives us a view of the courtyard, the pool, and other sick and lame people awaiting the opportunity for healing. It is a beautiful play in perspective. The light focuses on the face and upper body of Christ and on the head and upper body of the paralytic, emphasizing the two central figures of the miracle. This painting, too, captures the moments before the healing takes place, as Christ commands the paralytic to get up and walk. Christ's expression of warmth and confidence contrasts with that of the paralytic's frustration and uncertainty.

OMNIPOTENCE CONFRONTS IMPOTENCE

Healing the Ailing Man at the Pool of Bethesda

After this there was a feast of the Jews, and Jesus went up to Jerusalem. Now there is in Jerusalem by the Sheep Gate a pool, which is called in Hebrew, Bethesda, having five porches. In these lay a great multitude of sick people, blind, lame, paralyzed, waiting for the moving of the water. For an angel went down at a certain time into the pool and stirred up the water; then whoever stepped in first, after the stirring of the water, was made well of whatever disease he had. Now a certain man was there who had an infirmity thirty-eight years. When Jesus saw him lying there, and knew that he already had been in that condition a long time, He said to him, "Do you want to be made well?" The sick man answered Him, "Sir, I have no man to put me into the pool when the water is stirred up; but while I am coming, another steps down before me." Jesus said to him, "Rise, take up your bed and walk." And immediately the man was made well, took up his bed, and walked. And that day was the Sabbath. The Jews therefore said to him who was cured, "It is the Sabbath; it is not lawful for you to carry your bed." He answered them, "He who made me well said to me, 'Take up your bed and walk.'" Then they asked him, "Who is the Man who said to you, 'Take up your bed and walk'?" But the one who was healed did not know who it was, for Jesus had withdrawn, a multitude being in that place. Afterward Jesus found him in the temple, and said to him, "See, you have been made well. Sin no more, lest a worse thing come upon you." The man departed and told the Jews that it was Jesus who had made him well.

For this reason the Jews persecuted Jesus, and sought to kill Him, because He had done these things on the Sabbath. But Jesus answered them, "My Father has been working until now, and I have been working." Therefore the Jews sought all the more to kill Him, because He not only broke the Sabbath, but also said that God was His Father, making Himself equal with God. Then Jesus answered and said to them, "Most assuredly, I say to you, the Son can do nothing of Himself, but what He sees the Father do; for whatever He does, the Son also does in like manner. For the Father loves the Son, and shows Him all things that He Himself does; and He will show Him greater works than these, that you may marvel. For as the Father raises the dead and gives life to them, even so the Son gives life to whom He will. For the Father judges no one, but has committed all judgment to the Son, that all should honor the Son just as they honor the Father. He who does not honor the Son does not honor the Father who sent Him" *(John 5:1–23)*.

"Saved by grace through faith," the theme of Ephesians 2, is beautifully illustrated by the miracle recorded in John 5. The mercy of God links the two

chapters together, for God's mercy, Paul declared, made us alive in Christ (see Eph. 2:4), and mercy was what the ailing man experienced beside the Pool of Bethesda, which means "House of Mercy" (see John 5:2).

I. The Circumstances: John 5:1–5

An unnamed feast identifies the time of the miracle. It might have been Passover (in April) or Purim (in March, commemorating the deliverance of the Jews from Haman's plot to exterminate them [see Esth. 3:7; 9:17–22]).

Bethesda was near a sheep market or near the Sheep Gate (see Neh. 3:1). The location of the double pools is generally assumed to be near the modern Saint Stephen's Gate. Four colonnades surrounded the area, and a fifth divided the two pools. Under their shelter lay a miserable group of human beings, some blind, some lame, some with withered limbs, many helpless, but all hopeless, or they would not have been there. John 5:3b–4, whether originally a part of John's Gospel or not, explains why those sick people were there. They believed that an angel periodically moved the waters (though likely this movement was due to the action of a natural spring) and whoever first stepped into those waters would be healed (see John 5:7). For them, the angel was proof of God's presence in the waters.

Some were weak, sick, or ailing. All unredeemed people are so described by Paul (see Rom. 5:6, "without strength"). Some were blind. All unredeemed people are blinded by Satan (see 2 Cor. 4:4). Some were lame. All who do not follow God are described as lame (see Heb. 12:13). Some had withered limbs, rendering them helpless, as all sinners are. All were sinners, and their physical afflictions were clear proof of the sorrows of which Adam's sin has made us all heirs. Yet physical afflictions are not nearly as serious as spiritual ones, which have eternal consequences. The moving scene serves as a vivid reminder of the hopeless condition of all who are without a Savior.

In John 5:5 our attention is suddenly focused on one man, a desperate and undoubtedly well-known case around the pools. What his ailment was we are not told, but he had had it thirty-eight years. Neither do we know how long he had been at the Pool of Bethesda, but doubtless it was long enough for him to be in the depths of despair and frustration as time and time again he saw someone else beat him to the stirred-up water and watched the only hope he had for healing vanish. This is the scene that met the Lord as He walked that day under the porches of the House of Mercy.

II. The Confrontation: John 5:6–9

A. The Question (vv. 6–7)

How our Lord knew the length of time the man had been ailing is not stated. Perhaps through His omniscience; perhaps He simply inquired. In any case, He asked the crucial question, "Do you want to be made well?" (v. 6).

Notice some aspects of the question that parallel every lost person's confrontation with the gospel. Christ took the initiative. He sought the man, not vice versa (see Luke 19:10). The question implied human responsibility (see John 5:24). It exposed human inability, as the man's response clearly indicated (see John 6:44). It offered complete, not partial, restoration (see 2 Cor. 5:17). Perhaps it revealed the object of the man's faith as being in others, who he hoped would help him, and, ultimately, in the power of the pool. His hope of salvation may have been a mixture of faith and works (see Eph. 2:8–9). The ineffectiveness of that formula had been all too obvious for thirty-eight long years!

B. The Command (vv. 8–9)

Unlike other miracles, this one contains no demand for faith on the part of the man, and no revelation to the man of who the Savior was (see v. 13). It was simply a sovereign act of healing on Christ's part. And yet the man had to respond to the Lord if he was to be healed. God now commands all people everywhere to repent (see Acts 17:30). Each person's response to that command means the difference between life and death. By grace we are saved, through faith. Faith is never stated to be the cause of salvation in the New Testament; it is rather the channel through which the grace of God comes to us.

The cure was instantaneous and complete. Nor was there any thought of relapse, for the man was commanded to carry his pallet and himself out of Bethesda (the perfect tense of the participle in v. 10 underscores the completeness of his cure).

III. The Controversies: John 5:10–18

When people are confronted with a miracle, controversy is inevitable. In this case, there were three.

A. The Jews with the Man (vv. 10–13)

The Jews complained that the man was working on the Sabbath, because he was carrying his pallet! Since this hitherto hopeless case must have been well

known, you would think the Jews would be thrilled to see the man fully recovered. But traditions meant more to them than people. Bearing burdens was specifically forbidden in Jeremiah 17:21, so the leaders, probably Pharisees, accused the man of breaking the Law.

Apparently, however, the Pharisees were using the charge against the man as a ploy to get at Jesus, so they asked him to identify his healer. But the man did not know his healer's name, nor could he point Him out in the crowd since the Lord had already disappeared (vv. 12–13).

B. Jesus with the Man (vv. 14–15)

Later the Lord sought out the man, reminded him that his cure had lasted (in contrast to many of the "pool cures"), and told him to stop sinning. This last command indicates that some sin on the man's part may have been the cause of his illness. Sickness is not always the direct result of personal sin (see John 9:1–4), but in this case it apparently was. The Lord also warned him that should he refuse to give up his sin, something worse would happen to him. This warning could refer to another more severe malady or perhaps to hell as the man's ultimate punishment. The man then reported to the Pharisees that it was Jesus who had healed him. He probably feared for his own safety since he was still charged with violating the Sabbath. So he tried to shift the blame to Jesus.

C. The Jews with Jesus (vv. 16–18)

Then the leaders openly attempted to kill Jesus, laying the blame for the man's alleged violation of the Sabbath on Him. The Lord's response was twofold (v. 17). First, since God continually works for good in the universe, it was proper for Jesus to do good on the Sabbath. Cessation of work, which the Sabbath was all about, did not include ceasing to do good. Second, the Lord claimed to be working equally with the Father, a clear claim to be fully God and a claim clearly understood by the Pharisees. Verse 18 shows that they understood both aspects of His reply.

IV. The Postscript: John 5:19–22

Christ's answer to the Pharisees' charge that He claimed to be equal with God reinforced that claim with four statements (each beginning with "for" [*gar* in the original]): (1) in the equal relationship between the Father and the Son (v. 19), whatever one does, the other does as well; (2) the love between the Father and the Son gives rise to mighty works (v. 20); (3) the Son shares the

Father's power to give life—both spiritual and physical resurrection (v. 21); and (4) the Son will judge all men (v. 22).

That kind of omnipotence can take care of all impotence. Jesus Christ is, indeed, Lord of all.

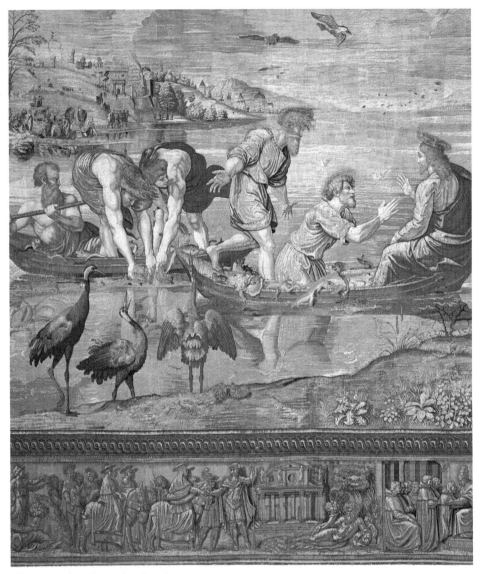

The Miraculous Draught of Fishes
Pieter Van Aelst, after a cartoon by Raphael, 1517; 15′ 11⁵/₁₆″ x 14′ 5⅝″; tapestry in silk and wool, with silver-gilt threads; The Vatican Museum, Rome, Italy (Scala/Art Resources, Inc.)

The scene here depicts Peter, amazed at the quantity of fish caught in the nets, falling down before Jesus and saying, "Depart from me, for I am a sinful man, O Lord!" (Luke 5:8). In the background one can see Vatican Hill with Saint Peter's Basilica undergoing construction, but it is the action of the monumental figures in the foreground that predominates in this beautiful tapestry. The cranes in the foreground are symbols of vigilance in contrast to the seagulls, which allude to sin and apostasy. The lower border depicts events in the life of Pope Leo X, who commissioned this work as part of a series of ten tapestries devoted to the lives of the apostles Peter and Paul for the Sistine Chapel. Only seven of the original series of works remain.

SUCCESSFUL SERVICE

The Miraculous Catch of Fish

Now so it was, as the multitude pressed about Him to hear the word of God, that He stood by the Lake of Gennesaret, and saw two boats standing by the lake; but the fishermen had gone from them and were washing their nets. Then He got into one of the boats, which was Simon's, and asked him to put out a little from the land. And He sat down and taught the multitudes from the boat. Now when He had stopped speaking, He said to Simon, "Launch out into the deep and let down your nets for a catch." But Simon answered and said to Him, "Master, we have toiled all night and caught nothing; nevertheless at Your word I will let down the net." And when they had done this, they caught a great number of fish, and their net was breaking. So they signaled to their partners in the other boat to come and help them. And they came and filled both the boats, so that they began to sink. When Simon Peter saw it, he fell down at Jesus' knees, saying, "Depart from me, for I am a sinful man, O Lord!" For he and all who were with him were astonished at the catch of fish which they had taken; and so also were James and John, the sons of Zebedee, who were partners with Simon. And Jesus said to Simon, "Do not be afraid. From now on you will catch men." So when they had brought their boats to land, they forsook all and followed Him *(Luke 5:1–11).*

O̶ur Lord was a master in the use of simple object lessons. On two very important occasions He used fishing to teach some vital truths to the disciples, one here at the beginning of His ministry and the other after the Resurrection (see John 21:1–11); both were on the Lake of Galilee. This occasion was evidently His second call to the disciples, for although He had asked them before to follow Him (see Matt. 4:19), apparently their response was only temporary and they had returned to their fishing business. Here He also taught them some basic principles for successful service.

I. Obedience to the Spoken Word: Luke 5:4–7

Successful service requires, first of all, obedience to the spoken Word. For us today that means obedience to what has been recorded in the Bible.

A. The Reason for Obedience (vv. 4–5)

We obey simply because God has spoken. It is at His Word and on the basis of it that we launch out and let down the nets, and He accomplishes the results.

29

We may be tempted to compromise the simple principle of obedience in several ways. First, we may choose to be guided by what friends think instead of what God says. Undoubtedly, there were skilled fishermen on the shore that day watching Peter to see if he were going to obey this Man Jesus. Public opinion or pressure from even the best of friends must not interfere with our obedience to His Word.

Second, we must do what He says even if it seems contrary to our best knowledge of the matter. The Lord asked Peter to do two things contrary to good fishing practice—launch out into the deep and do it in the daytime. He was asking a lot of that knowledgeable and experienced fisherman—He was asking him to believe.

Third, even circumstances may not be a safe guide. The Lord asked the disciples to do what the circumstances of the preceding night of fruitless fishing would indicate to be useless. But they needed to learn that obedience was more important.

Fourth, we must not be tempted to disbelieve because we are afraid (in a good sense) for the Lord's reputation. Perhaps Peter's words in verse 5 were an attempt to protect Jesus from embarrassment in front of the crowd. Sometimes we may be afraid to launch out in faith for fear that the matter will not come to pass and the world will laugh at Him. Yet, perhaps, we are really afraid they will laugh at us.

To be successful in our service, we must obey His Word, in spite of what friends might think or what knowledge might dictate or what circumstances might indicate or whatever fears might cause us to hesitate.

B. The Results of Obedience (vv. 6–7)

As soon as Peter obeyed, two things happened. First, there was success, for so great was the catch of fish that their nets began to tear. Second, there was expansion, for Peter was obliged to call on others to help with the catch (v. 7). When the Lord's work is done according to His Word, His prospering will follow.

II. Obeisance to the Living Word: Luke 5:8–11

Alone, obedience might breed a pharisaic attitude of superiority. It must be coupled with obeisance to the living Lord.

A. The Reason for Obeisance (vv. 8–10a)

When a person looks at himself or herself and then at the Lord, what else can

he or she do but completely bow in His presence? Peter saw himself as a sinful man. He was also a qualified fisherman, an experienced adult, a well-off businessman; but when confronted by the Lord he saw himself for what he basically was — a sinful person. Then he recognized Jesus for who He was — his Lord, his Master. That very sovereignty compels obeisance and confession of sin, and it also attracts the sinner to the Lord.

B. The Results of Obeisance (vv. 10b–11)

Certain inevitable results follow when the believer prostrates himself before the Lord. First will come serenity, for the Lord says, as He did to Peter that day, "Stop being afraid." Second, there will be service, for He promised Peter and us that we will catch people. Third, there will be successful service, for the word translated "catch" in verse 10 means "to catch alive." Successfully catching fish involves killing them in the process, but successfully catching men brings life in every case.

Fourth, obeisance results in separation from the world (v. 11), and separation involves a negative aspect (forsaking all) and a positive aspect (following Him). For the disciples, forsaking all meant leaving their homes, their families, their boats and tackle — everything they loved. But it also meant blessing, peace, and eternal rewards. Following would mean unkind treatment by their peers and uncertainties about the future. But it also would mean being three years in a course no school could ever offer and living intimately with the Son of God.

The formula for successful service, then, is simplicity itself: obedience and obeisance. As Christians, may we keep both at the center of our actions.

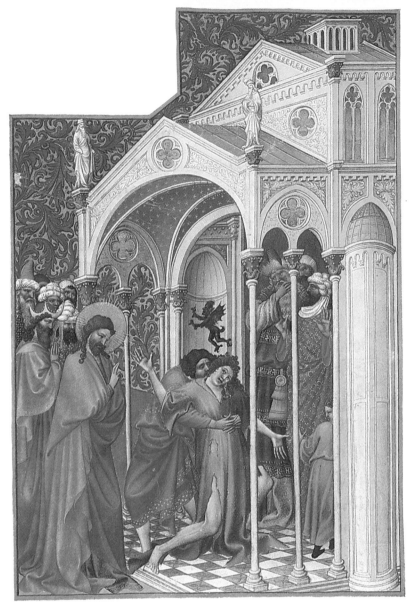

Casting a Demon Out of a Man at Capernaum
Limbourg brothers, ca. 1415; illuminated manuscript *(Book of Hours)*; Musée Condé, Chantilly, France (Giraudon/Art Resource, Inc.)

The Limbourg brothers — Pol, Jan, and Herman — are probably the most noted Franco-Flemish illuminators of their time (before 1399-ca. 1439). Considered by some scholars to be the king of illuminated manuscripts, this Book of Hours was commissioned by Jean, Duke of Berry of France, for whom the Limbourgs did most of their work. (A Book of Hours contains devotional prayers and meditations suited to seasons, months, days of the week, and hours of the day.) Their training as goldsmiths is evident in the attention to detail and the use of gold leaf in their manuscripts, especially here in the decorated background and garments and in Christ's halo. This page depicts the moment Christ cast the demon out of the possessed man. As some ornately dressed figures watch, the demon in the form of a small, black-winged dragon flees above the man's head. This page vividly illustrates the richness and quality of all the miniatures in this beautiful book. (See also page 33.)

THE AUTHORITY OF CHRIST

Casting a Demon Out of a Man in Capernaum

Then they went into Capernaum, and immediately on the Sab-
bath He entered the synagogue and taught. And they were as-
tonished at His teaching, for He taught them as one having
authority, and not as the scribes. Now there was a man in their
synagogue with an unclean spirit. And he cried out, saying, "Let
us alone! What have we to do with You, Jesus of Nazareth? Did
You come to destroy us? I know who You are—the Holy One of
God!" But Jesus rebuked him, saying, "Be quiet, and come out of
him!" And when the unclean spirit had convulsed him and cried out
with a loud voice, he came out of him. Then they were all amazed, so that
they questioned among themselves, saying, "What is this? What new doctrine is this? For
with authority He commands even the unclean spirits, and they obey Him." And imme-
diately His fame spread throughout all the region of Galilee *(Mark 1:21–28; see also Luke 4:31–37).*

In Capernaum, the Jewish capital of Galilee, the Lord was teaching one Sab-
bath in the synagogue when He was accosted by a demon speaking through a
man in the audience. The subsequent dialogue and miracle vividly displayed the
authority of Christ.

I. Authoritative Declaration: The Doctrine

If we may assume that the normal conventionalities were observed that Sab-
bath, then the procedure in the service was something like the following: As
Christ entered the synagogue, the chief ruler asked Him to be the messenger
for the day. As a part of His duties, He would have begun the service with two
formal prayers, followed by the *Shema* (the central creed of Judaism consisting
of Deut. 6:4–9; 11:13–21; Num. 15:37–41). Certain prayers of benediction,
followed by blessing by the priests, concluded the liturgical part of the service.
Then the Law and Prophets were read, followed by the sermon, which gave the
Lord the opportunity to express His teaching.

A. The Content of His Doctrine

We are not told the exact content of His teaching though we have an impor-
tant clue in the Sermon on the Mount (see Matt. 5—7). His message unfolded

the love of God; it emphasized the necessity of inward honesty in contrast to external appearances; it put real religion above ritual; it exhorted people to look at their hearts, for it emphasized that God requires truth in the inner parts. Such might have been some of the themes He used that Sabbath.

B. The Characteristic of His Doctrine

Unquestionably the principal characteristic of Christ's teaching was its authority. It struck the hearts of people. It had the ring of being God's truth.

C. The Consequence of His Doctrine

People were astonished when He taught. The Greek word translated "astonished" literally means "to strike with a blow."

II. Authoritative Denunciation: The Demon

A. The Description of the Demon

Christ's authoritative teaching aroused a demon who lived in a man present in the service. Demons are not only real beings but, as is evident in this case, they are ruling beings. The demon had usurped the authority of the man's own spirit. He was an intruder, using the man's own vocal organs to communicate with Christ.

B. The Declaration of the Demon

The demon said three things. First, "What have we to do with You . . . ?" (Mark 1:24; Luke 5:34) or "what have we in common?" This same phrase was used by the Lord to His mother in Cana (see John 2:4; cf. Matt. 8:29; Luke 8:28). It does not mean "what have we to contend about?"; rather it is a statement of the antithesis, here especially, between darkness and light. What did they have in common? Nothing.

Second, the demon asked if Christ had come to destroy him. Destroy in what sense? By casting him out of the body he was in. Embodiment seems to be the goal of demons; thus they feared disembodiment.

Third, he testified to the character of Christ as the Holy One of God. Though the source of the testimony was demonic, the substance was true, for He is that. His holiness or light is what struck terror into the heart of that missionary of darkness.

C. The Denunciation of the Demon

Though true, the demon's testimony was unacceptable, so the Lord told him to be silent (literally, "be muzzled," 1 Cor. 9:9; 1 Tim. 5:18). Why was it unacceptable? Because mere knowledge of who Jesus is, is not enough for accep-

tance with God. Without faith it is impossible to please Him (see Heb. 11:6). Therefore, the Lord did not accept the testimony of the demon.

III. Authoritative Demonstration: The Deliverance

A. The Command

Immediately the Lord commanded the demon to come out of the man. Here was clear proof of His authority.

B. The Cure

The demon had met a greater Ruler; he had to come out of the man. This was no gradual cure of some supposed psychosomatic illness. This was real demon control and immediate deliverance. But it was not without a last struggle. The demon threw the man down before leaving, yet without doing any harm to him. When Satan is losing the battle, he fights all the harder.

C. The Consequences

The people were amazed, and Christ's fame spread throughout the country. Notice that the amazement of the people was not merely about the miracle but also about the doctrine (see Mark 1:27). What He had said and what He did were inseparable in their minds (see a similar example in Acts 13:12). So it should be for us, too. We should practice what we preach and do so with authority—the authority that comes from a holy life lived in obedience to the authoritative Word of God.

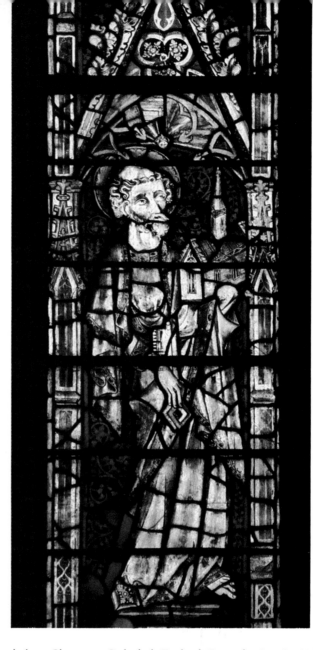

St. Peter

ca. 1350; stained glass; Gloucester Cathedral, England (Reproduction © 1984 Jack Farley)

The magnificent east window of the Gloucester Cathedral is one of the most characteristic and important examples of late Gothic stained glass in England. The cathedral itself had its foundations laid in the eleventh century and is Gothic, of a type called "perpendicular." The nave has narrow pillars stretching upward to a ceiling covered with a close-knit ribbed pattern. The east window contains many figures, one of whom is Peter, who holds a key and a church, symbolic of the belief that Christ commissioned Peter as the rock on which He would build His church. The window retains its two-dimensional quality in a simple mosaic of glass.

LESSONS LEARNED AT DINNER TIME

Healing Peter's Mother-in-law

Now as soon as they had come out of the synagogue, they entered the house of Simon and Andrew, with James and John. But Simon's wife's mother lay sick with a fever, and they told Him about her at once. So He came and took her by the hand and lifted her up, and immediately the fever left her. And she served them *(Mark 1:29–31; see also Matt. 8:14–15; Luke 4:38–39).*

For some reason, mothers-in-law seem to be notoriously infamous. In the two instances in the Bible where they are mentioned by name, however, just the opposite is true. In the Old Testament, the fragrance of Naomi's character permeates the Book of Ruth, while in the New Testament, Peter's mother-in-law was the subject of one of our Lord's miracles.

The setting was Peter's house in Capernaum, and the occasion was the first-century equivalent of Sunday dinner. Only, on that Sabbath day, when the Lord and Peter returned from the synagogue (where He had cast out a demon), no sumptuous dinner awaited them. Jewish custom made the Sabbath not only a day of rest but also a day of joy, not the least reason for which was the festive meal. We are sometimes inclined to remember only the thirty-nine kinds of work forbidden on the Sabbath day by the Mishnah (a collection of interpretations that Jewish rabbis used to explain the laws of Scripture) and to forget the fact that it was expected to be a day of delight (see Is. 58:13 and Prov. 10:22, which were applied to the Sabbath). Three meals of the choicest food were prescribed for the Sabbath along with regulations as to how that food could be kept warm, since no fire could be kindled on the Sabbath (see Ex. 35:3).

But that day in Capernaum there was no meal ready, for sickness had overtaken an important member of the household—Peter's wife's mother. That illness became the occasion for another of the Master's miracles as well as an opportunity for us to learn some important lessons.

I. A Lesson about Sickness

Being a follower of Christ does not exempt one from illness in this life. And until we get to heaven that shall be the case. The Bible assigns a number of reasons why people become ill. Sometimes, as in the case of Lazarus, sickness comes solely for the purpose of glorifying God (see John 11:4). Difficult as that may be to understand, it is nevertheless true that at times God is glorified through sickness, suffering, and even death. One of the tensions we all face in acknowledging the sovereignty of God is that we cannot understand the inclusion in His plan of things that to us seem out of place. But such things, including sickness, are often used to glorify the God of the plan (see Eph. 1:11–12).

On several occasions during His earthly ministry, the Lord came upon sick people whom He healed so that others might believe. In the case of the man born blind, for example, the demonstration of the mighty work of God in restoring sight resulted in the conversion of that man (see John 9:3,38). In another instance, sickness was allowed to sadden the home of the nobleman of Capernaum so that the Lord might heal the afflicted son and that the entire household then would believe in Him (see John 4:53). Obviously sickness is sometimes permitted for the particular purpose of bringing people to Christ.

A third reason for illness is the activity of demons. The Gospels abound with evidence that demons can inflict both mental (see Mark 5:2–5; Luke 9:37–42) and physical disorders (see Matt. 9:33; 12:22; Luke 13:11,16). Of course, not all illness is caused by demon activity, but some certainly is. Dr. Luke's diagnosis in Acts 5:16 clearly distinguishes between demon affliction and other illnesses.

Although we know that the ultimate reason for the existence of sickness is sin, nonetheless it is sometimes true that the experience of sickness is caused by some specific sin in the life of a believer. A clear example of such sin-caused sickness is found in the case of some members of the church at Corinth. Paul declared that the reason some of them were "weak and sickly" was traceable to their behavior at the Lord's Supper. They had partaken with particular unconfessed sins in their lives, and God had disciplined some of them with sickness.

Not every illness, however, can be said to be primarily for the glory of God or the salvation of someone, nor can it be attributed to demon possession or persistent sin; one may become sick from overwork. Such was the experience of Epaphroditus who nearly died because he had worked so strenuously (see Phil. 2:25–30). That killing pace was not the kind that often makes people sick to-

day—it had not advanced him up the business or social ladder; rather, it was "for the work of Christ" that he nearly died.

But none of these reasons for sickness seems to be why Peter's mother-in-law was ill. Dr. Luke gave a precise diagnosis (see Luke 4:38). The tense of the verb indicates that she had a chronic fever, and it was severe; he described it as "great." (Ancient Greek physicians divided fevers into great and small.) Furthermore, when the Lord spoke the word, the fever left her "immediately." The beloved physician's interest and insight give us these precise details about her illness that are not found in Matthew's or Mark's accounts.

But why was she miraculously cured? So that she might serve the Lord. Here is the clue to why God permitted her to be sick as well as many others of His children—so that we might learn that life and health and strength are given us so that we might serve. Sickness can be used to teach us what we should do with our health!

Another example of this principle is found in Acts 28 where we read of Paul's and Luke's ministering to the physical needs of people on the island of Malta. In return, those who were healed, whether through Paul's use of his miraculous gift or through Luke's use of his knowledge of medicine, ministered to Paul and Luke by giving them material things they needed (see Acts 28:10).

Life is for serving. This is one of the lessons of this miracle. Sometimes sickness is the teacher that helps us learn that lesson.

II. A Lesson about Selflessness

The Lord's own actions on that day teach us the second lesson from this miracle—that of selflessness, which is the very essence of Christianity. The teaching method the Lord used on this occasion is a most effective one. It is teaching by actions.

The day had already been a busy one for the Lord before He ever arrived at Peter's house. He had been to the synagogue service and had taught the people there. He had fought with a demon and cast him out of the possessed man in the synagogue. He certainly deserved a rest when He got to Peter's house that afternoon, but there He found a need that He gladly met.

Yet there was more, for that evening when the already full day's work should have been done, the whole city was gathered in front of Peter's house seeking help from the miracle-working Master. Again Jesus ministered tirelessly to the multitude. What an important example and lesson for followers of Christ who, impressed with their own importance, avoid contact with people in order to

"save themselves" for what they consider to be more important activities! Self-lessness means an untiring giving of self in serving others.

But selflessness also means an eager willingness to serve. According to Luke's account, only one request had to be made to the Lord to heal Peter's mother-in-law (the verb *besought* in Luke 4:38 indicates this). The response was immediate. It is little wonder that Matthew saw that day of such totally selfless ministry to others as the fulfillment of Isaiah's prophecy that He "took our infirmities, and bare our sicknesses" (Matt. 8:17; cf. Is. 53:4). The world says "get"; Christianity says "give." Give constantly; give eagerly; give selflessly.

III. A Lesson about Service

As soon as Jesus healed Peter's mother-in-law, she got up and began to wait on Him (and Peter, Andrew, James, and John who were with Him in the house, see Mark 1:29). The cure was instantaneous, and her response of service immediate. The same should be true of those who have been healed spiritually by Christ. Forgiveness of sins should result in faithful service.

Peter's mother-in-law's immediate response of service on that Sabbath teaches us several things about service in general and a woman's ministry in particular.

All the Gospels use the same word to describe her ministering. It is the word from which we get the English word *deacon*. The verb means "to execute the commands of another," and it evidently comes from two words that together mean "to raise the dust by hastening." A servant, then, is one who raises the dust in order to do speedily the bidding of his master.

The use of this word in the Gospels with respect to service done for Christ is limited to the ministry of angels or of women. After the temptation, angels came and ministered to the Lord (see Matt. 4:11; Mark 1:13). On two occasions Martha is said to have served Him; mention is made of a band of women who ministered to Him of their substance; and there is this occasion when Peter's wife's mother served the Lord (see Luke 10:40; John 12:2; Luke 8:3). This is not to say that His disciples and other men did not perform services for their Master, but it is apparently true to say that in the life of the Lord women had a special place as ministers to Him.

The exact nature of this service of women is seen in the miracle we are studying. It consisted in ministering to the physical needs of the group gathered in the home that day. This ministry is the same kind Martha performed as well as did the band of women who evidently provided money for the material needs

of the disciples. Peter's mother-in-law doubtless helped with the preparation of the Sabbath meal in the home that day. Spurgeon, a prince among preachers, commenting on this passage, said in his own inimitable way:

> But notice that what this good woman did was very *appropriate*. Peter's wife's mother did not get out of bed and go down the street and deliver an address to an assembled multitude. Women are best when they are quiet. I share the apostle Paul's feelings when he bade women be silent in the assembly. Yet there is work for holy women, and we read of Peter's wife's mother that she arose and ministered to Christ. She did what she could and what she should. She arose and ministered to him. Some people can do nothing that they are allowed to do, but waste their energies in lamenting that they are not called on to do other people's work. Blessed are they who do what they should do. It is better to be a good housewife, or nurse, or domestic servant, than to be a powerless preacher or a graceless talker. She did not arise and prepare a lecture, nor preach a sermon, but she arose and prepared a supper, and that was what she was fitted to do. Was she not a housewife? As a housewife let her serve the Lord. (C. H. Spurgeon, *Sermons on Our Lord's Miracles*, Vol. II. London: Passmore and Alabaster, 1909, pp. 225–26).

The rest of the New Testament does not depart far from the picture of appropriate ministry for women this miracle provides. A woman's service for the Lord is primarily related to her home, and the exercise of her ministry is private, not public. This is not degradation but distinctiveness; it is not inferiority but exaltation in the sphere in which God has placed her. In the Gospels, the service of women to Christ specifically consisted in caring for His physical needs by providing hospitality, by giving Him money, and at the time of His death by preparing spices for His body.

Our Lord's response to this ministry of women was significant, for He allowed them to follow Him; He taught them; He honored them with the first announcement of the Resurrection. But He did not choose a woman to be among the twelve disciples. The seventy missionaries were men (see Luke 10:1). The Lord's Supper was instituted in the presence of men only. The New Testament was written by men. Yet the ministry of women is clearly defined in the New Testament and superbly illustrated by the activity of this mother-in-law on that Sabbath day. This is the true diaconate of women.

These are the lessons of the miracle of the healing of Peter's mother-in-law. And yet the three lessons are but one lesson, the lesson of service. All service for the Master should be like His own service for others, unceasing and eager even at the end of a long day that had already been filled with good deeds. Such service of women is something peculiarly exalting to them when done according to the pattern and in the sphere that God Himself has designed.

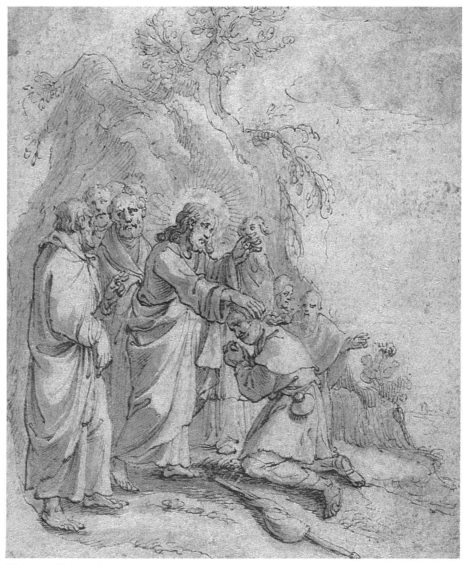

Christ Healing the Leper

Anonymous, early seventeenth century; Dutch school; pen and wash drawing; National Gallery of Art, Washington, D.C. (Ailsa Mellon Bruce Fund)

One of the most remarkable occurrences in the history of painting is the emergence in the seventeenth century of so many painters of genius in the small country of Holland. Jan Rubens, Anthony Van Dyck, Frans Hals, and Rembrandt Van Rijn led the way. Portraits, animals, biblical scenes, and landscapes were painted by a thousand artists. Drawings were traditionally considered to be preparatory studies for finished paintings and works in other media, but during the seventeenth century they began to be commissioned and collected as works of art in their own right. Here we see Christ's look of compassion for the leper as the needy supplicant bows before Him.

LOVE AND LAW

Curing a Leper

Then a leper came to Him, imploring Him, kneeling down to Him and saying to Him, "If You are willing, You can make me clean." And Jesus, moved with compassion, put out His hand and touched him, and said to him, "I am willing; be cleansed." As soon as He had spoken, immediately the leprosy left him, and he was cleansed. And He strictly warned him and sent him away at once. And He said to him, "See that you say nothing to anyone; but go your way, show yourself to the priest, and offer for your cleansing those things which Moses commanded, as a testimony to them." But he went out and began to proclaim it freely, and to spread the matter, so that Jesus could no longer openly enter the city, but was outside in deserted places; and they came to Him from every quarter *(Mark 1:40–45; see also Matt. 8:2–4; Luke 5:12–16)*.

I. The Leprosy of the Man

In one of the cities of Galilee during the Lord's first preaching tour of that area, a leper accosted Him. Leprosy is one of the oldest diseases known to man, for the Egyptians recognized it before 1500 B.C. It was not an uncommon problem in Christ's time (see Matt. 10:8; 11:5; Luke 7:22), but this incident is the first record of our Lord's dealing with it.

A. The Characteristics of Leprosy

Leprosy is a disease that knows no climatic or social boundaries. Although today the world's three million lepers are found mainly in tropical Africa, South America, India, and China, the disease has occurred and does appear in all parts of the world. Race, occupation, climate, or social status apparently have no bearing on its incidence.

Today leprosy appears in two forms. One affects the nerves and the other the skin. The latter seems to be the kind described frequently in the Bible. Neither is a disease of the blood, although the bacilli appear in the blood during times of fever. A person may harbor the disease for years before it shows any physical signs. When it does appear, it takes the form of nodules or of swelling of the extremities, and it usually affects the face, legs, or feet first. From then on the disease runs a fearful and sometimes lengthy course. The skin becomes fur-

rowed; the ear lobes, lips, and nose become thickened; the skin often becomes dry or scaly; the nails are often striated. Ulcerations occur easily, and although they may heal, they often penetrate deeply and spread, causing appalling mutilation. Fingers and toes may drop off, and blindness may result.

Methods of arresting the disease have been known for some time, and while modern drugs can eliminate the bacilli from the body, nothing can undo the toll the disease takes on a body before it is arrested. No one but the Lord could restore the digits that drop off or the blindness that occurs.

B. The Consequences of Leprosy

In the Old Testament certain guidelines were given for diagnosing leprosy (see Lev. 13). When it was discovered, the afflicted persons were rigidly cut off from the community. They were compelled to put on the signs of mourning as if they were dead. Their clothes were rent, their heads uncovered, their lips covered, and wherever they went they had to shout, "Unclean," in order to warn others away (see Lev. 13:45; Num. 12:12). Often a separate place was designated in the synagogue for lepers, and infraction of any of these regulations concerning separation was punishable with forty stripes.

The Hebrew word for leprosy comes from a root that means "to strike," signifying that leprosy was a "stroke" from God, something loathsome. Though the leper was always described as ceremonially unclean rather than sinful, the stigma and taboo attached to the disease suggest that it served as an illustration of sin.

Though we do not know how advanced the disease was in this particular man, we do know what restrictions and stigmas he lived under.

II. The Love of the Master

The leper's approach to the Lord showed great faith in His power: "If You are willing, You can make me clean," he said (Matt. 8:2). And Jesus could. But would He? Yes, because He was moved with compassion (see Mark 1:41). Love would bring that power to the man's aid. His powerful and willing love became active love, and the Savior touched the leper. Normally such an action would defile a person, but the sinless Christ was defiled by nothing, including touching the leper. Perhaps this can serve as an illustration of the deep mystery involved when the sinless Savior became sin for us on the cross (see 2 Cor. 5:21).

III. The Law of Moses

A. The Procedure of the Law

After being healed, the man was commanded to go to the priest and offer the ritual for a cleansed leper (see Lev. 14). Briefly the ritual was as follows: two clean living birds, a cedar rod, scarlet, and hyssop were taken; one bird was killed in an earthen vessel over running water; the hyssop was tied to the rod with the scarlet band, and it and the living bird were dipped in the blood of the dead bird; next, the blood on the rod was sprinkled over the leper seven times; and the living bird was set loose. At this point the leper was pronounced clean, but more was yet required of him. He had to wash his clothes, shave, bathe, stay away from his house for seven days, repeat the ablutions and shaving, and finally on the eighth day offer at the temple a sin offering, a trespass offering, a grain offering, and a burnt offering.

The Law was very specific and detailed about this procedure, and doubtless, because it had seldom if ever been used in the lifetime of the priests to whom the man was sent, there would have been a lot of scratching of priestly heads had he gone. But instead, he chose to disobey and publicize his healing to the detriment of the Lord's ministry. No doubt the leper was so overcome with gratitude for his deliverance and his deliverer that he thought he was doing something good to tell everyone about Jesus. But he should have obeyed the Lord's commands.

B. The Powerlessness of the Law

An important fact about the relation of the Savior, the sinner, and the Mosaic law is illustrated in this miracle. The Law was powerless to cleanse. It could pronounce a man cleansed, but it could not do it. This is still true. The Law cannot justify the sinner, no matter how much he or she may try to keep its requirements (see Rom. 3:20). It was not, and is not, a way of eternal salvation.

C. The Purpose of the Law

The Lord wanted the man to go to the priests as a testimony to them. In the process of supervising the ritual involved in pronouncing a leper cleansed, perhaps they might have realized who Jesus truly was. The Law is for the unrighteous person (see 1 Tim. 1:9), to lead him to Christ (see Gal. 3:23–24). Our Lord used it for this purpose (see Luke 10:27–37), and so may we as we seek to bear witness to Christ and His righteousness.

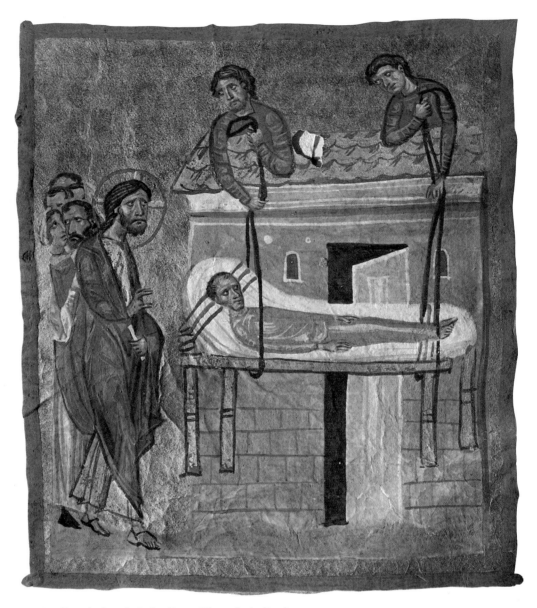

Healing the Paralytic Let Down Through the Roof
Twelfth century; illuminated manuscript; Greece (Magnum)

It is somewhat unusual to find illustrations of the text itself in illuminated Byzantine manuscripts of the Gospels. The more predominant use of the lectionary in the liturgy — instead of the actual books of Scripture — led to more elaborate effort being given to the lectionaries. However, those Gospel manuscripts that do have illustrations have them quite extensively. Here two friends of the paralytic lower him from the roof of the house into Christ's presence. Christ recognizes their faith and raises His hand in a gesture of blessing. (See also page 67.)

THE MIRACLE-WORKING CHRIST—BOTH GOD AND MAN

Healing the Paralyzed Man Let Down through the Roof

Now it happened on a certain day, as He was teaching, that there were Pharisees and teachers of the law sitting by, who had come out of every town of Galilee, Judea, and Jerusalem. And the power of the Lord was present to heal them. Then behold, men brought on a bed a man who was paralyzed. And they sought to bring him in and lay him before Him. And when they could not find how they might bring him in, because of the crowd, they went up on the housetop and let him down with his bed through the tiling into the midst before Jesus. So when He saw their faith, He said to him, "Man, your sins are forgiven you." And the scribes and the Pharisees began to reason, saying, "Who is this who speaks blasphemies? Who can forgive sins but God alone?" But when Jesus perceived their thoughts, He answered and said to them, "Why are you reasoning in your hearts? Which is easier, to say, 'Your sins are forgiven you,' or to say, 'Rise up and walk'? But that you may know that the Son of Man has power on earth to forgive sins"—He said to the man who was paralyzed, "I say to you, arise, take up your bed, and go to your house." Immediately he rose up before them, took up what he had been lying on, and departed to his own house, glorifying God. And they were all amazed, and they glorified God and were filled with fear, saying, "We have seen strange things today!" *(Luke 5:17–26; see also Matt. 9:1–8; Mark 2:1–12).*

If you ask a group of Christians what each one considers the most important thing about Jesus Christ, most will answer in terms of something He did or does. Actually the most significant thing about the Lord is not anything He did or does, including His death and resurrection, but the most important thing about Him is who He is.

You can easily see why this is true. If He is not who He claimed to be, then what He did or does will be adversely affected. For example, even though He actually died and rose again from the dead, if He were not who He claimed to be, then that death and resurrection did not accomplish what He said it would.

Taking the question one step further, then, what is the most important thing about who He is? The answer is that He is at once fully God and fully man. There is no way He could be an effective Savior unless He is God and man. A Savior must die in order to pay for sin. Only a human being can die; God

cannot die. Therefore, the Savior must be a man. But if He were only a man, then that death could not pay for sin. So an effective Savior must also be God.

In this familiar miracle, our Lord claimed to be both God and man. Set in Capernaum ("his own city"), the story opens in an atmosphere of dogged antagonism. Our Lord had just returned from a tour of Galilee, and interest in His message and ministry was spreading. Also increasing was the opposition from the Pharisees that had started earlier in Jerusalem because of their jealousy over His success (see John 4:1). Some Pharisees had come from Judea to Galilee to further their campaign against the Lord. This is the first mention of the Pharisees in Luke's Gospel (5:17).

I. The Miracle of Perception

A. Perceiving the Faith of the Paralyzed Man and His Friends

That day the upper room of the house (often the largest, see Acts 1:13; 20:8) was so jammed with people that the crowd overflowed into the courtyard below. Not another person could squeeze his way through the crush of bodies to get near the Lord. But upper rooms had access by means of an outside stair. The roof overhead was probably made of matting suspended over the rafters and then covered with earth and twigs. The opening was easily made, and four men lowered their paralyzed friend lying on his pallet through that opening. The Lord, perceiving the faith of all five men, responded.

Notice some things about faith. (1) Genuine faith is a working faith. The imperfect tense in Luke 5:18 shows that the four friends were making a great effort to get their friend to the Lord. Men of greatest faith are often men of hardest work. (2) Faith persists. What pains they went to in order to find a way around the crowd that prevented them from reaching their goal! The motto "No gain without pain" applies to many aspects of the Christian life. If we believe that it is important to study the Scriptures, pray, and discipline our lives, then we will persist to find the time and means to accomplish those worthy goals. It was important to get this man to Jesus, and his friends were not going to let personal inconvenience or the press of time or the roadblock of the crowd get in their way. (3) Faith succeeds. Our Lord did not scold the men for the unorthodox way they came to Him. He perceived their faith and rewarded it. Imagine not only the joy of the man released from his paralysis, but also the joy of his faithful friends.

B. Perceiving the Need of the Paralyzed Man

The Lord immediately got to the basic problem, which was not paralysis. Sin was the man's greatest problem. This is not to imply that the paralysis resulted from sin, but it is to remind us that a spiritual malady is far more serious than any physical affliction. All physical problems end with physical death, but the penalty for sin is eternal death to which there is no end. So the Lord, attending first to the principal need, announced that the man's sins were forgiven.

Matthew alone recorded that the Lord also said, "Cheer up!" ("be of good cheer," Matt. 9:2). The word is used in the New Testament only by Christ (see also Matt. 9:22; 14:27; Mark 6:50; John 16:33; Acts 23:11). That the Lord used it here seems to indicate that in the man's heart was a longing to receive more than physical healing. That was all he and his friends dared hope for, yet the Lord apparently perceived that the man longed to have a greater need met. And before He could even ask, if he had even dared to, Jesus answered that unspoken request with His "Cheer up!"

C. Perceiving the Thoughts of the Pharisees

On hearing the announcement of forgiveness, the Pharisees began to reason in their hearts that Jesus was guilty of blasphemy. In granting forgiveness, He had exercised a divine prerogative. How could Jesus of Nazareth, whom they considered to be only a man, take on Himself the authority to forgive the paralyzed man's sins? Obviously, they reasoned, He had blasphemed.

Blasphemy against another human being means to speak evil of him (see 1 Cor. 4:13; Titus 3:2; 2 Pet. 2:2; Jude 8). But blasphemy against God involves not merely cursing His name, but also attempting to usurp the rights that belong only to the Creator. Since forgiveness is one of those rights, then Jesus must have been blaspheming, according to the Pharisees.

To this charge the Lord delivered a stinging rebuke: "Why do you think evil in your hearts?" (Matt. 9:4). All things are, of course, open to His eyes, and nothing, not even the unspoken musings of the heart, can be hidden from the omniscient Lord. This ability of the Lord brings conviction or comfort, depending on what goes on in our hearts! But never forget, He perceives all.

II. The Miracle of Pardon

A. It is Supernatural

The central miracle in this gallery of miracles was the pardon from sin that

the paralyzed man experienced. It was a miracle from God and done by God Himself, in the person of Jesus Christ. Eternal pardon has to be from God. Man can forgive, but he cannot remove the eternal consequences of sin. Only God can do that. Eternal pardon has to be supernatural.

B. It is Complete

Human beings tend to forgive partially and selectively. "I can forgive him for that, but I could never forgive him for the other," we say. Our Lord forgives all our sins. "Your sins are forgiven you," He said to the man. He not only forgave what might have been troubling the man at the time, or the sin that caused the paralysis (if such were the case), but He forgave his sins—all of them.

C. It is Here and Now

God's forgiveness is not something we only hope for in the future. It is realized and experienced now. Matthew and Mark emphasized this aspect by using the present tense in the announcement, "Your sins are forgiven."

D. It is Permanent

Sometimes things we experience today disappear tomorrow. Not so with God's forgiveness of sins. Luke recorded the statement using a perfect tense, which emphasizes the permanence of God's forgiveness.

Supernatural, complete, present, and permanent pardon is indeed a miracle.

III. The Miracle of Power

A. Power that Proves

When the Pharisees accused the Lord of blasphemy, He put a question to them. Is it easier to say, "Your sins are forgiven you," or to say, "Arise and walk"? (see Matt. 9:5). The question is not, Which is easier to *do*? but Which is easier to *say*?

Obviously, it is easier to say, "Your sins are forgiven you," simply because there is no way to test immediately whether or not they have been forgiven. Entire religious systems thrive on the simple fact that it is easier to say one's sins are forgiven. Their followers cannot be sure, until it is too late, whether the religion delivered that promised forgiveness.

It is much more difficult to say, "Arise and walk." Said to a paralyzed man, those words were immediately subject to a visible test. Either the man would get up and walk immediately or he would not. And whether he did would prove the veracity of the healer.

So, in order to prove that the Lord could do the more difficult thing (forgive sins, and thus prove He was God), He did the easier—and more verifiable—thing (heal the man).

In so doing, the Lord proved that He was God. If only God can forgive sins eternally, and if He, Jesus, had just done that, then Jesus must be God.

But He also by this act declared Himself to be the Son of man. This term was the Lord's favorite designation of Himself while on earth (used over eighty times), and it was based on the appearance of the Son of man in Daniel 7:13–14. The concept includes several facets: (1) His lowliness and humanity (see Matt. 8:20); (2) His suffering and death (see Luke 19:10); (3) His future reign as King (see Matt. 24:27); and (4) in this miracle, His being the God-and-man Savior. The unifying element of the various facets of the Son of man is the relation to the earth, for the title links the Lord to the earth, both in His past suffering and in His future glory.

The Savior must be both God and man. Man in order to die, and God to make that death an effective payment for sin. Here the Lord claimed undebatably to be God by declaring the man's sins forgiven; here He also identified Himself as the Son of man. He is God incarnate, God in flesh. And therefore, He is the only true Savior the world has.

B. Power that Pictures

As with others of the miracles, this one serves as a picture of several aspects of Christian salvation and life.

It pictures many aspects of salvation: the helpless man (see Rom. 5:6), the loving, persistent help of friends (see Rom. 10:14–15), and the total dependence on God to save (see Eph. 2:8).

It also pictures aspects of the Christian life. The new life was seen immediately. The paralysis did not gradually leave the man. He did not crawl, then limp, then walk. He got up and walked then and there, and proved beyond any doubt that he had full strength by even carrying his own pallet!

The dramatic proof affected the crowd in three ways: they were astonished, they stood in awe of God, and they glorified Him. May our lives do the same.

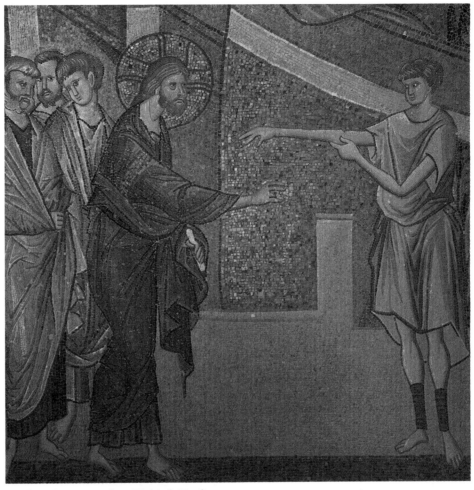

Healing the Man with a Withered Hand
Early fourteenth century; mosaic; Kariye Church, Istanbul, Turkey (Magnum)

At one time Kariye Church was used by the monastery of Chora, but it was rebuilt and decorated between 1310 and 1320 by the Comnenus family which had ruled the eastern Roman Empire from 1081 to 1185. It contains the richest collection of mosaics of the last golden age of Byzantine art. The artists worked a wide range of colors into their mosaics, and in this one the background and Christ's nimbus are in brilliant gold leaf. The nimbus, usually called a halo, is light, pictured as a disk or circle, around the head of a holy person. Here, only Christ has the three rays of light symbolic of the cross and His work as Savior. The exaggerated length of the man's arms draws our attention to his need and to Christ's ability to meet that need as He reaches out to touch him. (See also page 119.)

PRINCIPLES FOR CHRISTIAN SERVICE

Healing the Man with a Withered Hand

Now when He had departed from there, He went into their synagogue. And behold, there was a man who had a withered hand. And they asked Him, saying, "Is it lawful to heal on the Sabbath?"—that they might accuse Him. Then He said to them, "What man is there among you who has one sheep, and if it falls into a pit on the Sabbath, will not lay hold of it and lift it out? Of how much more value then is a man than a sheep? Therefore it is lawful to do good on the Sabbath." Then He said to the man, "Stretch out your hand." And he stretched it out, and it was restored as whole as the other. Then the Pharisees went out and took counsel against Him, how they might destroy Him (*Matt. 12:9–14; see also Mark 3:1–5; Luke 6:6–11*).

The Scriptures record seven miracles that Christ performed on the Sabbath. Perhaps this was one way He chose to emphasize the difference between rabbinic legalism and Christian liberty. For instance, on one Sabbath the disciples had been caught by the Pharisees picking and eating grain (see Mark 2:23–28). Although picking the grain was perfectly legal according to the Law (see Deut. 23:25), rubbing it in the hands was one of the kinds of work that Pharisaic tradition forbade on the Sabbath. When challenged, our Lord responded by declaring that the Sabbath was made for man, that is, in man's best interests, and that the Son of man is Lord of the Sabbath.

Although we recognize the difference between the Sabbath and the Lord's Day, certain principles are illustrated in these Sabbath miracles that concern our Christian service. In this one, legalism is a principle to be avoided, while liberty and love are to be our guides.

I. Legalism

The legalistic rabbis taught that a sick person could be given help and relief on the Sabbath only if his life were in danger. Obviously this case of a man with a withered hand was hardly urgent or life threatening, and his treatment could easily be postponed until the Sabbath was over. Our Lord's reply to the

thoughts He knew were in the minds of the Jewish legalists pointed out that if legalistic principles forbid the practice of good, then the legalist must be prepared to justify evil. To refuse to do good is to do evil. Legalism, then, is condemned because its negative rigidity, which forbids actions under certain circumstances, in reality condones evil. Or to put it another way, what we do not do may be just as wrong as something we do.

Not only can legalism lead to doing evil, but it can also make one a hypocrite. As our Lord pointed out, legalists who would not come to the aid of an afflicted man on the Sabbath would not hesitate to rescue their sheep on that day. That made the animal of greater worth than a human being. Let us be careful we do not wreck lives of people in the name of saving a cause or defending a conviction. Our commission is to nurture people, not to promote programs and causes. Let us beware that we do not sacrifice people on the altar of legalism.

II. Liberty

Legalism binds; liberty frees. But true liberty is not license. Liberty includes two ideas: the freedom to follow established customs and the freedom to abandon them when the need arises. Our Lord's actions on this occasion illustrate both aspects of true freedom.

The principle of conforming to custom is illustrated in the simple fact that the Lord was present at the synagogue service. Elsewhere we are told that this was His custom (see Luke 4:16), and His presence on this Sabbath was not accidental or exceptional but the practice of a lifelong habit. If our Lord had wanted to use reasons, such as those often heard today, for not attending public worship He could have found many. Certainly He got very little out of the message, for after all He was the fulfillment of every Scripture read or explained in the service. Surely He knew more about God and spiritual things than anyone present, including the leaders in the synagogue. Too, He knew that the organization He was supporting would soon be replaced by the church. But still He went regularly. Christian liberty, properly understood, does not free one from regular responsibilities, including attending worship services (see Heb. 10:25). Even if the preacher is a poor speaker and our knowledge of spiritual things exceeds his, still we must support the corporate worship of God.

Sometimes Christian liberty may involve unusual behavior. To heal on the Sabbath was unusual but not unrighteous, and the method the Lord used was unusual. The scene in the synagogue that Sabbath must have been a very dra-

matic one, for all the people would have been sitting on the floor when the Lord called the man with the withered hand to come and stand in plain view of all those gathered there. Yet the scene was dignified. Even our Lord's rebuke of the Pharisees was dignified. Unusual behavior does not have to involve disorderliness — and certainly not license.

What should or should not be done on Sunday is debated among believers. Applying this principle of liberty may lead to proper answers. Use liberty to follow some established customs — such as regularly attending the services of the day, and regularly keeping your financial accounts up-to-date (see 1 Cor. 16:2). Irregular activities may also be proper, as long as they glorify God (see 1 Cor. 10:31–32) and do good (see Acts 10:38).

III. Love

All service should be done in love. Love may sometimes involve anger, for love is not a sentimental emotion that overlooks truth. Love is the earnest desire to see the glory of God revealed in the one loved, so true love may have to involve correction. That day the Lord looked on the legalistic Pharisees with anger and compassion (see Mark 3:5). This is a perfect illustration of the Pauline principle of being angry without sinning (see Eph. 4:26). We may be angry at legalism, but we must always love legalists.

Love is also positive. Our Lord did not just say He loved the man; He proved it by healing him. The miracle was undeserved. There is no evidence of any faith on the part of the man. There was no particular reason why he should have been chosen out of the many who were afflicted at that time in Palestine. The man did not request the miracle; it seemed to come as a surprise to him. It was totally a sovereign act on the part of Christ. It was also a supreme act, for the withered hand was restored as new. It was a public act, and all in the synagogue that day saw the man's hand restored.

Avoid legalism, for it thwarts grace. Serve in true liberty (being free to follow custom or abandon it) that is saturated with love.

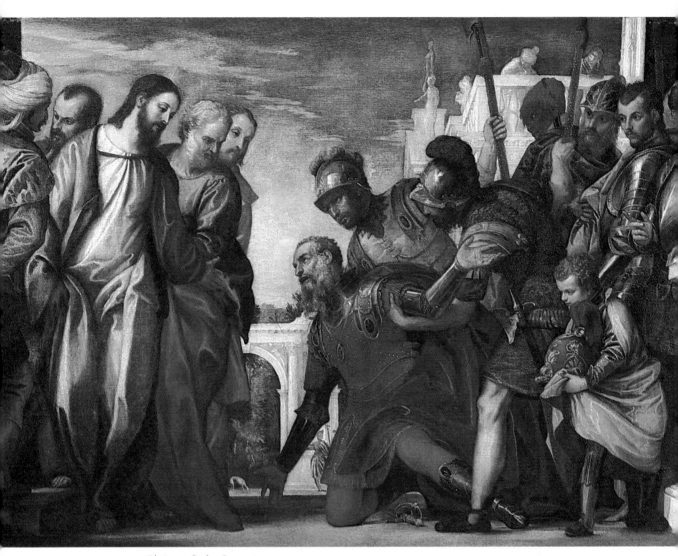

Christ and the Centurion
Paolo Veronese; 56″ x 82″; oil on canvas; The Nelson Gallery-Atkins Museum of Art, Kansas City, Missouri (Nelson Fund)

Born in Verona, Italy, Paolo Veronese (1528–1588) is known for the brightness and brilliant decoration of his paintings. His figures, dressed in splendid costumes, are usually crowded into elegant settings. This painting is one of several Veronese did of this miracle. Clad in armor, the centurion kneels before Christ to make his request and explain his position. Two soldiers lean forward to support their leader while an elaborately dressed page holds his helmet and several other soldiers observe the event. An attentive, simply clad Christ, accompanied by a group of His disciples, is in dramatic juxtaposition to the centurion and his grand entourage. The intensity with which Veronese portrays this miracle is consistent with his richness of style, a characteristic that once caused the Inquisition to accuse him of treating a religious subject too lightly.

A GOOD TESTIMONY

Healing the Centurion's Servant

Now when He concluded all His sayings in the hearing of the people, He entered Capernaum. And a certain centurion's servant, who was dear to him, was sick and ready to die. So when he heard about Jesus, he sent elders of the Jews to Him, pleading with Him to come and heal his servant. And when they came to Jesus, they begged Him earnestly, saying that the one for whom He should do this was worthy, "for he loves our nation, and has built us a synagogue." Then Jesus went with them. And when He was already not far from the house, the centurion sent friends to Him, saying to Him, "Lord, do not trouble Yourself, for I am not worthy that You should enter under my roof. Therefore I did not even think myself worthy to come to You. But say the word, and my servant will be healed. For I also am a man placed under authority, having soldiers under me. And I say to one, 'Go,' and he goes; and to another, 'Come,' and he comes; and to my servant, 'Do this,' and he does it." When Jesus heard these things, He marveled at him, and turned around and said to the crowd that followed Him, "I say to you, I have not found such great faith, not even in Israel!" And those who were sent, returning to the house, found the servant well who had been sick *(Luke 7:1–10; see also Matt. 8:5–13).*

Church services used to include a "testimony time." Today that time is more likely to be called "sharing." But by whatever label, it usually includes thanks to the Lord for blessings received or expressions of need for prayer and concern.

When a person is asked to give his testimony, this request usually means for him to rehearse his conversion experience. But a testimony is more than the report of how the Lord saved one or a statement of present needs or an expression of thanks for something God has done. A testimony is a declaration of what a person is. It is a statement of his or her reputation. And such a declaration may be seen as well as heard, for one can see a testimony as well as hear it. Actually, the spoken testimony that people hear, and the unspoken character that they see, ought to match perfectly.

And match they did in the life and speech of a rather remarkable character in the New Testament, a centurion who was likely in the service of Herod Antipas. The testimony of his life and of his lips corresponded exactly. He had a reputation of honesty, generosity, and kindness, and he gave a testimony of humility and faith.

57

Testimonies also can serve to convict those who hear or observe and who themselves do not measure up to the standard reflected in the testimony. This convicting aspect of a good testimony is also seen in this miracle.

I. The Testimony to the Centurion

Though some commentators have tried to equate this healing of the centurion's servant with the healing of the officer's son (see John 4:46–54), there are too many differences to support that conclusion (see the discussion on p. 19). The centurion commanded a hundred soldiers, more or less. All four of the centurions mentioned in the New Testament appear in a favorable light (this one; the centurion at the cross, Matt. 27:54; Cornelius, Acts 10; and Julius who treated Paul kindly on his voyage to Rome, Acts 27:1,3,43). Though this one might have served Herod, he might have commanded some of the Roman soldiers garrisoned at Capernaum.

He was a Gentile (see Luke 7:9). But like some other Gentiles, he sensed the emptiness of their polytheistic beliefs. Through daily contact with the Jewish people, he also knew something of the true God and of the special relationship the Jews had with their God, and he was attracted.

Undoubtedly he had walked up to that barrier in the temple at Jerusalem that prohibited Gentiles from proceeding further into the temple. He understood the distinction between Jew and Gentile, and he knew that he could not go into the holy place within the temple. Perhaps for this reason he did not approach the Lord but sent instead the elders of the Jews with his request.

It was Luke who gave this detail concerning the centurion's sending intermediaries. Matthew, telescoping his account, simply presented the matter as the centurion's own request. No contradiction exists; both accounts are true. It was the centurion's request, but it was delivered through the elders. Therefore, Matthew could correctly say that he asked, and Luke could say that they asked.

This same rather common phenomenon occurred when James and John and their mother asked the Lord about sitting on His right and left hands in the kingdom (see Matt. 20:20, compared with Mark 10:35). It also occurs in everyday speech. An executive might say, "I told them to cancel that order," when in reality he told them through his secretary who made the phone call.

A. He was an Honest Man

That the Jewish elders acceded to the centurion's request shows that he was

an honest man. The elders were under no obligation to help the centurion; certainly they would not have done so for a man they did not trust. He had a good reputation and rapport with those of another race and religion.

B. He was a Generous Man

Likely the centurion was a proselyte of the gate, which meant that he had not yet been baptized and circumcised, nor could he yet offer a sacrifice. Had he been a full proselyte to Judaism he would not have sent the Jewish elders to plead his case. He would have gone himself. But his sincerity and love were clearly demonstrated in that he had built a synagogue in Capernaum. The present-day ruins of a synagogue in Capernaum date from the third century, though that early synagogue may have been built on the same site as the even earlier one that the centurion financed.

"He loves our nation," the elders testified (Luke 7:5), and he proved that love in the most concrete way possible—he gave generously. By so doing, he also showed his love for the true God (see 1 John 3:17). Remember, this testimony is from people over whom the centurion had military and political power. He was a man who was as honest, fair, and generous out of uniform as he was in.

C. He was a Kind Man

The centurion's servant was dear to him (see Luke 7:2). Many masters in those days could not have cared less if a slave died, but this centurion did care. When he heard that Jesus was in Capernaum, he acted with no self-interest, but only out of concern for his slave. Matthew wrote that the servant was paralyzed and terribly tortured because of it.

II. The Testimony of the Centurion

A. He Demonstrated Humility

As Jesus and the Jewish elders approached the house, the centurion, with deep humility, sent another delegation.

What is humility? It is the absence of vanity or arrogance. It is the acknowledgment of one's worth in relation to someone of greater worth. It is ranking oneself within a hierarchy. The centurion measured his worth against the absolute standard, the Lord Jesus, and he concluded that he was not worthy. Luke used two words to express the totality of the centurion's humility (*hikanos* in v. 6, and *axioō* in v. 7). He deemed himself unqualified and undeserving. When the elders commended him to the Lord, they said he was deserving (*axios*, v. 4).

When ranked with them, he was; but when ranked with the Lord he was not, and he recognized that. Such is true humility.

B. He Demonstrated Faith

As a centurion, this man was accustomed to ranking people. He had soldiers under him, and there were others who outranked him. The ideas of rank, authority, and giving and taking orders made up the fabric of his life. So when he knew that the Lord was approaching his house, he saw himself as a lowly private being visited by the chief of staff. But he also knew from experience that a general does not need to carry out his own orders in person; he can command others to do what he says. Recognizing the Lord Jesus for who He was, the centurion instructed his friends to ask the Lord simply to command that his servant be healed and not to trouble Himself by coming in person.

What faith! we exclaim. It was remarkable faith, but not unreasonable faith. It was based on the knowledge that here was the Lord of the universe who made man and who could easily prolong the life of his servant if He so ordered. It was no blind faith, for the centurion's eyes were wide open to see the glory and power of the Person in whom he put his faith.

Faith is always cultivated by looking at its object. Faith is always weakened by looking at itself. When we come to Christ for salvation, we are told to believe Him. We are exhorted to live the Christian life by walking by faith in Him. If we look at our faith, we will be discouraged; if we look at Him, our faith will be strengthened. The centurion knew whom he believed; therefore he could believe.

Dr. Luke said that the servant was completely healed. Not only was the paralysis relieved, but the pain that tormented him was gone. This deliverance was complete.

III. The Testimony to the Nation Israel

The centurion's testimony also had a convicting aspect to it. Both Matthew and Luke recorded the Lord's astonishment: "I have not found so great faith in Israel." Jairus, the ruler of the synagogue, asked the Lord to come personally to lay His hand on his daughter (see Matt. 9:18). Even Mary and Martha thought that if Jesus had been personally present their brother would not have died (see John 11:32). But a Gentile centurion realized that the Lord only needed to give the command.

Matthew, whose Gospel was written primarily to Jewish people, recorded the pointed, though brief, sermon the Lord delivered to the Jews (see Matt. 8:11–12). It had two points: (1) the Kingdom will include Gentiles because the essential requirement for entrance is faith, not pedigree; and (2) some who have the Jewish pedigree and who ought by right to enjoy the Kingdom will be cast into outer darkness because they did not have faith. Some Gentiles will be in the millennial Kingdom (see Is. 2:2; Zech. 14:16), and some Jews will be excluded (see Ezek. 20:38). The mention of Abraham, Isaac, and Jacob indicates the millennial Kingdom is in view. Outer darkness stands in sharp contrast to the festive, lighted banquet hall pictured in Matthew 8:11 (literally, "will recline" at a banquet table). In that place of separation will be intense weeping and gnashing of teeth (the definite article appears with both terms, the weeping and the gnashing).

How tragic for the many individuals who should have acknowledged Him when He was here on earth but did not. And the same tragedy is repeated over and over again today. Only outer darkness awaits all who refuse to believe in Him.

Raising the Widow of Nain's Son
ca. 375; stone frieze; Musée Lapidaire Chrétian, Arles, France (Magnum)

A frieze is a sculptured or ornamental band, usually around the top of a wall or building. In early Christian art, sculpture played a lesser role than either painting or architecture. Unlike the statues in pagan temples, which were more like free-standing monuments, Christian sculpture tended toward shallow, small-scale forms and lacelike surface decorations in order to avoid the taint of idolatry. The earliest works were marble sarcophagi, dating from the middle of the third century onward. This frieze shows Christ to be a youthful, idealized Teacher or Philosopher with a stylized body. His calm, passive air is remarkable in a scene of such dramatic action. The scepterlike stick with which Christ touches the widow's son may be symbolic of His position as rightful king, emphasizing His divine rather than human nature. (See also page 89.)

THE PRINCE OF LIFE IN
THE PRESENCE OF DEATH

Raising the Widow of Nain's Son

Now it happened, the day after, that He went into a city called
Nain; and many of His disciples went with Him, and a large
crowd. And when He came near the gate of the city, behold,
a dead man was being carried out, the only son of his
mother; and she was a widow. And a large crowd from the
city was with her. When the Lord saw her, He had compas-
sion on her and said to her, "Do not weep." Then He came
and touched the open coffin, and those who carried him
stood still. And He said, "Young man, I say to you, arise." And
he who was dead sat up and began to speak. And He presented
him to his mother. Then fear came upon all, and they glorified
God, saying, "A great prophet has risen up among us"; and, "God has visited His people"
(Luke 7:11–16).

"It is a poor thing for anyone to fear that which is inevitable," wrote Tertullian
in the third century. He was speaking of death.

But most people do fear death, as the Bible says they will (see Heb. 2:15).
That fear is a widespread one, since all people are destined to die (see Heb.
9:27). A few will escape death by being translated directly from life on earth to
life in heaven at the rapture of the church (see 1 Cor. 15:51–52). But almost all
people will die. The word *appointed* in Hebrews 9:27 means "destined" or "re-
served." Death is reserved for all, and the only way anyone can conquer the
fear of death is to have the hope of eternal life that is "laid up for you in heaven"
(Col. 1:5). This word translated "laid up" is the same word as "destined" or
"reserved." Our hope is destined or reserved for us in heaven, and this hope is
what conquers the fear of death.

But in the meantime, death surrounds us. We all experience it within our
circle of loved ones, and we all see it on every hand. In this miracle, our Lord
serves as an example of what to do in the face of death.

It was the day after the healing of the centurion's servant. Jesus, accom-
panied by a crowd of people including His disciples, was about to enter Nain, a
city about a day's journey southwest of Capernaum. At the gate of the city His
crowd met another crowd. Since Nain was never fortified, "gate" simply indi-

cates the place where the road began to encounter the houses of Nain. The other crowd formed a funeral procession of the family and friends of the deceased and the hired mourners and musicians. This meeting shows how the Prince of Life responded in the face of death.

I. He was Compassionate: Luke 7:12–13

A. The Cause of His Compassion

Certain natural circumstances about this particular death moved the Lord to compassion. It was the death of an only son—the only son of a widow. Not only had this poor soul lost her husband, but now she had lost her only son. Perhaps this fact partly accounted for the large number of mourners in the crowd.

But our Lord was also moved for reasons not readily understood by any human being. Death was a usurper, not part of human history until Adam and Eve yielded to the deception of Satan. When sin entered human experience, so did death; and for thousands of years, both in His preincarnate state and then in His incarnate state, the Son of God saw death for what it was. "The sting of death is sin" (1 Cor. 15:56) because through sin death gained its power over people. Our Lord knew and saw this dimension of that funeral and was moved with compassion that came from His holy hatred of sin and its consequences.

B. The Character of His Compassion

The verb *had compassion* is related to the heart and lungs, which were considered by the Greeks as the seat of strong affections, whether love or hate. Thus the Lord is pictured here as having strong affection and compassion for this widow. Indeed, this verb form is used in the New Testament only in relation to Christ or the Father, either in recording our Lord's compassion (see Mark 1:41; Matt. 9:36; Mark 6:34 and Matt. 14:14; Mark 8:2 and Matt. 15:32; Matt. 20:34) or a request that He be compassionate (see Mark 9:22) or in parables depicting the Father's compassion (see Matt. 18:27; Luke 10:33; 15:20). In light of this, think what meaning Paul's words have when he wrote, ". . . how greatly I long for you in the compassions of Jesus Christ" (Phil. 1:8, author's translation).

C. The Constraint of His Compassion

His was not a mere "be warmed, be filled" detached concern for the woman. He did something. Notice in the references above that His compassion moved Him to other miracles: the feeding of the four thousand and the five thousand; the healing of two blind men at Jericho; the healing of a boy with a dumb spirit; and the healing of a leper and of the sick in general.

II. He was Commanding: Luke 7:13–14

Death often makes cowards of the living, but not so with our Lord.

He commanded that the widow should stop weeping. The word indicates that she was sobbing audibly, not silently.

He commanded that the son come back to this life. Always and uniformly it is the voice of the Lord that raises the dead. This was the case here and also in the cases of Jairus's daughter (see Luke 8:54) and Lazarus (see John 11:43). It will be the voice of the Son of God that all the dead will hear, calling them to come out of their graves (see John 5:25). Of course, in those future resurrections He will call to a new kind of existence, either eternal life in heaven or eternal existence in the lake of fire. The widow's son, Jairus's daughter, and Lazarus all came back to their former existence and therefore had to face the prospect of dying again!

III. He was Conquering: Luke 7:15–16

A. The Proof

The proof was incontrovertible. The young man sat up (proof that life had returned), and he spoke (proof that he was in possession of his senses). His body had been wrapped and laid on a funeral couch, not in a coffin, since he was to be buried in a tomb hewn out of rock rather than in the ground. This was the first of three resurrections Christ performed in His earthly ministry.

B. The Purposes

Jesus' conquest of death in this instance served several purposes. (1) It reunited a mother and her son. (2) It brought great fear on those who witnessed the miracle. The word *fear* means "awe," that is, being struck with the event and/or the Person who caused it. (3) It brought glory to God.

But even in the face of such a stupendous miracle, the people only acknowledged Jesus as a prophet, not as God and their Messiah. So great the miracle, but so deficient the result on most who saw it.

So it has always been. God's miraculous hand in nature, in Providence, and in the record of Scripture ought to make men bow in worship and acknowledgment before Him who is—as He claimed to be—the God and Savior of the world. The tragedy is, so many seem to miss the message.

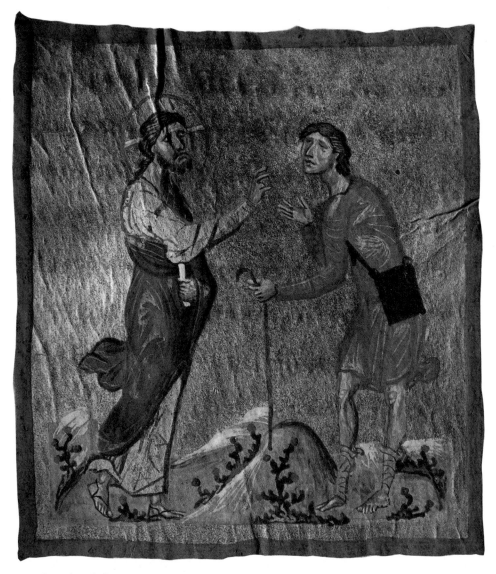

Healing the Blind
Twelfth century; illuminated manuscript; Greece (Magnum)

Byzantine illuminated manuscripts are characterized by fine and delicate drawing, brilliant coloring, and a generous use of gold. This miniature, for instance, has its entire background gilded. It focuses on Christ and the blind man with only a bare suggestion of natural environment. With one hand Christ holds a scroll representing His wisdom and His person as the living Word. His divinity and His role as the world's Savior are clearly emphasized. (See also page 47.)

PARDONING THE UNPARDONABLE SIN

Casting a Demon Out of a Deaf and Blind Man

Then one was brought to Him who was demon-possessed, blind and mute; and He healed him, so that the blind and mute man both spoke and saw. And all the multitudes were amazed and said, "Could this be the Son of David?" But when the Pharisees heard it they said, "This fellow does not cast out demons except by Beelzebub, the ruler of the demons." But Jesus knew their thoughts, and said to them: "Every kingdom divided against itself is brought to desolation, and every city or house divided against itself will not stand. And if Satan casts out Satan, he is divided against himself. How then will his kingdom stand? And if I cast out demons by Beelzebub, by whom do your sons cast them out? Therefore they shall be your judges. But if I cast out demons by the Spirit of God, surely the kingdom of God has come upon you. Or else how can one enter a strong man's house and plunder his goods, unless he first binds the strong man? And then he will plunder his house. He who is not with Me is against Me, and he who does not gather with Me scatters abroad.

"Therefore I say to you, every sin and blasphemy will be forgiven men, but the blasphemy against the Spirit will not be forgiven men. Anyone who speaks a word against the Son of Man, it will be forgiven him; but whoever speaks against the Holy Spirit, it will not be forgiven him, either in this age or in the age to come.

"Either make the tree good and its fruit good, or else make the tree bad and its fruit bad; for a tree is known by its fruit. Brood of vipers! How can you, being evil, speak good things? For out of the abundance of the heart the mouth speaks. A good man out of the good treasure of his heart brings forth good things, and an evil man out of the evil treasure brings forth evil things. But I say to you that for every idle word men may speak, they will give account of it in the day of judgment. For by your words you will be justified, and by your words you will be condemned" *(Matt. 12:22–37; see also Mark 3:22–30; Luke 11:14–23).*

We often forget that the controversy over the unpardonable sin erupted over a miracle that our Lord performed. The records in Matthew and Mark are parallel, but the miracle and debate recorded by Luke, though similar, probably occurred about a year later.

I. The Controversy Concerning the Sin

A. The Cause of the Controversy (Matt. 12:22–23)

The controversy developed because the Lord healed a man. The case was a

very difficult one, for the man was both blind and dumb (which probably meant that he was also deaf). Actually these were only symptoms of the real cause of his afflictions, which was demon-possession. Jewish exorcists plied their trade in those days, casting out demons from such people. But this case seemed impossible, for how could an exorcist communicate with a man who was blind, dumb, and probably deaf? When the Lord healed all his maladies at once, the people were astounded. They began to suggest that Jesus was the Son of David, which, in effect, meant that He was their long-promised Messiah. This acknowledgment riled the Pharisees and evoked their violent accusation.

B. The Charge in the Controversy (Matt. 12:24–29)

The Pharisees hurled their charge: Satan was obliging his friend Jesus by withdrawing demons from men, so who would want to follow a person who was a friend of Satan, as Jesus obviously was?

The Lord's reply consisted of three statements.

1. A kingdom or house that is divided against itself cannot stand. In other words, if the Lord were casting out demons by Satan's power then Satan would be working against himself, since he would be allowing Jesus to free someone already under Satan's control.

2. The Lord pointed out that the charge that He was using Satan's power was absurd since the Pharisees recognized that the Jewish exorcists did not cast out demons by the power of Satan, but by the power of God.

3. The only logical conclusion to be reached from the above facts is that the kingdom of God had come, since Christ was defeating Satan by taking his victims from him. And the power by which Christ was doing this was the power of the Spirit of God.

II. The Character of the Sin

A. It was a Sin Directed Against the Holy Spirit (Matt. 12:32)

By accusing Jesus of being in league with Satan, the Pharisees put themselves on the side of Satan. Furthermore, their accusation was not merely against Christ, but against the Holy Spirit as well, since it was by the Spirit's power that Christ cast out demons.

What did the Lord mean, then, when He said that a sin against the Son of man is forgivable but not one against the Holy Spirit? He meant that although people might misunderstand His ministry, such ignorance, though deplorable, is forgivable. But the people had no reason for misunderstanding the power of

the Spirit since His power and ministry were well known from Old Testament times. In other words, they could not reject the power of the Spirit that they had seen displayed, they could not continue to prefer darkness to light, and they could not prefer the works of Satan to those of God—they could not do all these things and still expect to be forgiven.

B. It was a Sin Determined by a Special Situation

Speaking against the Holy Spirit was not merely a sin of the tongue. It was a sin of the heart, expressed in words. Further, their extreme wickedness was exposed all the more by the holiness of Christ's personal presence. Theirs was a sin committed to His face. Thus, to commit this particular sin required a special situation—the personal presence of the Lord on earth performing miracles. To duplicate this circumstance today would be impossible; to commit this unpardonable sin would also be impossible.

Nevertheless, to show the same wickedness of heart in rejecting the power of God is not only possible today but occurs often and with tragic consequences. Attributing the works of the Spirit of God to Satan was the unpardonable sin of Jesus' day; rejecting the evidence of God's power (as in the resurrection of Christ) is unpardonable in any day.

C. It was Eternally Damning to the Soul

Such rejection, the evidence of a hardened heart, can never be forgiven, not because God withdraws His grace but because people withdraw themselves from all contact with God. Under such circumstances, forgiveness can never be granted in this age or any future age, since every person's eternal destiny is determined in this present life.

III. The Cure for the Sin: Matthew 12:30,33–37

No sin is unforgivable as long as a person has breath. The Lord urged His hearers to take their stand with Him rather than against Him (v. 30), to show repentance of heart (vv. 33–35), and to speak words that would demonstrate their righteousness, not those that would result in their condemnation (vv. 36–37).

His gracious invitation was extended to His worst enemies; it is still offered today to all who will believe. No sin is unforgivable as long as one has breath to call on the Lord for forgiveness.

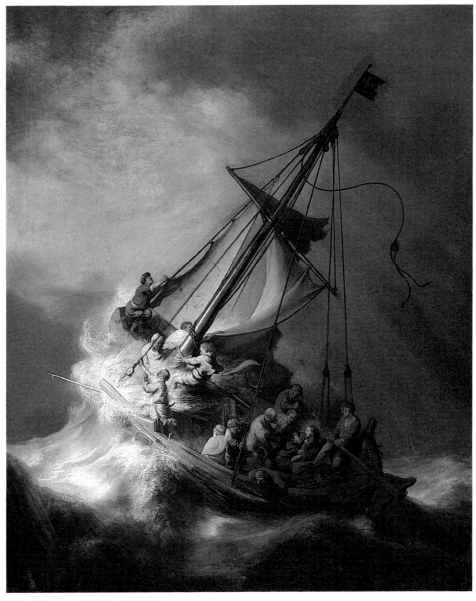

The Storm on the Sea of Galilee
Rembrandt, 1633; oil on canvas; Copyright Isabella Stewart Gardner Museum, Boston

Rembrandt, who lived from 1606 to 1669, was a genius of Dutch art. He created more than eight hundred biblical subjects even though religious art was not popular in seventeenth-century Calvinist Holland. Rembrandt had a grasp of human reactions that is well captured here in the moment before the miracle is to take place. One can feel the churning of the sea and the fear and fatigue of the disciples as they struggle against the winds. The use of light and diagonal movement of the boat heightens the drama and leads one from the struggling disciples to Christ, who has just been awakened by his frightened crew.

IN THE STORMS OF LIFE

What to Do When the Ship Is Sinking

On the same day, when evening had come, He said to them,
"Let us cross over to the other side." Now when they had left
the multitude, they took Him along in the boat as He was.
And other little boats were also with Him. And a great
windstorm arose, and the waves beat into the boat, so that it
was already filling. But He was in the stern, asleep on a
pillow. And they awoke Him and said to Him, "Teacher, do
You not care that we are perishing?" Then He arose and
rebuked the wind, and said to the sea, "Peace, be still!" And
the wind ceased and there was a great calm. But He said to
them, "Why are you so fearful? How is it that you have no faith?"

And they feared exceedingly, and said to one another, "Who can this be, that even the wind
and the sea obey Him!" *(Mark 4:35–41; see also Matt. 8:23–27; Luke 8:22–25).*

Although many Christians think otherwise, God has not promised His chil-
dren physical comfort, material prosperity, or freedom from persecution in this
day of grace. He has blessed us with all spiritual blessings (see Eph. 1:3), and
He has promised to supply all our material needs (see Phil. 4:19), but physical
comfort is not necessarily material need. Suffering and difficulty may well be
expected to characterize a normal Christian experience. This condition is what
Paul meant when he said that as believers we may expect suffering: "For Your
sake we are killed all day long; we are accounted as sheep for the slaughter"
(Rom. 8:36; cf. 1 Pet. 1:6–7). Of course, we are not ungrateful for times of
ease, but distresses are not necessarily an indication of God's disfavor. If that
were the case, then one would be forced to conclude that Paul was out of the
will of the Lord when he suffered want (see Phil. 4:12).

In the times of difficulty that come into our lives, we learn to know the Savior
better. This was the experience of the disciples one evening as they were cross-
ing the Lake of Galilee with the Lord in a small boat. As He slept, a storm
arose, and in the miracle that followed—the stilling of that storm—the disciples
learned lessons from their Teacher and ours. This miracle, then, becomes not
only an illustration of the truth that true disciples of Christ may be beset by
difficulties that cause fear and anxiety, but it also displays principles that believ-

ers may use today in times of affliction. There are in the accounts three such principles for stilling the storms of life.

I. Look at His Example

In two respects, our Lord serves as an example for us in the storms of life. First of all, His fatigue is an example of the fact that He experienced the same weariness while here on earth that we all often have. The day had been a busy one. Our Lord had been teaching and ministering all day long (see Mark 4:1), and being weary from His labors, He fell asleep during the sail across Lake Galilee. Priceless are the glimpses in the Word of the Babe in the stable, the Boy in the temple, the thirsty Man at the Samaritan well, the broken-hearted Friend at the tomb of Lazarus, and here the wearied Worker asleep in the stern of a boat. This example is wonderfully encouraging for all who grow weary in the work on days that are full and often beset with difficulties. The miracle attests strongly to the fact that ". . . we do not have a High Priest who cannot sympathize with our weaknesses . . ." (Heb. 4:15).

In addition, the Lord Jesus is an example in faith. As the group was crossing the lake, a storm arose. This is a frequent occurrence on Galilee as the wind is funneled through the ravines that surround the lake. That storm was especially bad, and as the waves filled the boat, the disciples feared for their very lives, for they were in mortal danger. But see in the stern of that craft the example of faith asleep on a pillow and safe in the care of His heavenly Father! So it should and can be with us in the midst of the storms of life, for His promise never to leave us nor forsake us is secure forever (see Heb. 13:5).

II. Listen to His Encouragement

As we have an example in the Person of our Lord, so we have an encouragement in His power. Unfortunately, often it is only in the storms of life that believers ever experience the power of Christ. But when we do experience that power, we discover that it is power that cares. Sometimes, as in the instance of this storm, we are forced to come to the end of all human resources before we are willing to experience the power of God. The skill of those expert seamen, their knowledge of the lake, and their past experiences as sailors were of no avail. In their anxiety the disciples were even questioning whether the Lord cared for them. But He did, and He does. Peter, for one, learned the lesson of

that night well, for later he wrote, "He cares for you" (1 Pet. 5:7, where the same word for "care" is used as in the accounts of this miracle). How blessed to know that an all-powerful Savior cares for us with an infinitely intelligent love!

The disciples were also encouraged by seeing a demonstration of His power to calm. In reality there was a double miracle that night: (1) the miracle of the wind ceasing and (2) the miracle of the immediate calm, for usually when the wind dies down, the water does not immediately cease to be agitated. "He calms the storm, so that its waves are still" (Ps. 107:29), and "The peace of God . . . will guard your hearts and minds through Christ Jesus" (Phil. 4:7).

III. Learn from His Exhortation

When the sea had been calmed, the Lord Jesus exhorted the disciples to learn two lessons from their experience — the lesson of fear and the lesson of faith. He first rebuked them for their cowardly fear. (This is the word *deilos* which appears in Mark 4:40.) Cowardice (for that is how the word is best translated) should have no place in the make-up of a Christian, because it is something God has not given the believer (see 2 Tim. 1:7). It belongs to the characteristics of the old nature (see Rev. 21:8). The word always has a bad connotation in its uses in the New Testament. The spirit of fear is a base spirit that will manifest itself in the carnal Christian in the time of persecution and make him or her ashamed of the testimony of the Lord (see 2 Tim. 1:8). Our Lord severely rebuked the disciples' lack of physical and moral courage that night. They had no right to cowardliness even if it had been God's will that they perish in the sea. Neither must any twentieth-century disciple be characterized by the cowardice that shows up in being ashamed of the Lord or fearful of His will.

Paradoxically, however, after the rebuke the Scripture says that the disciples "feared exceedingly" (Mark 4:41). Did they not learn the lesson or heed the Lord's exhortation? No, they had learned a lesson, for the fear they showed after the rebuke was of a different kind (the word used in v. 41 is *phobos*). This is a proper and necessary kind of fear that should characterize all believers (see 1 Pet. 2:17). Joseph Henry Thayer links the meaning of this word with having been struck with terror or a sense of alarm, and he says *phobos* is the protracted state resulting from that alarm (*A Greek-English Lexicon of the New Testament.* New York: Harper, 1899, p. 656). In other words, proper Christian fear is the

resultant state of life that follows from having been struck with God. To be struck with Him and live in that state is the idea. This fear stems from a genuine and continuous recognition of who it is in whose presence we live every moment of our lives. Such fear should never drive us from our Lord, but it should always keep us from undue familiarity with Him. It makes us alert, active, and attentive, as anyone knows who has been really terrified. God give us that kind of fear in the church today.

The Lord's second lesson to the disciples concerned faith. Never is it recorded that our Lord rebuked anyone for having too much faith, but how often He rebuked lack of faith! Each evangelist in his record of this miracle presented a different aspect of the faith the Lord enjoins us to have. Notice the differences in the reports. In Matthew's account the rebuke was, "O you of little faith" (8:26). Our Lord would have our faith large because we have an omnipotent God. Mark reported that the disciples asked, "Who can this be . . . ?" (4:41). In other words our faith must have as its content an intelligent understanding of who our Lord really is. According to Luke, He said, "Where is your faith?" (8:25). That is, our Lord wants our faith to be contemporaneous—a present reality. Large faith in a living Savior, and that today, is the exhortation of this second lesson. Only such faith truly honors Him.

When burdens, problems, trials, and difficult circumstances seem to overwhelm, look at the example of His blessed Person. Listen to the encouragement of His all-powerful voice saying, "Peace, be still." Learn to live moment-by-moment in His presence. Trusting in the Lord Jesus in these ways will surely still the storms of life.

Fierce raged the tempest o'er the deep,
Watch did Thine anxious servants keep,
But Thou wast wrapped in guileless sleep,
Calm and still.

"Save, Lord, we perish," was their cry,
"O save us in our agony!"
Thy word above the storm rose high,
"Peace, be still."

The wild winds hushed; the angry deep
Sank, like a little child, to sleep;
The sullen billows ceased to leap,
At Thy will.

So, when our life is clouded o'er,
And storm-winds drift us from the shore,
Say, lest we sink to rise no more,
"Peace, be still."

—Rev. Godfrey Thring (1861)

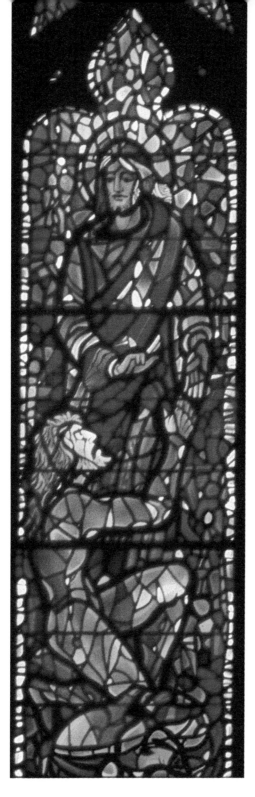

Healing Arts
Charles Z. Lawrence, 1979; 8′ x 16′; stained glass; Washington Cathedral, Washington, D.C. (Designed by Charles Lawrence and executed by the Willet Stained Glass Studios, Inc., Philadelphia, Pennsylvania)

This window is placed in the westernmost side of the south nave aisle of the cathedral. Composed of three panels, it gives symbolic recognition to those engaged in the field of medicine. This panel, the right lancet of the window, pays tribute to Charles Frederick Menninger and his sons Karl Augustus and William Claire (pictured above) for their pioneering work in psychiatric treatment. The major figure in the scene is Christ, who is depicted healing the demoniac of Gadara. Lawrence's linear technique is in keeping with the flat, two-dimensional nature of the medium. It is a beautiful example of the contemporary use of the medium.

WHAT WOULD HAPPEN IF CHRIST SHOULD APPEAR?

The Demoniacs of Gadara

Then they sailed to the country of the Gadarenes, which is opposite Galilee. And when He stepped out on the land, there met Him a certain man from the city who had demons for a long time. And he wore no clothes, nor did he live in a house but in the tombs. When he saw Jesus, he cried out, fell down before Him, and with a loud voice said, "What have I to do with You, Jesus, Son of the Most High God? I beg You, do not torment me!" For He had commanded the unclean spirit to come out of the man. For it had often seized him, and he was kept under guard, bound with chains and shackles; and he broke the bonds and was driven by the demon into the wilderness. Jesus asked him, saying, "What is your name?" And he said, "Legion," because many demons had entered him. And they begged Him that He would not command them to go out into the abyss. Now a herd of swine was feeding there on the mountain. And they begged Him that He would permit them to enter them. And He permitted them. Then the demons went out of the man and entered the swine, and the herd ran violently down the steep place into the lake and drowned. When those who fed them saw what had happened, they fled and told it in the city and in the country. Then they went out to see what had happened, and came to Jesus, and found the man from whom the demons had departed, sitting at the feet of Jesus, clothed and in his right mind. And they were afraid. They also who had seen it told them by what means he who had been demon-possessed was healed. Then the whole multitude of the surrounding region of the Gadarenes asked Him to depart from them, for they were seized with great fear. And He got into the boat and returned. Now the man from whom the demons had departed begged Him that he might be with Him. But Jesus sent him away, saying, "Return to your own house, and tell what great things God has done for you." And he went his way and proclaimed throughout the whole city what great things Jesus had done for him *(Luke 8:26–39; see also Matt. 8:28–34; Mark 5:1–20).*

Have you ever heard someone ask, "I wonder what would happen if . . . ?" The Bible answers some of these speculative questions. For example, we know what would happen if a man should come back from the dead and try to tell people the truth about heaven and hell. The Lord asserted that if such would happen people still would not be persuaded to believe (see Luke 16:31). We also know what would happen if God should openly judge the world rather than dealing in grace and longsuffering. People would blaspheme Him, not repent and turn to Him (see Rev. 16:9,21).

The Bible also answers the question, "I wonder what would happen if Jesus Christ would appear visible in our midst today?" The answer is here in the story of the healing of the demoniacs in the country of the Gadarenes, for the reactions of the twentieth century would be exactly the same as those of the first century.

After the disciples had made that memorable crossing of the Lake of Galilee when their lives were threatened by a storm that the Lord had to calm, they arrived on the eastern shore in the country of the Gadarenes. Immediately they met two demon-possessed men. Matthew records the fact that there were two men, while the accounts of Mark and Luke center on the one man who evidently was the spokesman.

Here's what did happen and would happen when or if Christ should appear in Person.

I. Spirits Flee

Our attention is first drawn to evil spirits, their reaction to the Savior, and certain facts about them.

A. The Deployment of Demons

Since Satan is not omnipresent, demons serve as his hands and feet in carrying out his plans. It is not often that Satan's purposes to control people are so vividly seen as they are in this account. Usually his wares are more subtly displayed, but he can be more open in his attacks. He can destroy a person's physical powers for good and turn them into instruments of self-destruction. He can make people useless to society (like these men whom the demons had driven into the wilderness). He can unbalance a person's mental capacities. Such activities of demons are illustrated often in the Gospels. Satan and his demons are working today (see Eph. 6:12), and their activity may be expected to increase as we approach the time of the return of Christ (see 1 Tim. 4:1).

B. The Destination of Demons

When the Lord began to rebuke the demons who possessed these two men, they requested that He not send them into the abyss (see Luke 8:31). That He might do this seemed to strike fear in their hearts. Apparently they did not want to be confined in the abyss, knowing that then they would no longer be free to roam the world and do Satan's will. Ultimately all demons will be cast into everlasting fire (see Matt. 25:41), though in the meantime they might have been confined in the abyss (see Rev. 9:1–3).

C. The Desire of Demons

The second request the demons made was that they be allowed to enter a nearby heard of swine. In this way they could have escaped Christ and yet not have been expelled from activity on the earth. In this story demon possession is seen to an extent not matched anywhere else in the Gospels. A Roman legion had from three thousand to six thousand men in it; these two men were possessed by a large number of demons. Clearly, the Lord spoke to the men; yet just as clearly the demons responded, using the men's faculties. Demon possession as seen here is the direct influence of demons over a person, stemming from the demons' residing in the people and deranging both their minds and bodies.

D. The Doctrine of Demons

Demons have a creed and teach a doctrine (see James 2:19; 1 Tim. 4:1). Here they recognized the Lord Jesus as God and admitted that they were subject to His control. That same controlling Christ lives within the believer, and His power is greater than Satan's (see 1 John 4:4).

II. Society Fears

If Christ should appear visibly, people would not flock to Him. Most would politely wish Him gone (as they did in this story). The thing that triggered the reaction of the people of the community was that herd of swine. The pigs revealed the true character of society's heart. Christ allowed the demons to enter the pigs, and they plunged into the Lake of Galilee and were destroyed. This action aroused the people against the Lord because it hit them where it hurt — in their pocketbooks.

A. The Reason for the Destruction

Commentators try either to condemn or to justify Christ for what He did. Those who condemn say this was an unjustified act of wanton destruction. Those who justify the action do so either on the basis of Christ's lordship rights over all of creation or relate it to His enforcing the Mosaic law. The swine keepers were in all likelihood Jewish people who had no business being involved in something the Law prohibited (and it was no small business, since there were two thousand pigs in this one herd, see Mark 5:13!).

It is significant that there is no record of any protest on the part of the owners of the pigs. Undoubtedly they knew they were in the wrong and Christ was doing right when He sent unclean spirits into unclean pigs.

B. The Report of the Destruction

When the men who fed the pigs saw what happened, they fled to their employers to report quickly so they would not be blamed. The fact that two men were healed was not a part of their report. Their only concern was their own jobs.

C. The Reaction to the Destruction

The reaction of the owners is curious but typical. They were not openly hostile, though underneath they must have been seething. They feared Him who had exposed their unlawful business, and they pleaded with Him to leave them alone. Would He please leave the area before they all went bankrupt?

D. The Result of the Destruction

The Lord did leave. He does not generally force Himself on unwilling hearts. He knocks at the door of the unsaved heart, and He beseeches the Christian to follow Him, but He does not coerce. Their wish was granted, and doubtless the people set about to recoup their losses. Little did they realize that their greatest loss was the loss of His presence and power.

III. Saints Follow

A. The Saint's Condition

The dramatic physical change in the two men illustrates the spiritual change that every person who trusts Christ undergoes. Instead of being naked, they were clothed; instead of raging, they were in their right minds; instead of wandering, they were settled. The changes the Savior brought involved their morals, their minds, and their activities. Those who knew them in their former condition were frightened by these changes.

B. The Saint's Commission

As expected, the two healed men wanted to be with Christ who had done this tremendous miracle in their lives. But He commanded them to go home and tell others what had happened. Because of their condition, these men had doubtless been forced to stay away from their homes for a long time, but now they could return. And when they returned, they were to show and tell what had happened to them. It is often easier to witness anywhere other than at home. But the ones nearest to us are a primary responsibility.

If Christ should appear visibly today, what would happen? There would be a stronger, more open warfare between Him and Satan's demons; the world

would tolerate Him only if He did not interfere; and His people — well, would they follow Him more obediently?

Rabbi, begone!
Thy powers bring loss to us and ours;
Our ways are not as Thine —
Thou lovest men — we, swine.

O get Thee gone, O Holy One,
And take these fools of Thine;
Their souls? What care we for their souls?
Since we have lost our swine.

Then Christ went sadly,
He had wrought for them a sign
Of love and tenderness divine —
They wanted swine.

Christ stands without your door and gently knocks,
But if your gold or swine the entrance blocks
He forces no man's hold, He will depart,
And leave you to the treasures of your heart.

— John Oxenham
from "Gadara, A.D. 31"

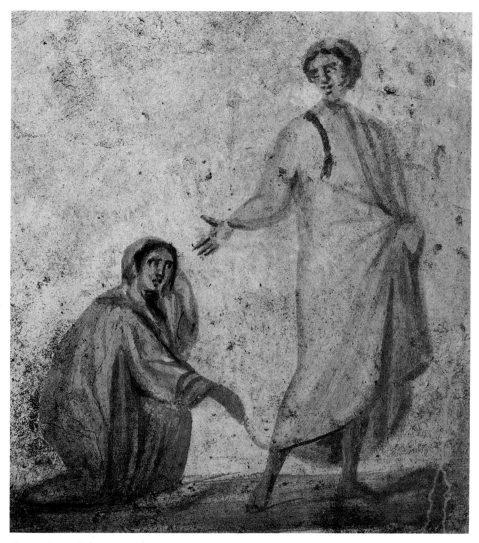

The Healing of the Hemorrhaging Woman
Late third century, A.D.; 24½" x 21½"; wall painting; Catacomb of S. S. Pietro e Marcellino, Rome, Italy (Scala/Art Resources, Inc.)

This portrayal of Christ with a beardless face and close-cropped hair is typical of the earliest Christian artwork. The motif of Christ as a youthful, idealized Teacher is thought to have originated among the educated men of the School of Alexandria, the actual center of Christian culture in the early years of the third century. Scenes like this one, taken directly from the Gospels, were first painted on the walls of burial places, but were later also found on basilica walls. The artists often used common Roman images but gave them symbolic content. The subject of the woman with the issue of blood may have been seen as an illustration of the inability of paganism to meet one's needs; though the woman "had spent all her livelihood on physicians and could not be healed by any" (Luke 9:43), only the Great Physician could bring her true healing.

A PARABLE OF SALVATION

Healing the Hemorrhaging Woman Who Touched His Garment

Now a certain woman had a flow of blood for twelve years, and had suffered many things from many physicians. She had spent all that she had and was no better, but rather grew worse. When she heard about Jesus, she came behind Him in the crowd and touched His garment; for she said, "If only I may touch His clothes, I shall be made well." Immediately the fountain of her blood was dried up, and she felt in her body that she was healed of the affliction. And Jesus, immediately knowing in Himself that power had gone out of Him, turned around in the crowd and said, "Who touched My clothes?" But His disciples said to Him, "You see the multitude thronging You, and You say, 'Who touched Me?'" And He looked around to see her who had done this thing. But the woman, fearing and trembling, knowing what had happened to her, came and fell down before Him and told Him the whole truth. And He said to her, "Daughter, your faith has made you well. Go in peace, and be healed of your affliction" *(Mark 5:25–34; see also Matt. 9:20–22; Luke 8:43–48).*

This could be called a parenthetical miracle!

The Lord had just returned from the eastern side of the Lake of Galilee where He had cast out the legion of demons from the two men and sent them into the herd of swine. Returning to Galilee, He was met by a crowd who expected to see Him do more miracles. Mark used a word (5:24) that pictures the crowd as pressing on the Lord and each other almost to the point of suffocation.

Though most probably thronged Him out of curiosity, two people—Jairus and a woman—came because of special needs. Jairus claimed the Lord's attention first, but as the Lord was on the way to Jairus's home to respond to his request, the woman experienced her miracle of healing. And her story serves as a parable of God's grace in salvation.

I. The Condition of the Sinner: Mark 5:25–26

A. Helpless (v. 25)

Literally the text describes the woman as "being in a flow of blood." For

twelve years she was helplessly at the mercy of constant hemorrhaging. She had had her problem for as many years as Jairus's daughter had been alive (see Luke 8:42). The writings of the apostle Paul remind us that the unsaved person finds himself enslaved to sin, helpless to break that bondage (see Rom. 6:20–21).

B. Hopeless (v. 26)

It was not that the poor woman had not tried to find a cure. She had made her weary way to physician after physician, spending all her money but finding no relief. Not only that, but she had actually grown worse. Interestingly, Dr. Luke only reported that she had seen many physicians, omitting the details about her financial ruin and her worsening condition! The physicians she had seen, learned as they were, could discover no cure and treated only the symptoms while the disease took its inevitable course, causing its victim to grow worse and worse. How this situation parallels the course of sin scarcely needs to be mentioned.

The woman's hopeless condition had a religious consequence as well. The constant hemorrhaging caused her to be ceremonially unclean (see Lev. 15:19–30), keeping her from enjoying worship at the temple and the benefits of a right relationship to God and the Jewish community. Sin always separates the individual from the Lord.

II. The Compassion of the Savior: Mark 5:27–29

A. It Attracts (v. 27)

Having heard of Christ's mighty works, the woman came up behind the Lord, squeezed her way through the crowd, and touched His garment. More precisely, according to Luke, she touched one of the tassels on His garment. These tassels, or fringes, were one of the three symbols that continually reminded the Jewish people that they must obey God's commandments. The other two were the phylacteries worn on the body and the mezuzah, or small cylinders, attached to the doorposts of the houses. Four blue fringes (white was permitted later) of woven cords with tassels were attached to the four corners of the outer garment, so that two hung in the back and two in the front (see Num. 15:37–41). A man who wanted to parade his supposed piety put wider fringed borders on his garment (see Matt. 23:5).

B. It Alleviates (v. 28)

With feeble faith the woman had kept saying to herself over and over again

(imperfect tense) that if she could only touch His garment she would be made whole. She finally was able to do so. Immediately she felt the blood flow stop, and she knew that she was healed. Of course, it was not the garment that healed, but Christ. Neither was it the touch, but faith (v. 34).

C. It Assures (v. 29)

Not only was the woman healed, but also she felt in her body the evidences of that healing. Mark stated that the hemorrhage was "dried up," a word used, for example, of a fountain's drying up. Dr. Luke said that it stood still, a word used by medical writers to denote the stoppage of bodily discharges, especially the kind the woman had (see W. K. Hobart, *The Medical Language of St. Luke*). Mark also suggested the permanency of the cure by using the perfect tense, "she was healed" (v. 29).

When Christ saves a soul, He does so immediately and completely. Salvation does not involve a gradual forgiveness of sins, but an immediate and complete forgiveness. Further, He gives us ways we can be assured that we have been saved. Old things pass away and new things come (see 2 Cor. 5:17). The presence of those new things—peace, answers to prayer, changed desires—gives assurance that we do indeed possess new life. The old and the new will always be in conflict as long as we live on earth, but the presence of the new provides assurance to the believer.

III. The Confession of the Saint: Mark 5:30–34

A. The Inquiry of the Lord (v. 30)

Though it would be possible to touch the tassel of a garment without the wearer's feeling it, the omniscient Lord knew that the woman had touched Him and that He had released power to heal her. Her touch did not cause power to be released involuntarily from Him, for the miracle could not have been accomplished without His willing it to be so. But in order to elicit a public confession from her, He asked who touched Him. Sometimes, as here, He wanted the public to know what He did, and sometimes He did not.

B. The Ignorance of the Leaders (v. 31)

Peter responded for the disciples to the Lord's question (see Luke 8:45), and his response demonstrated their total lack of perception. They thought the Lord asked a foolish question, since many in the press of the crowd had touched Him. They failed to perceive that He was inquiring not about an ordinary touch but about a touch in faith.

C. The Involvement of the Woman (vv. 32–34)

Graphically, Mark described Christ as looking all around until His eyes fell on the woman who, realizing that she was discovered, immediately confessed what she had done. She was afraid because, being ceremonially unclean, she would defile until evening anyone she touched. Naturally, then, she expected Christ to be angry with her for having defiled Him. In the analogy with salvation, this illustrates His becoming sin for us, for there was no other way He could pay for our sins except by taking that sin upon Himself.

Gently and completely, He relieved all her fears by addressing her as "daughter," thus speaking to her as a father would to his child. No other woman was so addressed by the Lord.

Then the Lord corrected whatever view she had of her healing by letting her know that it was her faith, not her touch, that had cured her. And with a final word of reassurance He told her to go in peace and know that she was completely cured.

Faith is the only way we can be saved. After faith should come faithfulness; after healing, holiness; after cleansing, confession.

What an unfortunate, desperate condition she was in. Yet in spite of all the discouragement of these twelve years, the woman exhibited a determination to change her hapless state. She had every reason to give up. Her malady was, thus far at least, incurable. She might have resigned herself to what seemed to be the inevitable, asking God to give her patience to bear her infirmity, but not daring to ask Him to cure it. Reason dictated that she should have given up hope of a cure long ago.

Experience led to the same conclusion also. And her experiences with the physicians over those twelve years were not pleasant ones. The state of medicine in that day must have made its practitioners seem more like tormentors than healers. Still she went wearily from one to another, hoping against hope that she might find one who could solve her problem. But the fact that she went must have been borne of a desperate hope. Now she braved the crowd that surrounded the Lord, for she thought He could heal her. To touch His clothes, she knew, was to touch Him, and her faith and hope was in His power.

D. The Influence on Jairus

Jairus was about to receive the shocking news that his daughter was no longer at the point of death but was now dead. Would his faith be strong

enough for this? The messengers who brought the report did nothing to shore up his faith, for their advice was to quit troubling Jesus about the matter. The girl was dead; no one could do anything to help her now.

What must Jairus have been thinking at this moment? We do not know his thoughts, but hearing the woman's testimony could only have helped attack the doubts that must have been in his mind. Perhaps this is the reason for these two miracles happening together. What may seem like an interruption or a parenthesis served as an important way to strengthen Jairus' faith. The healed woman's confession ministered to someone else's need. No one can ever predict what may be the influence of our testimony to the power of Christ. Closet Christians do not influence others. Confessing Christians do.

As Spurgeon said in his unique way:

> You may reason . . . and say that Jesus does not need that you should testify for Him. Indeed, it is true that He does not need anything of any of us; but is this a fit way of treating your Lord? You may say that quietude on your part would be excusable; but as the Saviour did not think so in this woman's case, I believe that He will deal with you as with her, and compel you to come out and own the wonders of His grace. . . . Note well that this woman was not permitted to withhold the open avowal of her indebtedness to Christ, even though it was certain that her health and her conduct would witness to his power (C. H. Spurgeon, *Sermons on our Lord's Miracles*, London, Passmore and Alabaster, 1909, 2:219–20).

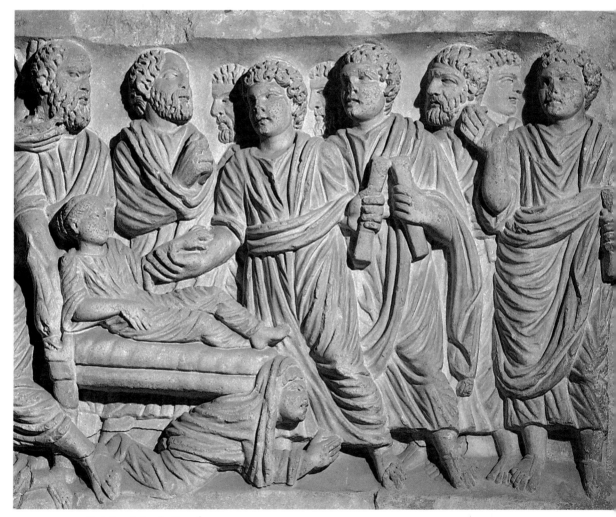

Raising Jairus's Daughter
Ca. 375; stone frieze; Musée Lapidaire Chrétian, Arles, France (Magnum)

Typical of early Christian art, this frieze does not tell about events and figures physically or emotionally; it is more passive as it calls the viewer's mind to a higher symbolic meaning. In a classic style, the figures are frozen here in the moment when Christ raises Jairus's daughter. The action is not dramatic, and little emotion appears on the figures' faces, although the women bowed at Christ's feet convey some sense of the miracle's wonder. Christ is portrayed as an idealized figure — the wise, youthful Teacher with a scroll in one hand and the other touching the child. The emphasis is on His divine nature. (See also page 63.)

WHEN THEY LAUGHED AT A FUNERAL

Raising Jairus's Daughter from the Dead

Now when Jesus had crossed over again by boat to the other side, a great multitude gathered to Him; and He was by the sea. And behold, one of the rulers of the synagogue came, Jairus by name. And when he saw Him, he fell at His feet and begged Him earnestly, saying, "My little daughter lies at the point of death. Come and lay Your hands on her, that she may be healed, and she will live." So Jesus went with him, and a great multitude followed Him and thronged Him. . . . While He was still speaking, some came from the ruler of the synagogue's house who said, "Your daughter is dead. Why trouble the Teacher any further?" As soon as Jesus heard the word that was spoken, He said to the ruler of the synagogue, "Do not be afraid; only believe." And He permitted no one to follow Him except Peter, James, and John the brother of James. Then He came to the house of the ruler of the synagogue, and saw a tumult and those who wept and wailed loudly. When He came in, He said to them, "Why make this commotion and weep? The child is not dead, but sleeping." And they laughed Him to scorn. But when He had put them all out, He took the father and the mother of the child, and those who were with Him, and entered where the child was lying. Then He took the child by the hand, and said to her, "Talitha, cumi," which is translated, "Little girl, I say to you, arise." Immediately the girl arose and walked, for she was twelve years of age. And they were overcome with great amazement. But He commanded them strictly that no one should know it, and said that something should be given her to eat *(Mark 5:21–24,35–43; see also Matt. 9:18–19,23–26; Luke 8:41–42,49–56).*

Why? Why? we ask. I suppose no questions disturb us more than those which begin with the word *why*.

Why does a twelve-year-old girl die? Why does God delay answering my prayers?

Surely Jairus asked those questions. His twelve-year-old daughter was dying. When he finally got to Jesus, the Master apparently paid little attention to his pleading, for He stopped to converse with the woman whom He healed of her hemorrhage, ignoring the urgency of hurrying to Jairus's daughter to lay hands on her and heal her before she expired. And sure enough, while the Lord delayed, the girl died. Why did she die? Why did the Lord delay?

How many people have asked these same questions through the centuries?

While God does not always give us full answers this side of heaven, this miracle provides some insight into these difficult questions.

I. In Distress, Christ is Willing: Mark 5:21-24

A. The Person

A Jewish synagogue was controlled by a body of eight elders, presided over by the "ruler of the synagogue." Jairus held the position of ruler, probably in the synagogue at Capernaum (see Luke 8:49). His functions were not priestly but administrative, including supervision of the building and the services. Larger synagogues apparently had several rulers (see Acts 13:15).

B. The Problem

Jairus's daughter was at the point of death, and her loving father was at the point of despair. Nothing hurts parents as much as those things that hurt their children. Adding to Jairus's sorrow was the fact that the child was his only daughter (see Luke 8:42), on whom he as a typical father must have doted.

C. The Prayer

Since Jesus had made His headquarters at Capernaum, Jairus had likely had contact with Him through His reputation, if not personally. As a ruler of the synagogue he undoubtedly knew about the healing of the royal official's child (see John 4:46-54) and of the centurion's servant (see Luke 7:1-10).

As ruler of the synagogue he must also have known of Jesus' claims to be the Messiah. What his reaction was we do not know. But this was no time for theological discussion. His daughter was dying. Jesus had healed others. Perhaps He could help his daughter.

He came and fell at the Lord's feet and begged Him to come to his house and lay His hands on his daughter. It took courage and humility for one who occupied such an important position in the synagogue to prostrate himself before One who many considered to be a maverick. But the situation was desperate, and our Lord responded by starting with Jairus toward his house.

The writer to the Hebrews assures believers today that this same Jesus stands ready to help those who are tested (see 2:18), for when we pray to our High Priest He will have mercy and grace to help in our time of particular need (see 4:16).

II. In Delay, Christ is Working: Mark 5:25-34

Barely had they started on their way when the woman with the hemorrhage touched the Lord and He turned His attention to her problem. What agony that

must have been for Jairus who knew that every minute that passed brought his daughter nearer to death. But, of course, the Lord had not forgotten Jairus's need, for while He apparently delayed, the Lord was working not only in the woman's life but also in Jairus's. The delay served to test further Jairus's faith and also to demonstrate the greater power of the Lord who would eventually not merely heal the child but bring her back to life.

Jairus, like us, probably could not understand the reason for the delay or see the greater purpose behind it. But he had to trust the Lord, for he had no other option. And when we cannot see or understand, we can and must trust the One who has promised never to leave or forsake us.

III. In Disappointment, Christ is Watching: Mark 5:35–36

A. The Word of the Messenger

What Jairus feared happened. His daughter died before Jesus could get there and lay His hands on her. Now what would he do? If the Lord had not stopped to take care of that woman! Now there was no hope. The messenger urged Jairus to stop troubling Jesus, for it never occurred to him that Jesus could raise the dead. The Lord had raised the widow of Nain's son, but either the news had not reached Capernaum or the messenger did not believe the report.

B. The Wisdom of the Master

Just when Jairus had lost all hope, the Lord, ever-watchful over the entire situation, commanded Jairus to stop being afraid and to keep on believing. Surely the messenger's report had stabbed Jairus's heart through and through with fear, but Christ commanded him not to abandon the faith that had driven him to seek His help in the first place.

The Lord is always watching over us and will step in exactly at the right time. God is never off schedule.

IV. In Deliverance, Christ is All-powerful: Mark 5:37–42

A. Powerful to Command

The Lord commanded the crowd not to follow Him to Jairus's home. Only Peter, James, and John, that inner circle of the disciples, were permitted to go with Him (cf. Mark 9:2; 14:33).

B. Powerful to Correct

But one crowd was soon replaced by another, for when they reached the

house, they found the crowd of mourners literally making an uproar. In v. 38, the same word is used of an excited mob (see Matt. 27:24; Acts 21:34). Some of the crowd were professional mourners, including musicians (see Matt. 9:23) and wailing women (see Jer. 9:17). Even the poorest family would hire at least two minstrels to play and one woman to cry, but Jairus was a ruler of the synagogue who doubtless had many more. The word for "wailing" (v. 38) is the same as in 1 Corinthians 13:1, "clanging." It was not a quiet scene.

Again the Lord took charge, asking the crowd why the commotion, since the girl was not dead but asleep. Some commentators understand this question to mean that the child was not actually dead but only in a coma. Most understand that the Lord was indicating that she was dead, but her death, like sleep, would be temporary, since He was about to raise her. The Lord was trying to encourage Jairus by assuring him that his daughter's death would shortly end in restoration, just as sleep ends in awakening.

Obviously the crowd of professional mourners knew she was dead. Christ permitted them to laugh at His statement that the girl was asleep so that there could be no doubt about the validity of the restoration that was about to happen. However, they would not be permitted to witness the raising itself, only its results.

C. Power to Call to Life

Only six people were allowed in the room where the body lay—the three disciples, the parents, and the Lord. Then Christ took the dead hand (which act made Him ceremonially unclean, see Luke 5:13), spoke to the body, and instantly the child rose and began to walk about. It is always the voice of Christ that raises the dead. So it was when He was on earth (see Luke 7:14; John 11:43), and so it will be in the future (see John 5:28). The verb *walked* is in the imperfect tense, indicating that the girl did not merely take a few halting steps, but that she continued to walk around.

V. In Directing, Christ is Practical: Mark 5:43

A. Direction Concerning the Facts

Jesus ordered the parents not to spread the word about what had happened. Obviously people would know, for the child herself would be seen, but not everyone would have known that she in fact had died. Some would likely assume she merely recovered from her sickness. What did the mourners think?

92

They were certain that the girl had died, and they must have seen her walking about. Did any of them believe? We do not know. But still the parents were not to be sources of information about what had happened. Widespread knowledge of this miracle might precipitate a confrontation with the authorities too soon.

B. Direction Concerning Food

No detail is too small to escape the Lord's attention. The child needed to eat, and in their joy the parents overlooked this. So Christ commanded she be given food.

Could He not have created the necessary food on the spot? Certainly He could have, but the pattern of His miracles does not include doing for people what they can do for themselves. He had done what only God can do — raise the dead; others could now take over. And the girl was expected to resume the normal activities of life.

All these circumstances serve as good examples for us today. Our Lord can do what seems impossible; we must assume and discharge our responsibilities to do what we can do. And should we experience a miracle, we should not idolize it, but thank God for it and go about the normal activities of the Christian life.

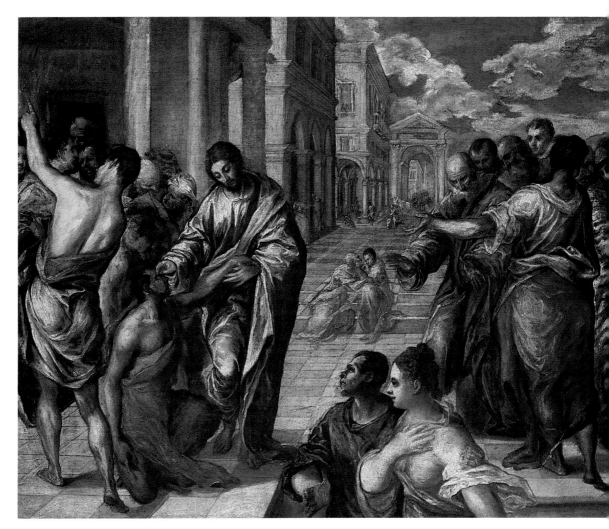

The Miracle of Christ Healing the Blind
El Greco, 1568–70; oil; Copyright 1979 by The Metropolitan Museum of Art, New York, gift of
Mr. and Mrs. Charles Wrightsman, 1978

Born in Crete in 1541, El Greco lived until 1614. Because he had been trained to paint icons in the
Byzantine style, his artwork reflected the clear Greek figures characteristic of the earlier iconography. But
after he moved to Italy and spent time in Rome, his work was influenced by the artists and artwork he
encountered there. This painting is his third version of the miracle, and reflects the Roman influence. The
scene depicts the moment before the blind man receives his sight. Only one other figure besides Christ seems
very involved in the event, a man who bends down to take a closer look as it happens. The others seem to be
disputing and conversing among themselves. Christ still has remnants of a halo (the shining light around his
head), a carry over from medieval works that designated a holy personage in that way.

FAITH AND FOLLY

Healing Two Blind Men

When Jesus departed from there, two blind men followed Him, crying out and saying, "Son of David, have mercy on us!" And when He had come into the house, the blind men came to Him. And Jesus said to them, "Do you believe that I am able to do this?" They said to Him, "Yes, Lord." Then He touched their eyes, saying, "According to your faith let it be to you." And their eyes were opened. And Jesus sternly warned them, saying, "See that no one knows it." But when they had departed, they spread the news about Him in all that country *(Matt. 9:27–31).*

Eye problems must have been quite common in Palestine in Christ's time. Someone has estimated that one out of every five adults of that day was afflicted with some kind of eye disease.

I. The Failure in Their Sight: Matthew 9:27

Because blindness was so prevalent in those days it served as an apt illustration for the biblical writers of spiritual blindness. Note some of the parallels between a blind person and an unsaved person.

Both experience *darkness*. The world is in darkness (see Eph. 6:12), as are those who live in it (see Rom. 2:19). The person who belies his profession of faith by hating his brother walks in darkness and is blinded by it (see 1 John 2:11). Satan blinds the minds of all who have not trusted Christ (2 Cor. 4:4).

Both experience *danger*. Spiritual blindness affects the intellect and lifestyle sometimes even to the point of involvement in the most degrading practices (see Eph. 4:18–19). If the light of the gospel is rejected, then that person's ultimate destiny is outer darkness forever (see Matt. 25:30).

Both experience *dependence*. Just as sightless people need various kinds of help, so the spiritually blind have to depend on others to deliver the message that will "open their eyes, and . . . turn them from darkness to light, and from the power of Satan to God, that they may receive forgiveness of sins and an inheritance among those who are sanctified . . ." (Acts 26:18). Let those of us who know the truth not fail them.

II. The Faith in Their Savior: Matthew 9:27–29

A. The Proclamation of Their Faith (vv. 27–28)

As the two men followed the Lord along the road, they pleaded for mercy and acclaimed Him as the Son of David. That ascription was an undisguised acknowledgment of their faith in Jesus as Messiah. Blind though they were, they saw in the Lord Jesus what the Pharisees, who were students of the Bible, had failed to see. And they understood even though they had never been able to witness personally any of Jesus' miracles.

The title "Son of David" linked Messiah with the great covenant made with King David (see 2 Sam. 7:12–16) in which God promised that David's house, kingdom, and throne would be established forever. The covenant did not promise uninterrupted rule by David's family (in fact the Babylonian captivity interrupted it), but it did promise that the right to rule would always remain in David's dynasty. Isaiah clearly predicted that the Messiah would ultimately occupy David's throne and rule the Kingdom (see Is. 9:7). Gabriel announced to Mary that the child she would bear would be the Son of David and the one to reign over Israel (see Luke 1:32–33).

When Jesus of Nazareth began His public ministry in the synagogue in Nazareth, He identified Himself as Messiah by claiming that another of Isaiah's prophecies was being fulfilled by Him (see Luke 4:16–21; cf. Is. 61:1–2). That claim, which included an assertion of His deity, was what divided the people who heard Him. The two blind men were quite clearly convinced that Jesus of Nazareth was indeed their Messiah, and since He was, He could certainly give them sight. Had He not said in Nazareth that He would give sight to the blind (see Luke 4:18)?

But "Son of David" was a title also charged with political overtones. Messiah would rule on the earth. Some of Christ's followers did not realize that His earthly rule would not be at His first coming since He was rejected then. At that point in His ministry, Jesus apparently did not want to flaunt that title with its political connotations in the face of the authorities lest it detract from other priorities in His ministry. So He paid no attention to the blind men until they could go into a house and talk more privately.

When they did go into the house, He probed their faith. Was it only an echo of the enthusiastic crowd? Was it superficial or genuine? He asked them directly if they believed He could heal them, and their reply was a clear yes.

B. The Power of Their Faith (v. 29)

The two men believed that Jesus could heal them, and on that basis He did. Sometimes, as here, Christ's miracles were performed in response to faith (see Matt. 8:10; 9:2,22; 15:28), and yet on other occasions the Lord found no faith and still performed the miracle (see John 5:6–9; 11:39–44; Mark 5:39–40; Luke 22:50–51). Modern healers who explain their lack of results on the basis of a lack of faith by the people wanting to be healed are not following Jesus' example.

III. The Folly in Their Service: Matthew 9:30–31

A. There was a Directive (v. 30)

Jesus sternly warned the two men to let no one know what had happened. The verb used indicates a strict warning (see Mark 1:43). It is not easy to understand exactly why the Lord was so concerned that no one know of this miracle. Perhaps He wanted to deemphasize those political overtones so that opposition would not be stirred up at that time. Perhaps He saw that people were being too much attracted by His miracles rather than heeding the message they were supposed to authenticate. Or perhaps the Lord simply knew that it would be better for the spiritual welfare of the men if they kept quiet. It may not always be wise to encourage a new convert to tell what Christ has done for him. Certainly Scripture cautions against parading and promoting new converts (see 1 Tim. 3:6). Perhaps those men needed to prove themselves in other ways before they could be given the privilege of public witness.

B. There was Disobedience (v. 31)

Their motives may have been fine, but what the two men did was clearly disobedience. Even though they may have thought they were honoring Christ by spreading the news about Him, in reality they were doing Him great dishonor by disobeying Him. Unmasked, their sin was that of putting their own intelligence above Christ's. They had faith to be healed, but not faith to follow the command of their Healer. Disobedience stems from lack of faith, for true obedience is faith in action. Faith does what is commanded, asking no questions and raising no objections.

On this sad note the story ends. But the lesson is clear: obedience is always the primary matter in God's sight (see 1 Sam. 15:22), for God's directions are infinitely wiser than ours. In wisdom He directs; in faith we are to obey.

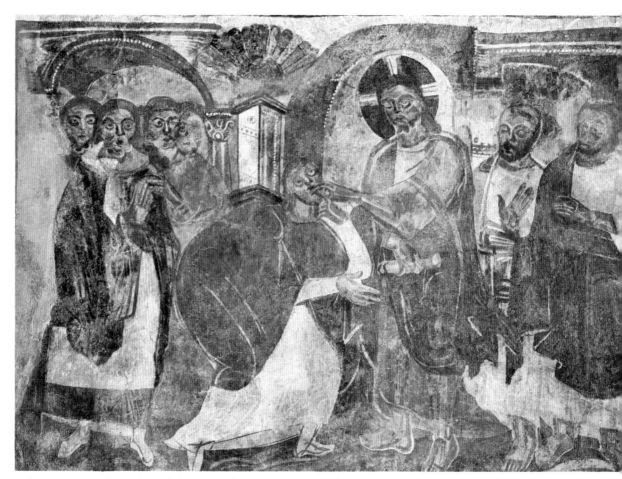

The Healing of the Deaf and Dumb Man
Late ninth century; fresco; Johanneskirche Monastery, Munstair, Switzerland (From *Early Medieval Painting*, "Mosaics and Mural Painting," by Andre Grabar; Book Illumination by Carl Nordenfalk. © 1957 by Editions d'Art Albert Skira, Geneva, Switzerland.)

 This mural is in the church of a monastery thought to have been founded around 780–790. The entire interior of the church was frescoed, and this scene was one of sixty-two New Testament scenes decorating the nave. The church has one of the most detailed Gospel cycles known in the art world. Painted in the Carolingian style, this fresco has luminous pink and white tones, due primarily to the use of colors available locally that have withstood the test of time. The gestures of the highly stylized figures tell the story as Christ touches the deaf and dumb man's mouth while His disciples watch in amazement. The moment at which the actual healing takes place is captured by the artist, and he sets it in front of a background filled with decorative architecture.

STICK OUT YOUR TONGUE

Healing the Mute Man

As they went out, behold, they brought to Him a man, mute and demon-possessed. And when the demon was cast out, the mute spoke. And the multitudes marveled, saying, "It was never seen like this in Israel!" But the Pharisees said, "He casts out demons by the ruler of the demons" *(Matt. 9:32–34)*.

How often I heard the doctor say, "Stick out your tongue," when I was growing up. And when I stuck it out he would look at its color and texture, and then look down my inflamed throat. The symptoms were all too evident, but the cause was a microscopic bug impossible to see with the naked eye.

Similarly, this miracle, likely performed near Capernaum immediately after the healing of the two blind men, portrays the tongue as a symptom of a more serious disease.

I. The Cause: Matthew 9:32

To all outward appearances this man had simply lost the power of speech. He could not communicate with anyone. But his problem ran much deeper than that; in reality, being unable to speak was due to being demon-possessed. Jesus experienced frequent confrontations with demons during His ministry.

II. The Concern: Matthew 9:32

Happily, this afflicted man had concerned friends. Though unnamed, they are the heroes of this story, for they saw to it that their friend, whose case seemed hopeless, made contact with the One who could cure the root problem (demonization) and thus relieve the symptom (dumbness).

Had the man and his friends previously sought help from exorcists? The text does not say, though if his condition were longstanding they probably had (see Matt. 12:27).

The early historian Josephus described how an exorcist named Eleazar tried to cast out demons during the time of Vespasian (A.D. 69–79): "He put a ring that had a root . . . to the nostrils of the demoniac, after which he drew the demon out through his nostrils; and when the man fell down at once, he adjured the demon to return unto him no more . . . reciting the incantations which he composed" (*Antiquities,* VIII, ii, 5). Rabbi Johanan ben Zakkai, a contemporary of Josephus, prescribed the following technique to expel demons: "Take roots of herbs, burn them under him [the possessed person], and surround him with water, whereupon the spirit will flee" (*The Interpreter's Dictionary of the Bible*, Vol. 2. New York: Abingdon, 1962, p. 199).

Whether this man had tried some kind of exorcism like that or not, we do not know; we do know that nothing had succeeded and he could not speak.

III. The Cure: Matthew 9:33

Very simply and clearly, Matthew declared that the demon was cast out of the afflicted man. Christ's cure was uncomplicated, direct, nonmagical, and complete.

All this pictures the grace of God in salvation. Because of sin, no person can communicate with God without the help of the Lord Jesus. All stand speechless before a holy God. Whatever "cures" a person may try, nothing that does not deal with the root problem of sin will work. And only the Lord Jesus can deal effectively with that problem.

IV. The Consequences: Matthew 9:33

A. To the Man

The man's power to speak was immediately restored. Every time that he opened his mouth from then on, everyone who heard him had conclusive evidence that he had been cured.

B. To the Multitudes

The crowd marveled, acknowledging the uniqueness of what had happened. The crowd's reaction seems to indicate that the exorcists, whatever success they may have had, had never done anything like this. The crowd admired the Lord for what He had done, but that does not mean they acknowledged His claim to be the Son of God, nor that they received Him as their Messiah. People then and now can admire Him without knowing Him personally.

V. The Controversy: Matthew 9:34

The Pharisees were also moved—but moved toward a stronger stand against Him. If this miracle followed the one we call the unpardonable sin (see Matt. 12:22–37, and harmonies of the Gospels consider that to be the correct chronology, since Matthew's groupings of miracles and other events were not always chronological), then clearly the Pharisees had not taken Christ's advice to repent. Instead they had further hardened their position against Him, persisting in their sin.

Such opposition reminds us that even when faced with miraculous evidence, the unsaved person's heart will not necessarily respond. On another occasion the Lord declared that even if someone would do the ultimate miracle and rise from the dead, people will not believe (see Luke 16:30–31). It is not miracles people need to see; it is the message they need to believe.

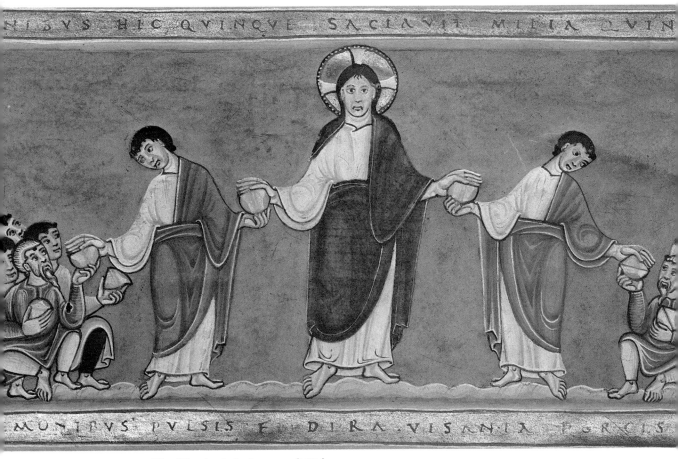

The Miracle of the Loaves and Fishes

1035–1040; illuminated manuscript (The Gospel of Echternach); Germanisches National Museum, Nuremberg, West Germany

One of the unique developments in the art of bookmaking was the illuminated manuscript. At Echternach, in what is now Luxembourg, we have some of the prime examples of this exalted combination of text and art. In the miracle of the loaves and fishes several distinctives of the German style of illumination can be seen. Strong, vigorous outlines and dynamic movement are coupled with the use of thick, luxurious colors to add dramatic intensity to the portrayal of this miracle. (See also page 152.)

THE LORD IS FAITHFUL

Feeding Five Thousand Men

After these things Jesus went over the Sea of Galilee, which is the Sea of Tiberias. Then a great multitude followed Him, because they saw His signs which He performed on those who were diseased. And Jesus went up on a mountain, and there He sat with His disciples. Now the Passover, a feast of the Jews, was near. Then Jesus lifted up His eyes, and seeing a great multitude coming toward Him, He said to Philip, "Where shall we buy bread, that these may eat?" But this He said to test him, for He Himself knew what He would do. Philip answered Him, "Two hundred denarii worth of bread is not sufficient for them, that every one of them may have a little."
One of His disciples, Andrew, Simon Peter's brother, said to Him, "There is a lad here who has five barley loaves and two small fish, but what are they among so many?" Then Jesus said, "Make the people sit down." Now there was much grass in the place. So the men sat down, in number about five thousand. And Jesus took the loaves, and when He had given thanks He distributed them to the disciples, and the disciples to those sitting down; and likewise of the fish, as much as they wanted. So when they were filled, He said to His disciples, "Gather up the fragments that remain, so that nothing is lost." Therefore they gathered them up, and filled twelve baskets with the fragments of the five barley loaves which were left over by those who had eaten *(John 6:1–13; see also Matt. 14:13–21; Mark 6:31–44; Luke 9:10–17).*

Apart from the Resurrection, this miracle of feeding five thousand men is the only one recorded by all four Gospel writers. And it is the only "sign" miracle recorded by all.

The place was the area of Bethsaida near the northeast corner of the Lake of Galilee. The Lord and His disciples had retreated there hoping to find some peace and quiet, for they were weary and needed some rest from the pressures of ministry. The area was deserted, though not a desert, for it was covered with grass. The time was before Passover in the early spring, a year before the Crucifixion. The occasion met the need of the crowd and provided a test for the disciples. And, as His miracles do, this one also revealed something about the Lord—in this case, His faithfulness.

I. His Faithfulness in Teaching

A. He Was Weary

The retreat never came to pass, though the Lord needed it. Emotionally, He was drained because of the news of the murder of John the Baptist. Both Matthew and Mark suggest this event was the reason why He sought solitude in a deserted place.

Physically, He was weary because of the schedule of ministry He kept. The imperfect tenses in John 6:2 indicate that the multitudes kept following Him because He kept performing signs. The disciples, too, had been involved in a strenuous tour of ministry and needed a time of rest (see Mark 6:31).

Spiritually, as the opposition to Christ's ministry mounted, He felt the oppression against Him increasing. It would climax a year later at Golgotha.

B. He Was Willing

It was only four or five miles directly across the lake from the area of Tiberias where the group had been ministering to Bethsaida. And it was not farther than ten miles by land around the north end of the lake. So when some people saw the Lord and the disciples getting into a boat to cross the lake, they spread the news and gathered this large group of thousands of people who ran overland to meet the Lord when He landed on shore. Perhaps the wind was against the disciples as they rowed, or perhaps they deliberately slowed their trip, hoping that the ever-increasing crowd would weary of running and disperse before they landed.

But such was not to be. When the Lord saw the multitude, He welcomed them, not thinking of Himself or His own needs, but willing and anxious to minister to them in spite of His weariness. He saw their hunger for truth, which their spiritual leaders had not met. They had no shepherd, though they had scribes and rabbis galore. His compassion overcame His weariness, and He taught them and healed the sick.

It is not sinful to grow weary *in* the ministry, but it is unChristlike to grow weary *of* the ministry. Compassion should motivate us to serve.

C. He Was Working

Teaching was the most prominent characteristic of the earthly ministry of Christ. He saturated the multitudes with His teaching, as on this occasion. He also trained the twelve disciples, as He did here too. Teaching is one of the thrusts of the Great Commission, and the spiritual gift of teaching is among the three most important gifts (see 1 Cor. 12:28).

But the true shepherd not only teaches, he also tends the sheep. The Lord healed the sick in the crowd, and He fed them. His was not a detached "pulpit" ministry. It was also a person-to-person ministry. He was the epitome of a pastor-teacher (see Eph. 4:11).

II. His Faithfulness in Training

A. The Inquiry of the Lord

Probably the question "Where shall we buy bread . . . ?" (John 6:5) was asked earlier in the day of teaching. It was logical to ask Philip where they might buy bread, for he was a native of nearby Bethsaida and would be expected to know. John, however, added that the Lord did not need to know anything from Philip since He knew everything (see John 6:6). But He wanted to test Philip.

How? Remember when Philip first met the Lord he reported to Nathanael that he had found the one of whom Moses wrote (see John 1:45)? Would Philip remember what Moses had done when he gave the Israelites bread from heaven in the wilderness? Would he recall how Elisha had on a much smaller scale fed a hundred men with twenty barley loaves (see 2 Kin. 4:42–44)? Would Philip acknowledge that One far greater than Moses was there, fully capable of meeting this overwhelming need?

B. The Impotence of the Leaders

If all the other disciples had not personally heard the Lord's question to Philip, they soon heard it from Philip himself. Some time elapsed between the question to Philip and the response from the committee of disciples. Perhaps most of the day of teaching came between John 6:6 and 6:7. And during that time you can easily believe that the disciples were discussing what they would say to the Lord.

When evening came, their considered committee conclusion was to send the crowd away. After all, if they were able to come the ten miles or so to hear the Lord earlier in the day, they could surely return ten miles to their homes to eat.

Why did they come to this conclusion? Because they looked at circumstances instead of Christ. Two hundred denarii worth of bread, they had calculated, would not be enough. Perhaps they had taken a rough count of the crowd, or perhaps this was just a wild guess. In either case, two hundred denarii was far more than their treasury could finance. And that would not feed the crowd anyway.

A denarius was the average daily wage for a rural worker (see Matt. 20:2).

Normally it would purchase about ten quarts of wheat or thirty of barley. (In the coming tribulation, one denarius — or its equivalent — will buy only one quart of wheat or three of barley. One quart of wheat was the daily ration per man in Xerxes' army. Thus in that future time all of a man's wage will feed only himself, with nothing left for his family.) Two hundred denarii would buy around two thousand quarts of wheat or six thousand quarts of barley. One-third of that (for one meal) would feed five thousand men but not also the women and children in the crowd. So the disciples' computation or guess was right.

But circumstances always need to be examined with the eyes of faith.

Why did the disciples want to send the crowd away? Because they lacked faith. They had knowledge. They had experience. They had seen what Christ did at Cana when the wine ran out. During that very day, they had seen people healed. But they still lacked faith.

Notice how contagious this attitude was. Andrew, though sometimes pictured as the hero of the story, was affected. When he reported to Christ that they found only a boy's meager lunch, he probably did it with some sarcasm. His comment, "what are they among so many?" (John 6:9), is hardly one of faith!

III. His Faithfulness in Tending

A good shepherd tends to the needs of his sheep. As we have opportunity, let us do good to all people, especially those who are of the household of faith (see Gal. 6:10). Feeding people is ministry too, and our Lord saw to it that the crowd did not go away hungry.

A. The Supply

Barley bread (flat cakes) was the food of the poor (see Judg. 7:13; Ezek. 13:19). The two fish the lad had were little tidbits to make the coarse barley bread more palatable. Though this poor small lunch was all that was to be found in the large crowd, it was enough in the Master's hand.

B. The Seating

Taking charge, the Lord commanded the disciples to have the people recline on the grass in groups of about fifty each. And the disciples, though they lacked faith, did not lack obedience. The five thousand men alone would have necessitated one hundred groups of fifty each. Mark 6:40 used a word to describe these groups that literally means "garden plots." What a scene it must have been! The setting sun, causing the water of the lake to shimmer and coloring

the mountains with purple hues, and the "plots" of fifties painted on the background of the lush green grass set the stage onto which the Lord of heaven stepped to perform this spectacular miracle.

C. The Serving

After giving thanks, the Lord gave the food to the disciples who in turn gave it to the people. The Lord often used people to minister His blessings to others (see Eph. 4:11–12), and the more the disciples gave, the more they received.

D. The Satisfying

More than five thousand stomachs testified to the authenticity of this miracle. It was no snack or sacramental meal in which just a tiny fragment of bread was given to each one. Nor was it a case of discovering others in the crowd who had lunches they shared. Such suggestions are without foundation. When all were completely satisfied, the disciples gathered up what was left over in twelve baskets. Abundance is no justification for waste.

An astounding miracle! But greater works than these we can do today. How can that be? Something infinitely greater than giving food to people is giving them the news of the gift of eternal life. Everyone in that huge crowd got hungry again and soon. But those who eat the Bread of Life shall never hunger again. To offer people that Bread is a greater work.

> *Bring to Christ your loaves and fishes*
> *Though they be both few and small,*
> *He will use the weakest vessels —*
> *Give to Him your little all.*
> *Do you ask how many thousands*
> *Can be fed with food so slim?*
> *Listen to the Master's blessing —*
> *Leave the miracle to Him.*
>
> *Christian worker, looking forward*
> *To the ripened harvest field,*
> *Does the task seem great before you?*
> *Think how rich will be the yield,*
> *Bravely labor with your Master,*
> *Though the prospect may seem dim,*
> *Preach the Word with holy fervor —*
> *Leave the miracle to Him.*
>
> —Author unknown

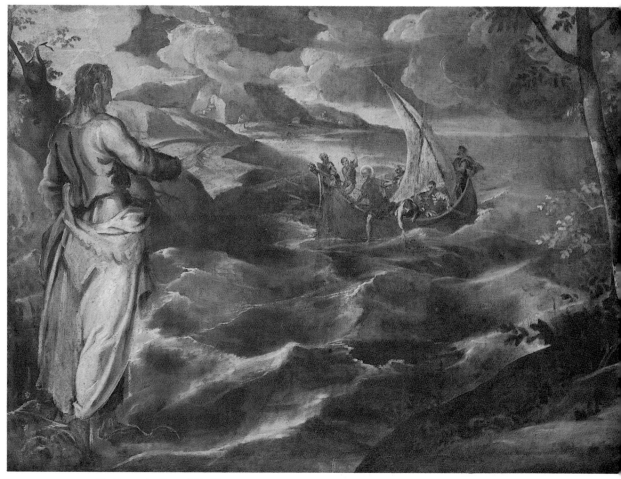

Christ at the Sea of Galilee
Jacopo Robusti Tintoretto, ca. 1575–1580; 46″ x 66¼″; oil on canvas; National Gallery of Art, Washington, D.C. (Samuel H. Kress Collection, 1952)

Jacopo Tintoretto (1518–1594) was one of the greatest painters of Venice, Italy, and received recognition during his lifetime. Tintoretto sometimes used small wax models arranged on a stage so that he could study lighting from candles and other factors that would be in effect where his work was to be installed. On the left side of this painting Christ's solitary figure stands in the water, directing the viewer's attention toward the disciples struggling to sail their boat on the wind-swept sea. Peter can be seen confidently stepping out of the boat at his Master's bidding. Noted for his swift, linear brushstrokes Tintoretto heightens the drama of the scene by his treatment of the clouds and water. One can sense the stormy atmosphere that is in such contrast to Christ's calm, strong vertical presence. (See also page 123.)

THE ALL-SUFFICIENT SAVIOR

Christ Walking on the Water

Immediately Jesus made His disciples get into the boat and go before Him to the other side, while He sent the multitudes away. And when He had sent the multitudes away, He went up on a mountain by Himself to pray. And when evening had come, He was alone there. But the boat was now in the middle of the sea, tossed by the waves, for the wind was contrary. Now in the fourth watch of the night Jesus went to them, walking on the sea. And when the disciples saw Him walking on the sea, they were troubled, saying, "It is a ghost!" And they cried out for fear. But immediately Jesus spoke to them, saying, "Be of good cheer! It is I; do not be afraid." And
Peter answered Him and said, "Lord, if it is You, command me to come to You on the water." So He said, "Come." And when Peter had come down out of the boat, he walked on the water to go to Jesus. But when he saw that the wind was boisterous, he was afraid; and beginning to sink he cried out, saying, "Lord, save me!" And immediately Jesus stretched out His hand and caught him, and said to him, "O you of little faith, why did you doubt?" And when they got into the boat, the wind ceased. Then those who were in the boat came and worshiped Him, saying, "Truly You are the Son of God" *(Matt. 14:22–33; see also Mark 6:45–52; John 6:14–21).*

All three accounts of this miracle place it immediately after the feeding of the more than five thousand people by the Lake of Galilee. Certainly more than ten thousand people (perhaps as many as fifteen thousand) had been fully satisfied by that miracle, for there were baskets of leftovers that were carefully gathered. By this spectacular miracle the Lord had proved Himself to be all-sufficient for the multitude's physical needs on that occasion. But before the next day dawned, He would show Himself sufficient for other needs that His disciples had.

I. The Savior Protecting

Matthew's and Mark's accounts begin with a note of urgency; John explains why. Immediately, the Lord sent the disciples across the lake to Bethsaida, which was near Capernaum. One Bethsaida was the site of the feeding of the five thousand on the east bank of the upper Jordan just above where it flows into the Lake of Galilee, but the disciples were sent to another town by the

same name, northwest of the lake, near Capernaum. The distance between the two towns was only four or five miles.

Meanwhile the Lord had retreated to a mountain to pray. After seeing the miracle of the feeding of the five thousand, the multitude had wanted to make Christ King. Doubtless they saw in Him a leader who might successfully overthrow the Roman hold on Palestine, and their nationalistic spirit caused them to seize on what they saw as their moment of opportunity. But the disciples' departure and the Lord's withdrawal quickly put an end to the little effort to make Him King.

As God, Jesus is King, and His kingdom relates to earth, but not at that time in history. Many commentators miss the point, declaring that Jesus did not want to be an earthly king. Not only did He want to be when He came the first time offering the promised Messianic kingdom, but He will, when He comes the second time, rule over this present earth. When the people rejected His offer to be King, He began to teach them of the mysteries of the kingdom that characterize this present time between His first and second comings (see Matt. 13). It was not that they wanted to make Him an earthly king that was wrong; it was the timing of it. They had spurned His condition of personal repentance for entering the kingdom; they wanted only a political leader against Rome.

The disciples might have been caught in the middle of this tug of war had the Lord not sent them away. The crowd would naturally have expected them to rally with them; Christ would have expected them to reject the crowd's actions. To protect them from possible harm, the Savior sent them away. In this action the Lord was protecting them.

But soon they faced another problem—a bad storm on the lake. How often during that night they must have wished for the calm of the shore! But the Lord sent them to contend with the waves to protect them from having to contend with the crowd.

Adversity is not always chastisement. Often our Lord offers a way of escape, which though difficult in itself protects us from a more serious danger that we know nothing about. When afflictions come, we naturally ask why, and that is not wrong. It might be wrong, however, if we attempted to answer the question, for we only see a part of the plan and we cannot know what might have been. But our Lord can and does know, so we obey Him and trust Him in the problem, remembering that it may be His way of protecting us from something worse. Sometimes the storm is the best will of God (compare with the delay in John 11:5–6).

II. The Savior Preparing

Evening had come, that is, sundown, when the disciples got into their boat. The Jews distinguished two evenings (see Ex. 12:6; literally "between the evenings"): one began about 3:00 P.M. (when they had begun preparing to feed the five thousand, see Matt. 14:15); the other began at sundown (referred to here). The disciples would not see their Lord again until the fourth watch of the night (between 3:00 and 6:00 A.M.). Little did they realize when they began that short journey that they would be fighting the storm and the waves for nine to twelve hours.

Unlike another storm when Christ was asleep in the boat (see Matt. 8:23–27), this time the disciples were alone. Was He preparing them for the time when He would no longer be present visibly on the earth? Was He teaching them to increase their faith in Him who — for those hours at least — was invisible to them?

Maturity does not come overnight. It requires time, growth, building on lessons learned before, and passing harder tests. Our Lord suits the circumstance to our particular need. The disciples needed to learn that night that Christ's power was no less great and no less available to them just because He was not with them in the boat. We, too, need to remember that He is no less active or available to us today simply because He is not here on earth visible to us.

III. The Savior Praying

Surely one of the most important ministries Christ does for us today from His ascended and glorified position in heaven is to pray for us (see Rom. 8:34; Heb. 7:25). From His vantage point on the mountain where He was that night, He could see the disciples struggling against the storm. And today He sees our struggles, testings, trials, and rough waters, and for each of us in every circumstance He is praying. He prays that we should be saved fully and eternally (see Heb. 7:25). And He prays that we should be sanctified (see John 17:17).

But the fact that our Lord prays for us does not make it unnecessary for us to call on Him for help in time of specific need. Our Lord wanted to teach the disciples that lesson also. And so in their moment of desperation He walked on the lake to them. During the nine or more hours they had been rowing that night, they had only gone three or four miles, and these experienced sailors obviously needed help. Nevertheless, Mark's account says that even though the

Lord knew their need and was coming to them He "would have passed them by" (6:48). Why? Wasn't He going to help them? Why did He even think to pass them by?

The answer is simple. He wanted them to call to Him for help. What they needed was not to be theirs automatically, but only in response to their cry of desperation and dependence.

But instead of recognizing Him, the disciples thought they saw a ghost. Perhaps they even took the sight as a harbinger of their own impending deaths. But where their eyes deceived them, their ears reassured them, for when they heard the familiar voice telling them it was their Master their fears vanished.

Today our Lord prays for us in heaven, but He also wants us to call on Him in our time of need. Then He will respond with timely help (see Heb. 4:16). The greatest temptation we face is thinking we can get along without Him.

IV. The Savior Providing

A. Providing His Presence

When the Lord came to them, He said, "Be of good cheer" and "Be not afraid." His presence provided cheer in place of their desperation and courage in place of their fear. The phrase "be of good cheer" is used in the New Testament only in relation to Christ. He alone brings cheer. The word can also be translated "courage" (see Matt. 9:2; 14:27; Mark 6:50; John 16:33; Acts 23:11). How often the Lord reassured the disciples not to be afraid (see Matt. 10:26,28,31; 17:7; 28:5,10)! To recognize Him for who He is brings relief from fear.

B. Providing His Power

Matthew alone recorded Peter's attempt to walk on the lake as the Lord was doing. Peter asked the Lord to bid him to come, and He did. And for a while Peter actually did walk on the water of the Lake of Galilee. All went well until Peter began to look at the effects of the strong wind. Then he began to sink. His concentration of faith was broken, and even his ability to swim failed him (see John 21:7). In desperation he called on the Lord to save him, and the Lord did.

Notice that Jesus did not rebuke Peter for attempting to walk on the water. He only rebuked him for doubting. And apparently even the momentary doubt passed, for the Lord asked him why he had doubted. To have rebuked him for the attempt might have deterred Peter from future bold acts of faith. And the miracle showed Peter that faith was the key.

Immediately, the disciples asked Christ into the ship, and more miracles happened. The wind ceased, and right away they arrived at the shore (John 6:21).

What should be our reaction to such a Savior? The same as the disciples' reaction. They wondered (literally, "were amazed," see Mark 6:51), and they worshiped (see Matt. 14:33). Mark added that this miracle impressed the disciples in a way the feeding of the five thousand had not. Evidently they had not learned from the events of the day before that the Lord was really in control of all the forces of nature and of the circumstances of life. But now they recognized that and acknowledged Him as the Son of God. Matthew added that others in the boat (the crew or other passengers) also worshiped Him. They did not reason, they did not philosophize, they did not try to explain. They worshiped. They recognized His worth, for that is what it means to worship.

May our response be just the same.

> *Fierce was the wild billow,*
> *Dark was the night;*
> *Oars labored heavily,*
> *Foam glimmered white;*
> *Trembled the mariners,*
> *Peril was nigh:*
> *Then said the God of God,*
> *"Peace! It is I."*
>
> *Jesus, Deliverer,*
> *Come Thou to me;*
> *Soothe Thou my voyaging*
> *Over life's sea:*
> *Thou, when the storm of death*
> *Roars, sweeping by,*
> *Whisper, O Truth of Truth,*
> *"Peace! It is I."*

—Ascribed to Anatolius
(date unknown)
Translated by
Rev. John M. Neale (1892)

Christ and the Canaanite Woman
Limbourg brothers, fifteenth century; illuminated manuscript; Musée Condé, Chantilly, France (Giraudon/Art Resource, Inc.)

In the fifteenth century, miniatures in illuminated manuscripts began to take on the characteristics of modern painting: perspective, depth, detail, more accurate representation of figures. (Compare the miniature, for instance, with that on page 67, which was made three centuries earlier.) These qualities are vividly demonstrated in this miniature. Set against a picturesque landscape is the scene in which the Canaanite woman asks Christ to heal her daughter. On the right the possessed daughter lies in a bed in an open structure. On the left Christ talks with His disciples, His back turned to the woman crying out to Him for mercy. In the lower part of the page Christ addresses the woman and, touched by her faith, consents to her request. The entire scene at the bottom of the page duplicates the action of the previous scenes but from a different perspective. (See also page 33.)

PRINCIPLES FOR PRAYER

Healing the Syro-Phoenician's Daughter

Then Jesus went out from there and departed to the region of Tyre and Sidon. And behold, a woman of Canaan came from that region and cried out to Him, saying, "Have mercy on me, O Lord, Son of David! My daughter is severely demon-possessed." But He answered her not a word. And His disciples came and urged Him, saying, "Send her away, for she cries out after us." But He answered and said, "I was not sent except to the lost sheep of the house of Israel." Then she came and worshiped Him, saying, "Lord, help me!" But He answered and said, "It is not good to take the children's bread and throw it to the little dogs." And she said, "True, Lord, yet even the little dogs eat the crumbs which fall from their masters' table." Then Jesus answered and said to her, "O woman, great is your faith! Let it be to you as you desire." And her daughter was healed from that very hour *(Matt. 15:21–28; see also Mark 7:24–30)*.

Withdrawing is not always an unworthy thing for a Christian to do. Sometimes our Lord avoided an undesirable situation by simply absenting Himself. One such occasion occurred shortly before this miracle was performed. After the miracle of feeding five thousand men and before departing for Capernaum, He withdrew because He realized the crowd would come and try to forcibly make Him King (see John 6:15). But even in Capernaum He was not safe from the insistence of the people, especially after He had again offended the Pharisees by exposing them as hypocrites (see Matt. 15:1–20).

Therefore, the Lord and His disciples sought escape and rest in Phoenicia. This district included the coast and the plain from Mount Carmel northward; its two chief cities were Tyre and Sidon. The inhabitants were descendants of the Canaanites, the original inhabitants of Palestine (see Gen. 10:15), and being pagans, they bore a particular ill will toward the Jewish people. As far as the record goes, our Lord had no ministry there except this miracle.

The daughter was plagued with a demon. Having heard of the Lord's reputation as a miracle worker, the mother approached Him. But the Lord's response reminded her that not being an Israelite excluded her from His ministry, and it

was not until she realized her place that her request was granted. This story furnishes illustrations of some basic principles concerning prayer.

I. Principles Related to Our Asking

A. Prayer Must Be Directed

When the mother first came, she cried to the Lord (see Matt. 15:22). She addressed Him directly as the "Son of David." In using that title she may have been acknowledging that He was the One who fulfilled God's promises. Likewise, in praying, we come directly to the One who always keeps His word.

B. Prayer Must Be Definite

The daughter had a specific need—she was demonized—and her mother requested help for this particular problem. Similarly we should be definite when we ask God for help, which may mean specifying our needs or sometimes asking God to show us our needs when we are uncertain what they really are.

C. Prayer Must Be Determined

The Lord warned against vain repetition in prayer (see Matt. 6:7), but He encouraged persistence (see Luke 11:5–10; 18:1–8). Three times this mother beseeched the Lord. The first was evidently outdoors while He was on the way to the house where He was staying (see Matt. 15:22). The second and third times were in her house (see Matt. 15:25,27; Mark's account apparently began when they reached the house, that is, at Matt. 15:25). It is interesting to notice that after the first definite request, she did not repeat the specifics again. That illustrates the difference between proper persistence and improper vain repetition. Also the mother's three supplications followed the pattern of asking, seeking, and knocking (see Luke 11:9). The first time she asked; then inside the house she sought the Lord and worshiped Him; finally she knocked as she persisted for a third time. Then her petition was granted.

D. Prayer Must Be Dispensational

The mother's second appeal was answered by these strange words: it is not right to take the children's bread and cast it to dogs. Christ was not being offensive; He was simply stating the truth that He was not sent except to the lost sheep of the house of Israel, and she did not qualify for His attention. Being a Gentile, she had no guaranteed basis on which to approach the Lord at that point in His ministry. No covenant relationship existed between God and the Canaanites as it did between God and the Israelites. Today such a relationship exists that assures us that God hears the prayers of all believers regardless of

racial or cultural background. "Until now you have asked nothing in My name. Ask, and you will receive, that your joy may be full" (John 16:24). No prayer in Old Testament times, even those magnificent ones of David, Solomon, Daniel, and Nehemiah, was offered on the basis of the name of Christ, but today no prayer should be offered by any saint on any basis other than the name of Christ.

II. Principles Related to God's Answering

A. He May Be Silent

To the Syro-Phoenician woman's first appeal, the Lord "answered her not a word" (Matt. 15:23). Often it is the same when we pray. Heaven seems to be shut, and God is silent. But even though the mother was not answered, she was heard. Silence on God's part does not mean deafness to our requests.

B. He Will Sustain

Neither does silence mean denial, for by His silence the Lord did not mean to repel the woman; rather He meant to instruct her. Thus, to her second request He said, "Let the children be filled first, for it is not good to take the children's bread and throw it to the little dogs" (Mark 7:27). Even in this reply there were several things to sustain the faith of the mother. For one thing, the Lord said that the children had to be filled first. This statement implied that others would be filled later. For another thing, the Lord used the diminutive word for dogs, "little dogs," which is generally used for household pets. In other words, He was not especially comparing her as a Gentile to the dogs of the street, but to the pets in the family who were fed from the table, though not fed the children's portion. The term "dogs," which on Jewish lips was usually one of reproach, actually offered hope to this woman. She grasped at the privilege of household dogs to expect crumbs from the table.

C. He Always Supplies

Finally, the woman's request was granted. Her faith was not presumptuous, for she took her place as a Gentile without any covenant relation to God, but her faith was persistent and properly placed in the One who could heal her daughter. God has promised to supply our needs (see Phil. 4:19), but not necessarily our wants. Sometimes our prayers are unanswered or the answers are delayed (from our viewpoint) because of sin or misdirection or wrong timing. But God always hears and always answers according to His will, which is best. Our responsibility, of course, is to make our requests known to Him.

Healing a Deaf Man
Early fourteenth century; mosaic; Kariye Church, Istanbul, Turkey (Magnum)

 Kariye Church's exquisite mosaics are in a perfect state of preservation. In two vast cycles they illustrate the lives of Mary and of Christ. In this mosaic Christ and two disciples attend to the needs of a deaf man who points to his ear, indicating his physical ailment. A motif of early Christian art is represented by the scroll in Christ's hand which symbolizes His wisdom and His identity as the living Word. (See also page 53.)

THE PLIGHT OF ALL PEOPLE

Healing a Deaf Man

And again, departing from the region of Tyre and Sidon, He came through the midst of the region of Decapolis to the Sea of Galilee. Then they brought to Him one who was deaf and had an impediment in his speech, and they begged Him to put His hand on him. And He took him aside from the multitude, and put His fingers in his ears, and He spat and touched his tongue. Then, looking up to heaven, He sighed, and said to him, "Ephphatha," that is, "Be opened." Immediately his ears were opened, and the impediment of his tongue was loosed, and he spoke plainly. Then He commanded them that they should tell no one; but the more He commanded them, the more widely they proclaimed it. And they were astonished beyond measure, saying, "He has done all things well. He makes both the deaf to hear and the mute to speak" *(Mark 7:31–37).*

This miracle, recorded only by Mark, occurred as Christ returned from Tyre and Sidon where He had granted the request of the Syro-Phoenician woman by healing her daughter. It was a long, circuitous route that He traveled from the Mediterranean to Decapolis. Decapolis, lying south and east of Galilee, began on the west side of the Jordan and stretched across that river to the east, encompassing the territory of Manasseh (see Num. 32:33–42). As the name *Decapolis* indicates, originally the area contained ten cities, most of them having been built by followers of Alexander the Great and rebuilt by the Romans. Near the beginning of His ministry, it was to Decapolis that Jesus went after He had cast demons out of two men and into a herd of swine in Gadara (see Mark 5:20), and multitudes from Decapolis followed the Lord (see Matt. 4:25).

I. The Plight of Mankind — Deafness: Mark 7:31–52

The deafness of the man brought to Jesus pictures the spiritual condition of all humankind (see Acts 28:27). How? Because, as illustrated in this case, the deafness had serious ramifications in three areas.

119

A. Isolation

Unlike the blind person who, although also isolated, could be communicated with, it was nearly impossible to communicate with a deaf person. Oral communication was impossible; written communication was slow and laborious; sign language was crude and inadequate. So a deaf person remained isolated from much in life in those times of no mass media and no science of lip reading or sign language.

Similarly, the unsaved person is deaf to God's Word, though he has the ability to see God's revelation in nature (see Ps. 19:1-6). But God's Word is to him foolishness (see 1 Cor. 2:14).

B. Ignorance

Since he lived in a day before mass media communication including books, this deaf man must have known very little about most areas of life. He would have known only what he could learn through sight. No television, no newspaper, no magazines, no encyclopedias, which today feed our minds, were available to him to read and thus to compensate for what he could not hear. He lived in intellectual darkness (see Eph. 4:18).

C. Inability

In addition to being deaf, the man also had difficulty in speaking. Apparently, he could speak only in a stammering and unintelligible voice. Though not totally mute, he was practically so, for only when he was healed was he able to use his organs of speech properly (v. 35). Similarly, the unsaved man cannot communicate with God. He makes sounds about religious interests, but that is all.

II. *The Power of the Master—Deliverance: Mark 7:33–37*

A. The Method of Deliverance — Contrary (v. 33)

Though the man's friends had specified the method they wanted the Lord to use (to lay His hands on him), Jesus did not tie Himself to their wishes or to any one method. First, He separated the man from the crowd so as not to cater to their persistent desire to see a sign. Then He put His fingers into the man's ears and placed His own saliva on his tongue. Christ probably used this different method in order (1) to show clearly that the power to heal proceeded from His Person, and (2) to encourage the man who could not hear anything that Christ might have spoken or prayed.

The lesson is clear: a method, however successful, may be inappropriate in

some instances. We must deal with people as individuals, meeting their needs with a variety of methods.

B. The Motivation of Deliverance — Compassion (v. 34)

Our Lord gave a deep sigh. Luther is reported to have said, "This sigh was not drawn from Christ on account of the single tongue and ear of this poor man, but is a common sigh over all tongues and ears, yea over all hearts, bodies, and souls, and over all men from Adam to his last descendant." The next chapter records another occasion when Christ sighed over the people's desire to have a sign (Mark 8:12 where the verb is intensified). Sin causes believers to sigh today also, for we groan while waiting for the redemption of our bodies (see Rom. 8:23). Life in our present bodies produces groans (see 2 Cor. 5:2,4). Disobedient church members cause their leaders to groan (see Heb. 13:17), and sin sometimes causes brothers to murmur or groan against each other (see James 5:9). Sin and sighing go hand in hand!

As He groaned, the Lord looked up into heaven. Though the deaf man could not hear the sigh, he could see the Lord looking up—a sight that must have encouraged his faith. Then, in Aramaic, the Lord said, "Be opened."

C. The Manner of Deliverance — Complete (vv. 35–37)

The cure was complete, for the man spoke in a right manner and his hearing was restored. But the Lord commanded that no one be told. Publicity would only impede His mission at that point. But the more He insisted, the more the crowd spread the news. They acknowledged that Christ did all things well, an echo of Genesis chapter 1, and that He was fulfilling the prophecy of Isaiah 53:5–6. In other words, knowingly or unknowingly, the crowd was acknowledging that Jesus of Nazareth was the Creator-Messiah.

Today He is still doing all things well even in this scene of sin (see Rom. 8:28). And one day He will reign over the earth and bring righteousness, healing, peace, and prosperity.

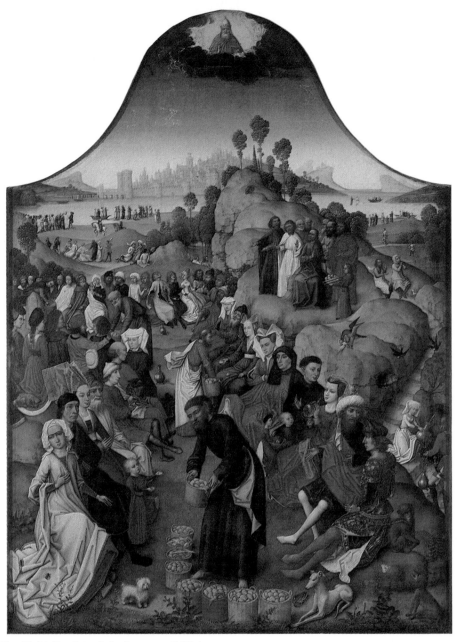

The Multiplication of the Loaves and Fishes
Flemish triptych depicting the miracles of Christ, center panel, ca. 1500; total height 44⁹⁄₁₀″ x
32⁷⁄₁₀″; oil on panel; Felton Bequest 1922, National Gallery of Victoria, Melbourne, Australia

The center panel of this famous triptych depicts the miracle of the multiplication of the loaves and fishes as
it is described in all four Gospels. Details peculiar to John's account in 6:3–9 and in Mark 6:43 and Matthew
14:21 are shown in the picture. In the distance, Christ sits on the mountain with seven of His disciples
surrounding Him and a young lad with loaves and fishes looking on. In the foreground a disciple collects the
baskets of leftover bread and fish. In the background on the left, Christ is depicted healing the sick, and on
the right He is seen dismissing the multitude. Further to the right, the disciples are apparently entering the
boat on the Sea of Galilee, and further back Christ and Peter are seen walking on the water. In the back-
ground is either Capernaum (John 6:17) or Bethsaida (Luke 9:10).

FEASTING ON THE BREAD OF LIFE

Feeding Four Thousand Men

In those days, the multitude being very great and having nothing to eat, Jesus called His disciples to Him and said to them, "I have compassion on the multitude, because they have now been with Me three days and have nothing to eat. And if I send them away hungry to their own houses, they will faint on the way; for some of them have come from afar." Then His disciples answered Him, "How can one satisfy these people with bread here in the wilderness?" He asked them, "How many loaves do you have?" And they said, "Seven." And He commanded the multitude to sit down on the ground. And He took the seven loaves and gave thanks, broke them and gave them to His disciples to set before them; and they set them before the multitude. And they had a few small fish; and having blessed them, He said to set them also before them. So they ate and were filled, and they took up seven large baskets of leftover fragments. Now those who had eaten were about four thousand. And He sent them away. And immediately He got into the boat with His disciples and came to the region of Dalmanutha *(Mark 8:1–10; see also Matt. 15:32–39).*

Some commentators have said that the miracle of feeding four thousand men is merely an echo of the earlier miracle of feeding five thousand men. However, significant differences exist between the accounts that make this impossible. Rather, these are two distinct miracles of similar nature.

1. The locations are different. The five thousand were fed in an area northeast of the Lake of Galilee in the district of Bethsaida. The four thousand were also fed on the eastern shore of the lake but further south in the area of Decapolis.

2. The circumstances surrounding the two events differ. The feeding of the five thousand followed the death of John the Baptist; the four thousand were fed after the Lord returned from Tyre and Sidon where He had healed the Syro-Phoenician's daughter. The five thousand were with Him only one day; the four thousand, three days. Twelve baskets of fragments remained after feeding the five thousand, while only seven were left after the four thousand were satisfied. These are specific and clear differences that indicate two separate events.

123

3. For the believer, the clinching argument is found in the Lord's own words. Both Matthew (16:9–10) and Mark (8:19–21) recorded that the Lord distinguished the two events, both the different number fed and the different number of baskets of leftovers.

Of course there are striking similarities between the two miracles. Both took place in desolate places. Both involved a large number of people. In both instances the disciples were also present. The available food in both cases was completely inadequate to feed the crowds. Both times the Lord multiplied the little food that was available so that everyone in those large crowds ate and was filled. Not only was that so, but there was food left over that was gathered up after everyone was satisfied.

The principal teaching of both miracles, however, is quite plain: Christ is the Bread of Life on which His people feast.

I. The Source of the Bread

A. Not Through Good Men

Good men as they were, the disciples could not supply the needs of the crowd that had been with the Lord for three days. The source of the Living Bread is Christ who came down from heaven (see John 6:33–35). No human can provide that Bread. Man can and must dispense it, but he cannot supply it.

But the disciples could and did offer the Lord what little was available. When the five thousand were fed, the Lord had to tell the disciples to search the crowd to see how much food there was among all those people (Mark 6:38). On this occassion, however, when the Lord asked the disciples how many loaves there might be among the people, the disciples were prepared with the answer. They had already discovered what food there was before the Lord questioned them. As the days wore on without anything to eat, they realized something would have to be done. Does the fact that they on their own set about to discover what food was available suggest that they had some faith, however weak, that the Lord would miraculously feed the people as he had done before?

B. But Through the Son of Man

It was our Lord's compassion for the multitude that evoked this miracle. Three days they had been together without anything to eat, and the Lord did not want to send them away "lest they faint on the way." The verb "to have compassion" literally means to have one's heart contracted convulsively at the

sight of crying human need. The Gospels record the Lord's compassion on the widow at Nain mourning the loss of her only son (Luke 7:13), on blind Bartimaeus and his friend (Matthew 20:34), and on the multitudes on several occasions (Matthew 9:36, because they were weary; Mark 6:34, because they were without a shepherd to care for them; Matthew 14:14, because of sicknesses; and on this occasion because the 4,000 had nothing to eat). Physical needs and afflictions moved the heart of the Savior, and moved Him to do something about them. Only after the people had been fed did the Lord send them away.

As a man, our Lord knew the needs of human beings. As God, He can supply those needs. God does not grow hungry, but the Son of man did, and so He understood the needs of the hungry crowd. Man cannot miraculously feed more than four thousand people, but God can. And so only one who is both God and man could know and do what was needed in this instance.

This distinction illustrates why the only completely satisfactory priest must be a God-and-man priest, as our Lord is. To be sympathetic, He must have become incarnate to experience (apart from sin) what humankind experiences. But to be able to meet the needs concerning which He sympathizes, He must also be God. And Jesus Christ is both God and man, a sympathetic and sufficient High Priest.

II. The Supply of the Bread

A. It was Supplied Freely

Neither the disciples nor the crowd could afford to buy the bread needed to satisfy their needs. But the Lord supplied it freely, though He used what they offered Him, infinitesimal as it was in relation to the huge crowd. This is often His way. He uses what we offer to Him, multiplies it to meet the need, and employs our hands in administering those gifts.

B. It was Supplied Fully

More than four thousand stomachs attested to the fact that the supply was a full one.

We should not miss how well this illustrates God's provision of eternal salvation. Human beings cannot provide it; but the God incarnate can and did. He became Man in order to die, and because He was also God He could guarantee that His death would be a complete payment for sin. His salvation is free and full. All we can do is to receive it and be thankful for it.

III. The Sufficiency of the Bread

A. The Extent of It

Most of the five thousand were Jewish. This crowd of four thousand was a mixture of Jews and Gentiles — probably mostly Gentiles. Nine of the ten cities that comprised the area of Decapolis were east of the Jordan. This was a Gentile world with its temples, amphitheaters, art, games, literature, and even swine raising! Most of these Gentiles were separated from their Jewish neighbors only by the Lake of Galilee and the Jordan River. Further confirmation that this group was largely Gentile is found in Matthew's statement that when these people saw the miracles Christ performed in those three days they were together "they glorified the God of Israel" (15:31).

The Bread of Life was offered to all, to the Jew first (in the feeding of the five thousand) and also to the Gentile (in the feeding of four thousand).

B. The Excess of It

No crowd can strain the limits of His provision. All were satisfied abundantly, and seven large baskets of fragments remained. Matthew added the fact that the number four thousand did not include the women and children present.

This miracle exhorts us to remember that our Lord is sufficient for each need that arises.

It appears that the disciples did not think that the Lord's miraculous feeding of five thousand would be repeated. Otherwise, why would they have asked Him where they could get food enough to feed the four thousand? They had been present and had participated in the previous miracle. On their own they had already discovered what food was available. Why did they question Christ as if He would not do the same thing again? Their apparent lack of faith seems hard to explain. Or does it? Do we not do the same thing? The Lord does something special for us in meeting a particular need or desire. We are filled with gratitude, realizing full well that only He could have arranged the answer to our need. Then another need arises. With the new emergency comes the same question: what shall I do? Faith shrinks. The obstacle grows. The memory lapses. We wonder how this new need will ever be met. We forget that all our Lord has done for us in the past is an indication of His *continuing* love and care of us. We all tend to forget God's past provisions when faced with a new challenge to our faith. The Christ who can feed five thousand can surely feed four thousand. The Christ who can save us can surely care for us (see Rom.

8:32). The Friend who sustained us yesterday will surely do the same tomorrow. The Bread of Life will never be in short supply. Nor will it ever be stale. With each new challenge He will be there to give us all we need. His grace is sufficient and always so.

IV. A Different Way of Looking at this Miracle

This miracle may also be viewed as a study in contrasts.

A. Contrasting Attitudes

1. Christ's attitude was one of compassion for the people and their needs.
2. The disciples' attitude was one of concern for circumstances and limitations.

B. Contrasting Abilities

1. Christ lacked nothing.
2. The disciples lacked faith.
3. The crowd lacked sustenance.

C. Contrasting Actions

1. The Master supplied the bread.
2. The men served the bread.
3. The multitude was satisfied by the bread.

However one looks at this miracle, one sees the Lord, all-sufficient and filled with compassion for the needs of people. People may disappoint us, but God never will.

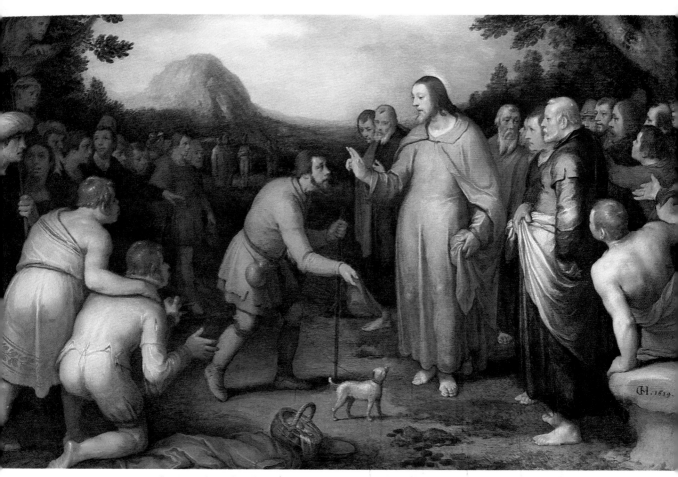

Christ Healing the Blind Man
Cornelius van Haarlem, 1619; oil; original in the Bob Jones University Gallery of Sacred Art, Greenville, South Carolina

The Dutch painter Cornelius van Haarlem (1562–1638) is noted for the founding of the Haarlem academy, along with two other Dutch artists — Henerik Goltzius and Karel van Mander. Students of this school were characterized by a preference for classical subjects. Christ and the blind man dominate the center of the painting. They are surrounded by a large crowd; some individuals watch with expectant interest while others appear skeptical of what they are about to see. On the right, one man stares out of the painting toward the viewers and beckons them to observe the wondrous event.

GROWING IN GRACE

Opening a Blind Man's Eyes at Bethsaida

Then He came to Bethsaida; and they brought a blind man to Him, and begged Him to touch him. So He took the blind man by the hand and led him out of the town. And when He had spit on his eyes and put His hands on him, He asked him if he saw anything. And he looked up and said, "I see men like trees, walking." Then He put His hands on his eyes again and made him look up. And he was restored and saw everyone clearly. And He sent him away to his house, saying, "Neither go into the town, nor tell anyone in the town" *(Mark 8:22–26).*

As we noted earlier, two Bethsaidas existed in the time of Christ. One was the home of Philip, Andrew, and Peter, situated on the northwest corner of the Lake of Galilee near Capernaum (see Mark 6:45). The other was on the east bank of the upper Jordan about a mile north of the Lake of Galilee. Near here the Lord fed the five thousand and performed this miracle of opening the eyes of a blind man.

Only Mark recorded this miracle. Immediately, one notices many similarities between it and the earlier miracle of restoring the hearing and speech of another man (see Mark 7:31–37). In both cases the men were brought to the Lord by friends. In both miracles the Lord led the person away—in the first, from the crowd, and in the second from the town. In both cases He touched the affected part with spittle and put His fingers into the ears of the deaf man and His hands on the eyes of the blind man. In the first instance the man was completely restored at once; here, the healing took place in two stages.

That unusual feature of this miracle—the two stages involved in the healing—provides a clue to the spiritual lesson it teaches. Conversion is not a growth process. One is either converted or unconverted. But our comprehension of what the Lord does and our growth in appreciation of all that it means to be converted are developing things. This growth in understanding and assurance is illustrated in the Lord's unusual procedure in opening the blind man's eyes.

I. The Giver of Grace: Mark 8:22

Our Lord healed a number of people of blindness during His earthly ministry. Matthew recorded several healings of the blind: two particular blind men (see 9:27–31); Jesus' mention of blind people being healed when He was comforting John the Baptist's disciples (see 11:5); the healing of blind people that provoked the unpardonable sin (see 12:22); additional unspecified numbers of blind (see 15:30); and blind people in the Temple on Palm Sunday (see 21:14). Mark recorded this miracle and the healing of the two at Jericho (one being Bartimaeus, see 10:46–52, also recorded by Matthew and Luke, though they didn't mention Bartimaeus by name). John recorded the healing of the man who was born blind (see 9:1–41).

That our Lord Himself is the giver of grace is clearly illustrated in this healing. Though others, perhaps relatives, friends, or neighbors (the "they" of v. 22), brought the blind man to the Lord, only the Lord, not they, could give the man what he needed and wanted. Friends can help, but friends cannot save.

II. The Ground of Receiving Grace: Mark 8:22–23

At best, the man exhibited little faith. But it is not the quantity or even the quality of faith that matters; it is the object of faith. Notice how weak his faith was.

For one thing, the man had to be brought to Jesus. Likely this involved more than just being helped along physically because of his blindness. His friends likely had to overcome his reluctance to seek a cure from the Lord.

For another thing, the Lord gently took him by the hand and led him away from the village not only to avoid the crowd that would have gathered but also to encourage and reassure the man by dealing with him in a personal and intimate way. Though Bethsaida was at that time larger than a village, its development had occurred recently, so the old designation "village" was still used popularly.

III. The Growth in Grace: Mark 8:23–25

As in the case of the stammering deaf man (see Mark 7:33), the Lord put spittle on His hands to demonstrate unmistakably that the power to heal came from His own Person. Then He asked if the man could see anything. Excitedly, the man replied that he saw the men (the definite article is present and likely

refers to the disciples whom he saw). He knew that they must be men because they appeared like walking trees. His sight was not yet fully restored. Since the people looked to him like trees, they were obviously still indistinct.

The Lord placed His hands on the man again, and his sight was completely restored. The word *clearly* is a compound of *afar* and *radiance*, indicating that the man now saw sharply even things at a distance.

Conversion is instantaneous, but our comprehension of it and the assurance that flows from fuller knowledge increase. Our Lord applies His touch again so that we may see clearly the riches of His grace.

Verse 25 says that the man "saw everyone clearly." The imperfect tense indicates that he continued to see without relapsing into blindness again. Once we were blind, but now we see, and we continue to see more and more clearly. This sight comes from the grace of God and our growth in that grace (see 2 Pet. 3:18).

Finally, the Lord commanded the man to go directly home and not back into Bethsaida. Apparently he did, for there is no indication that the news of his healing was widely known.

As with all things in the Christian's life, our call is to do what the Lord instructs, not to second-guess His motives for issuing His orders.

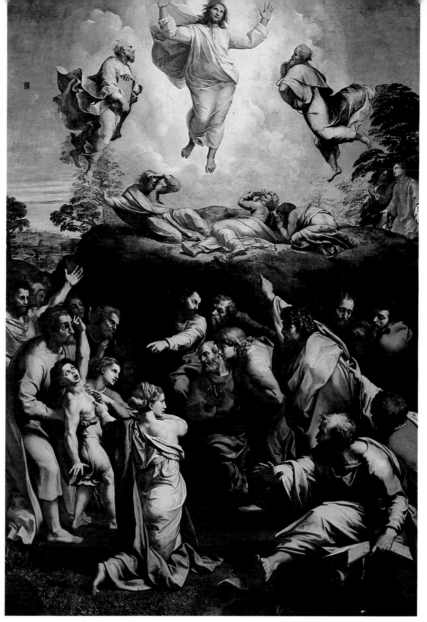

Transfiguration and the Episode of the Epileptic Boy
Raphael, ca. 1520; altarpiece painting; Vatican (after restoration), Rome, Italy (Scala/Art Resource, Inc.)

Raphael (1483–1520) was commissioned to paint this altarpiece for Giulio de' Medici, but he died before fully completing it. Two different scenes are shown here as Raphael links the Transfiguration with one of Christ's miracles, but he masterfully blends them into a coherent whole. In the upper section of the painting the transfigured Christ hovers in the air between Moses and Elijah while three of His disciples shrink back on the ground, overpowered by His divinity. In the lower section appears the scene Christ found when He descended the mountain. His disciples have attempted but failed to heal an epileptic boy; thus Christ is called upon to heal him. Raphael conveys the antithesis of the two sections—the doubting disciples below and the supernatural confidence of the transfigured Christ above.

THE POWER OF CHRIST

Curing an Epileptic Boy

And when He came to the disciples, He saw a great multitude around them, and scribes disputing with them. Immediately, when they saw Him, all the people were greatly amazed, and running to Him, greeted Him. And He asked the scribes, "What are you discussing with them?" Then one from the multitude answered and said, "Teacher, I brought You my son, who has a mute spirit. And whenever he seizes him, he throws him down; he foams at the mouth, gnashes his teeth, and becomes rigid. So I spoke to your disciples, that they should cast him out, but they could not." He answered him and said, "O faithless generation, how long shall I be with you? How long shall I bear with you? Bring him to Me." Then they brought him to Him. And when he saw Him, immediately the spirit convulsed him, and he fell on the ground and wallowed, foaming at the mouth. So He asked his father, "How long has this been happening to him?" And he said, "From childhood. And often he has thrown him both into the fire and into the water to destroy him. But if You can do anything, have compassion on us and help us." Jesus said to him, "If you can believe, all things are possible to him who believes." Immediately the father of the child cried out and said with tears, "Lord, I believe; help my unbelief!" When Jesus saw that the people came running together, He rebuked the unclean spirit, saying to him, "You deaf and dumb spirit, I command you, come out of him, and enter him no more!" Then the spirit cried out, convulsed him greatly, and came out of him. And he became as one dead, so that many said, "He is dead." But Jesus took him by the hand and lifted him up, and he arose. And when He had come into the house, His disciples asked Him privately, "Why could we not cast him out?" So He said to them, "This kind can come out by nothing but prayer and fasting" *(Mark 9:14–29; see also Matt. 17:14–21; Luke 9:37–43).*

The foot of the Mount of Transfiguration furnished the stage for this miracle. That means it most likely occurred at the base of Mount Hermon, about forty miles northeast of the Lake of Galilee. After spending the night with the Lord on the mountain, Peter, James, and John descended with Him only to be greeted with hostility and inability. Surveying the crowd, we can see the reactions of three different groups of people to the power of the Lord.

I. The Persistent Fanatics: Mark 9:14–16

The Lord's absence while on the mount gave His enemies an added opportunity to try to discredit Him by discrediting His disciples in front of the peo-

ple. The scribes (probably from a local synagogue) seized the opportunity to engage the nine disciples who had not ascended the Mount of Transfiguration in an argument. And the disciples were losing, for their inability to help the epileptic boy was all too evident.

When the Lord appeared, He asked what was the trouble. Some texts say He asked the scribes; others indicate He asked the crowd. However, the answer came from someone in the crowd (v. 17), and from this point on the Lord apparently ignored the scribes and dealt with the boy's problem. This furnishes a good example for us when we are faced with similar situations. Minister to people. Proclaim the truth to people. By-pass the leaders, if necessary, to reach people. Do not concentrate on winning an argument at the risk of losing the people. Fanatics are always with us. Do not focus on them, but on the people they seek to sway.

II. A Perplexed Father: Mark 9:17-27

A. The Cause of His Perplexity

The father had a serious problem: his boy was demon-possessed. The boy had been this way since childhood (see v. 21), and his seizures were extremely severe. Frequently (see vv. 18,20), he fell to the ground, foamed at the mouth, ground his teeth, and stiffened. It was a life-or-death struggle, for the demon actually tried to kill the boy. Though his affliction was epilepsy (see Matt. 17:15), he also suffered from demon possession. Luke added that the boy was an only son (see 9:38), which must have brought added grief to his father.

B. The Cure for His Perplexity

After hearing the problem from the father, the Lord addressed the crowd and diagnosed the root cause as unbelief. He commanded that they bring the boy to Him. The verb is plural, indicating that the boy was not then with his father, but had apparently been taken by others for safekeeping not far away. They brought him to the Lord, and the demon, now in the presence of the powerful Christ, tried again to destroy the boy. In desperation the father cried for help.

In verse 23 the Lord picked up on the father's plea "if You can" (see v. 22) to reveal the root problem—lack of faith. To say "if You can" is to reveal weak faith. Of course He can. He is the all-powerful Christ. But the father was not sure of this fact, and so he said, "if You can." But when the Lord threw those words back at him, He was clearly asserting, "Of course I can."

Immediately, the father grasped the point and cried out that he did believe, but he still needed help to believe. He did have faith but realized he needed a

stronger faith. He, as well as his son, needed help. A growing faith recognizes its deficiencies and weaknesses.

How can faith be strengthened? By looking at the faithful One, the powerful Christ. The power is not in our faith, but in Him. Our faith is the channel that brings that power to bear on the problem at hand.

Christ rebuked the demon who made one last fierce effort to destroy the boy. The crowd thought the boy was dead after a convulsion that left him looking as if he were dead. But taking him by the hand, the Lord raised him up, and Matthew indicates the cure was total and immediate (see 17:18). Luke adds that they were all astonished at the majesty of God (see 9:43). Seeing God for who He is increases faith. When faith is weak, look to the Lord, not to self.

III. The Powerless Disciples: Mark 9:28–29

When the disciples and the Lord went into a house, the disciples acknowledged their failure and asked why it had happened. After all, they had cast out demons before (see Mark 6:13); this situation was not one they had never encountered. The Lord gave them two reasons: (1) their unbelief, or "little faith" (see Matt. 17:20), and (2) their lack of prayer (see Mark 9:29). (Matthew 17:21 and the phrase "and fasting" in Mark 9:29 are not found in some manuscripts.) Why had their faith diminished? Because the disciples had allowed some unbelief to affect their own relationships with the Lord. What unbelief? Unbelief about Christ's impending death. He had plainly told them that He would be killed and then raised from the dead (see Matt. 16:21–23; Mark 8:31–33; Luke 9:22), and they did not believe Him. In fact, Peter rebuked the Lord for even saying such a thing, and the Lord reacted in the strongest way by asserting that Peter was acting as Satan's agent. Evidently, the other disciples agreed with Peter, and that was how unbelief had clouded their relationships with the Lord.

The Lord also said they should have prayed, for they were dealing with an especially powerful demon, and there are differences among demons (see Matt. 12:45). Apparently the one that afflicted the boy was particularly difficult to cast out, and no formula of exorcism could accomplish it. But the disciples' previous success had dulled their sense of dependence on the Lord's power. Here is a lesson for all Christian leaders. Experience can teach, but it cannot empower. Faith and fervent prayer keep us in touch with Him who is our Source of power.

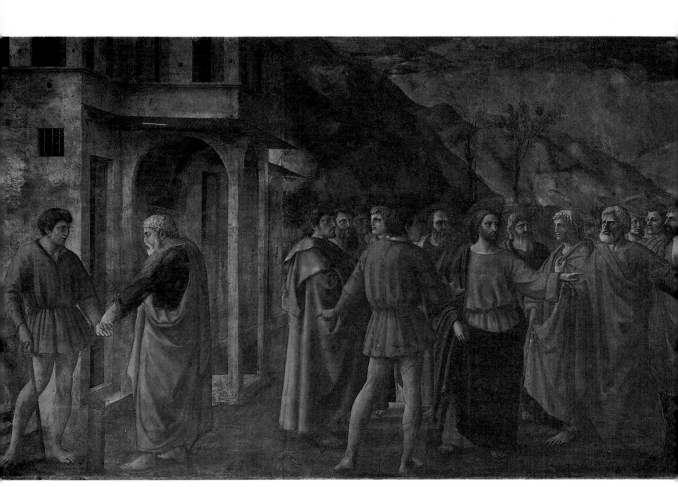

The Tribute Money
Masaccio, ca. 1427; fresco; Brancacci Chapel, Saint Maria del Carmine, Florence, Italy (Scala/Art Resources, Inc.)

Born in 1401, Masaccio died at the early age of twenty-seven. Yet in his few short years this young genius became a principal figure in early Renaissance painting, and the Brancacci Chapel was his crowning achievement. In this fresco Masaccio uses the age-old method known as "continuous narration" as he illustrates the major scenes of the miracle. In the fresco's center Christ instructs Peter to catch a fish which, He says, will have in its mouth the money needed for the tax collector. Note the skillful way in which Masaccio has painted the figures' clothing; their rich folds and textures almost appear to be real fabric. It is said that the apostle with full locks, a resolute countenance, and a pointed beard is actually a self-portrait of the artist.

TO PAY OR NOT TO PAY, THAT IS THE QUESTION

The Coin in the Fish's Mouth

And when they had come to Capernaum, those who received the temple tax came to Peter and said, "Does your Teacher not pay the temple tax?" He said, "Yes." And when he had come into the house, Jesus anticipated him, saying, "What do you think, Simon? From whom do the kings of the earth take customs or taxes, from their own sons or from strangers?" Peter said to Him, "From strangers." Jesus said to him, "Then the sons are free. Nevertheless, lest we offend them, go to the sea, cast in a hook, and take the fish that comes up first. And when you have opened its mouth, you will find a piece of money; take that and give it to them for Me and you" (Matt. 17:24–27).

Nothing is certain but death and taxes. Our Lord experienced both. A question about the poll tax payable to Caesar furnished the occasion for His oft-quoted saying, "Render therefore to Caesar the things that are Caesar's, and to God the things that are God's" (Matt. 22:21). A question about a temple tax became the basis for a significant dialogue with Peter and an unusual miracle involving a fish.

I. The Levy

From Transfiguration to taxes! That's the Lord's story in Matthew 17, and it is often our experience as well. From some mountaintop experience we are rudely awakened to the realities of life by some taxing circumstance! On the Mount of Transfiguration Christ had shown His glory to Peter, James, and John, the inner circle of the disciples. From there He was making His way to Jerusalem for the Feast of Tabernacles. This festival derived its name from the fact that during the week-long observance in the fall of the year the Israelites lived in booths or tabernacles (see Lev. 23:33–44). On the way to Capernaum the Lord reiterated the prediction of His death and resurrection (see Matt. 17:22–23), and when He arrived there, the tax collectors appeared.

They first approached Peter, who was apparently the recognized spokesman

for the group. Would his Master pay the "tribute"? This two drachma tax was not a civil tax levied by the government, but a religious one. It was based on a regulation in Exodus 30:11–16 that required every Israelite over twenty years of age to pay a half shekel (equal to two drachmas) as a ransom for his soul. At twenty an Israelite was considered to be fully grown. He was then liable for military service (see Num. 1:3; 2 Chr. 25:5), and if a Levite, he then began his service (see 1 Chr. 23:24–27; 2 Chr. 31:17; Ezra 3:8). Originally, the silver collected was used for making the sockets that supported the boards of the tabernacle and those of the pillars for the veil, the hooks for the pillars of the court, their capitals, and connecting rods (see Ex. 36:20–25; 38:25–31). The ransom money, then, was always in sight as long as the tabernacle stood.

When the Jewish people returned from exile in Babylon, a voluntary tax of one-third shekel was adopted in the time of Nehemiah (see Neh. 10:32–33), but before the time of Jesus it was increased to a half shekel. Every Jewish male over twenty was liable for this amount annually, even those who lived outside Palestine, and the money was used for the upkeep of the temple. When the temple was destroyed in A.D. 70, Rome required the tax still to be paid and used for the rebuilding of Jupiter Capitolinus in Rome as a punishment on the Jews for their rebellion.

Passover, in the spring, was the due date for the tax. But apparently it could be paid at Pentecost, not quite two months later, or as late as the Feast of Tabernacles in the fall. Since the Lord had not paid the tax that previous Passover, the tax collectors were anxious to have Him pay. Would He? After all, He had rather different views about Jewish observances. He had made rather extraordinary claims. Why had He not paid earlier? Would He pay now?

II. The Lord

To the tax collectors' question, Peter replied without hesitation that, of course, his Master would pay. Perhaps he was so sure because Jesus had paid other years. But then Peter seemed to have second thoughts, realizing that he should have consulted the Lord first. Perhaps some of the implications of his recent confession of Jesus as the Christ, the Son of the living God fleeted through his mind (see Matt. 16:16). Was such a One really obligated to pay the tax? He decided to go into the house where the Lord was and ask Him.

A. The Lord Knows All

When Peter entered the house, the Lord, anticipating what he was going to

ask, engaged him in a dialogue. The Lord knew Peter's thoughts, and the Lord knew the conversation that had taken place between Peter and the tax collectors outside. He knows all things, but He used that omniscience to help Peter, not to condemn him.

Often people hang a plaque in their homes, one line of which says, "He is the silent listener to every conversation." And indeed He is. This fact is both convicting and comforting. It is convicting when we remember that He hears every idle or useless word—words that we will have to account for (see Matt. 12:36)—and comforting when we are assured that He hears the words we speak to encourage and help others (see Mal. 3:16).

B. The Lord Owns All

The dialogue that followed taught Peter another truth about the Lord. Christ asked, "Do kings take tribute from their family or from strangers?" Of course, the correct answer is, from strangers. Whom does a king tax for the maintenance of his palace and retinue? Surely not his own family, but outsiders. Whose temple is it for which this tax was used? God's temple. Jesus is God's Son. He and the Father are one (see John 10:30); thus He is God and the owner of the temple. It is His temple (see Mal. 3:1). The owner does not pay tax to himself!

C. The Lord Controls All

Yet He would pay the tax for Himself and Peter and in a manner that would teach Peter that He controls all. He could have created the money on the spot, but He chose to demonstrate His control over details by having Peter catch a fish that would have the exact amount of money in its mouth!

How many fish were swimming about in the Lake of Galilee that day? I have no idea. There were 22 species of fish in the lake. A catch of 153 fish is recorded in John 21:11. But there must have been hundreds of thousands of fish in the lake. Of those, how many might have a coin in their mouths? This occurrence would not be impossible at all, but not too many would have a coin in their mouths. Of those, how many would have a stater (equal to four drachmas) in their mouths? Not a one drachma coin or a denarius or a mite or a farthing, but a stater? And of that small number—perhaps only one or two fish in the entire lake—what are the chances that one such fish would be swimming near Capernaum? And what are the chances that that fish would take Peter's hook first? Such minute and infinite control!

In other miracles we have seen Jesus' control of storms, sickness, death,

disease, and demons. Nothing is outside His control. Our needs, circumstances, and times are in His hands. He does cause all things to work together for good to those who love Him (see Rom. 8:28).

III. The Lessons

Important lessons were part of Peter's curriculum that day. He had learned that Jesus knew all, owned all, and controlled all. Jesus was and is God. But Peter was also to learn two other lessons.

A. He Serves All

Christ paid the tax so that He would not offend. This same verb is used in Romans 14:21 and 1 Corinthians 8:13, two important passages about the Christian's service and relationship to fellow believers. Our Lord had every right not to pay, but He gladly surrendered His rights in order to serve better. In this same spirit His followers are to serve too. While we may have the right to eat meat offered to idols or to drink wine, if doing these things causes another Christian to be hindered in his or her spiritual walk, then we should gladly give up those rights. Paul said, "For you, brethren, have been called to liberty; only do not use liberty as an opportunity for the flesh, but through love serve one another" (Gal. 5:13).

Practicing this truth involves getting and keeping priorities straight. The success of our Lord's mission did not depend, at that point, on proving to all that He was the Son of God by refusing to pay the tax (even though He wanted Peter to understand this). Jesus did not hesitate to cleanse the temple or to predict its destruction, but proper priorities at that juncture dictated conforming to a temple law not even commanded in the Torah. He knew what to insist on and what not to insist on. He knew when to forego His rights for the sake of His ministry.

B. He Ransomed All

The original half-shekel tax was paid by every man as "a ransom for himself to the LORD" (Ex. 30:12). Our Lord told Peter to pay "for Me and you." Every person must pay a ransom for himself because of sin, but Jesus did not need to be ransomed any more than He needed to pay the tax. He did pay, but for the sake of His service, not any sin.

The required ransom was paid by substitution. The temple tax was paid with money that substituted for the individual going personally and working on the temple in Jerusalem. Ransom for sin was paid by the substitutionary death of

Christ. Shortly, the Lord would reveal this very clearly to the disciples by declaring that the purpose of His coming was "to give His life a ransom for many" (Matt. 20:28). The word *for* in both Matthew 17:27 and 20:28 is the preposition *anti,* which undebatably means "in the place of," or "as a substitute." This is Christ's own interpretation of the meaning of His death; the payment of the tax was a foreshadowing of it.

Do you suppose Peter had this occasion in mind when he wrote that we are "not redeemed with corruptible things, like silver or gold, . . . but with the precious blood of Christ, as of a lamb without blemish and without spot" (1 Pet. 1:18–19)?

This is the miracle of the tribute money. It met the need exactly; it taught Peter about his Lord; it teaches us lessons for life today.

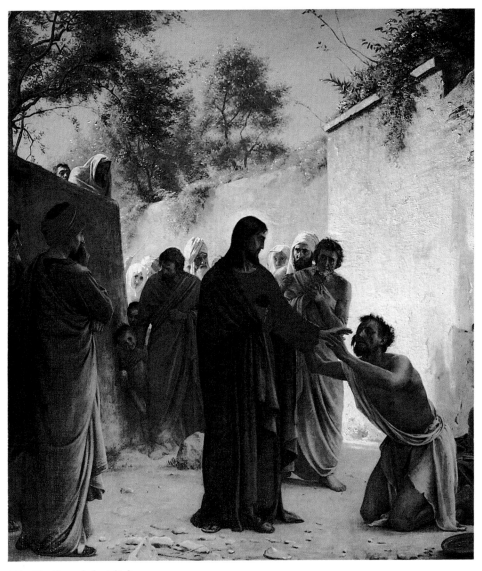

The Healing of the Blind
Carl Heinrich Bloch; exhibited at Charlottenborg, 1871; 40½″ x 35⁹⁄₁₀″; The Chapel at Frederiksborg Castle, Denmark (Globe Photos, Inc.)

Danish painter Carl Bloch (1834–1890) employed predominantly historical and biblical motifs. Here Rembrandt's influence upon him is apparent in the warm, human setting of this miracle. Bloch makes us feel Christ's compassion toward the blind man as well as the blind man's earnest desire to receive his sight. While other figures look on curiously, Christ extends His hand to heal him.

CONFRONTING THE WORLD'S BLINDNESS

Giving Sight to the Man Born Blind

Now as Jesus passed by, He saw a man who was blind from birth. And His disciples asked Him, saying, "Rabbi, who sinned, this man or his parents, that he was born blind?" Jesus answered, "Neither this man nor his parents sinned, but that the works of God should be revealed in him. I must work the works of Him who sent Me while it is day; the night is coming when no one can work. As long as I am in the world, I am the light of the world." When He had said these things, He spat on the ground and made clay with the saliva; and He anointed the eyes of the blind man with the clay. And He said to him, "Go, wash in the pool of Siloam" (which is translated, Sent). So he went and washed, and came back seeing. Therefore the neighbors and those who previously had seen that he was blind said, "Is not this he who sat and begged?" Some said, "This is he." Others said, "He is like him." He said, "I am he." Therefore they said to him, "How were your eyes opened?" He answered and said, "A Man called Jesus made clay and anointed my eyes and said to me, 'Go to the pool of Siloam and wash.' So I went and washed, and I received sight." Then they said to him, "Where is He?" He said, "I do not know."

They brought him who formerly was blind to the Pharisees. Now it was a Sabbath when Jesus made the clay and opened his eyes. Then the Pharisees also asked him again how he had received his sight. He said to them, "He put clay on my eyes, and I washed, and I see." Therefore some of the Pharisees said, "This Man is not from God, because He does not keep the Sabbath." Others said, "How can a man who is a sinner do such miracles?" And there was a division among them. They said to the blind man again, "What do you say about Him because He opened your eyes?" He said, "He is a prophet." But the Jews did not believe concerning him, that he had been blind and received his sight, until they called the parents of him who had received his sight. And they asked them, saying, "Is this your son, who you say was born blind? How then does he now see?" His parents answered them and said, "We know this is our son, and that he was born blind; but by what means he now sees we do not know, or who opened his eyes we do not know. He is of age; ask him. He will speak for himself." His parents said these things because they feared the Jews, for the Jews had agreed already that if anyone confessed that He was Christ, he would be put out of the synagogue. Therefore his parents said, "He is of age; ask him." So they again called the man who was blind, and said to him, "Give God the glory! We know that this Man is a sinner." He answered and said, "Whether He is a sinner or not I do not know. One thing I know: that though I was blind, now I see." Then they said to him again, "What did He do to you? How did He open your eyes?" He answered them, "I told you already, and you did not listen. Why do you want to hear it again? Do you also want to become His disciples?" Then they reviled him and said, "You are His disciple, but we are Moses' disciples. We know that God spoke to Moses; as for this fellow, we do not know where He is from." The man answered and said to

them, "Why, this is a marvelous thing, that you do not know where He is from, and yet He has opened my eyes! Now we know that God does not hear sinners; but if anyone is a worshiper of God and does His will, He hears him. Since the world began it has been unheard of that anyone opened the eyes of one who was born blind. If this Man were not from God, He could do nothing." They answered and said to him, "You were completely born in sins, and are you teaching us?" And they cast him out.

Jesus heard that they had cast him out; and when He had found him, He said to him, "Do you believe in the Son of God?" He answered and said, "Who is He, Lord, that I may believe in Him?" And Jesus said to him, "You have both seen Him and it is He who is talking with you." Then he said, "Lord, I believe!" And he worshiped Him. And Jesus said, "For judgment I have come into this world, that those who do not see may see, and that those who see may be made blind." Then some of the Pharisees who were with Him heard these words, and said to Him, "Are we blind also?" Jesus said to them, "If you were blind, you would have no sin; but now you say, 'We see.' Therefore your sin remains" *(John 9:1–41)*.

Light and darkness are always in conflict. Our Lord had asserted not long before this miracle took place that He was indeed the Light of the world (see John 8:12). The Pharisees, parading their Abrahamic ancestry, tried to cover up the fact that they were actually walking in darkness. The discussion grew virulent when the Lord accused them of being children of Satan. But a while later (there is no time indication in John 9:1), the Lord demonstrated His claim to be the Light of the world by giving sight to a man who had been born blind.

This well-known miracle was recorded only by John and, like each of the few miracles John did record, it is described in great detail. The miracle claimed deity and messiahship for the One who did it. In the Old Testament, giving sight to the blind is a prerogative of God (see Ex. 4:11; Ps. 146:8) and an activity of the Messiah (see Is. 29:18; 35:5; 42:7). The Pharisees denied both these claims of Jesus—that He was God and Messiah—but now they were confronted again with proof that He was. Light and darkness did battle once more.

I. The Reason for the Miracle: John 9:1–5

A. The Occasion for the Discussion (vv. 1–2)

As the disciples passed by a well-known beggar who was blind from birth, they asked the Lord a theological question. It was based on the assumption that suffering, especially something as drastic as blindness, was due to sin. But what sin could have caused blindness from birth? Either the man must have sinned somehow before birth, or his parents must have sinned and he had to bear the consequences of their sin. But neither alternative seemed possible, and so the

disciples asked the Lord who sinned, the man or his parents. They knew no other options.

B. The Outcome of the Discussion (vv. 3–5)

Replying, the Lord said there was another explanation. The blindness served as an occasion for showing the glory of God in the miracle about to be performed. In answering this way, the Lord did not deny the solidarity of the race, as a result of which sin is transmitted, any more than He denied the existence of sin or the relationship between sin and suffering. But in this instance, He said that the plight of the man was unrelated to his own sin or his parents' sin. It was for the glory of God.

But the Light of the world would dispel the man's darkness. This was a work of God; that is, its origin was from heaven. Not only the Lord, but also His followers (note the "we" some texts have in v. 4) must (this is an obligation) do God's works while there is opportunity. For Christ, the night that would soon come was His death. For us, it is also death or the rapture of the church. In the meantime we can do even greater works (see John 14:12) by offering people eternal life.

II. The Requirement for the Miracle: John 9:6–7

The requirement was faith. In order that the blind man might show his faith, the Lord made clay of His spittle, put it on the man's eyes, and commanded him to go and wash it off in the Pool of Siloam. In doing this the Lord violated several manmade laws concerning the Sabbath. In making the clay He technically violated the prohibition against kneading. In putting it on the man's eyes He violated the prohibition against anointing. In healing the man He violated the prohibition against healing on the Sabbath except in emergencies. No wonder the Pharisees were outraged at His action!

The Pool of Siloam, south of the temple, today is a reservoir fifty-eight feet long, eighteen feet wide, and nineteen feet deep. The name, as John explained, means "sent" because the waters were sent through an aqueduct to the pool. Here the name takes on a double meaning. The man was sent to the pool to receive his sight by the One whom the Father sent to be the Light of the world.

For the blind man, the Lord's orders were a test of faith. It was not a complicated requirement. Neither was it easy to believe that washing off clay in the Pool of Siloam would restore sight. It is never easy to believe, especially when

so much is at stake. Notice how little knowledge the man had of who Jesus was. He knew His name (see v. 11), and he knew He was a prophet (see v. 17). And that is apparently all. Only later (vv. 35–38) did he recognize Him as the Savior.

III. The Reactions to the Miracle: John 9:8–41

A. The Reaction of the Neighbors (vv. 8–12)

Apparently, the man went home after washing. Imagine being able to see his way home for the first time in his life! But when he arrived, his neighbors were so astonished that some denied he was the same beggar they had known. Finally, the man himself had to assert that he was indeed the beggar who was blind. When asked how he received his sight, he rehearsed the events of the miracle. He only identified his benefactor as "a Man called Jesus," showing not only his own little knowledge of Him but also the neighbors' little knowledge. Still, they could scarcely believe what their senses saw and heard.

B. The Reaction of the Pharisees (vv. 13–17)

Light repels as well as attracts. In this instance it stirred intense opposition from the Pharisees. For them, legalities obscured the light, and technicalities kept them from the truth. After all, they reasoned, it was Sabbath, and Jesus had broken their laws about the Sabbath; obviously He was a sinner. And if He were a sinner, how could He do such a miracle? Their logic was irrefutable, but their conclusion was wrong. The man could see, and Jesus had done it. So there was a division among them. Some clung to logic. Some acknowledged the facts.

The Pharisees' investigation may have been only an informal inquiry, or it may have been a formal interrogation before a synagogue court (of which there were two in Jerusalem). The latter situation might better account for the fear of the parents when they were questioned.

C. The Reaction of the Parents (vv. 18–23)

Some of the neighbors disbelieved that this man was the blind beggar they had known for so long. The Pharisees tried to discredit the miracle since a sinner—and Christ was a sinner in their eyes—had done it. The parents attempted to disassociate themselves from their son and his experience. They were asked two questions by the Pharisees: Is this your son, and How is it that he now sees? They acknowledged readily that he was their son, but they claimed ignorance of the details of the miracle and shifted the responsibility to the son. They wanted nothing to do with anything that might jeopardize their

standing in the synagogue (v. 22). To "confess . . . Christ" (v. 22) evidently means simply to give general support to Jesus, something the parents did not want to do at all. Though formal excommunication from the synagogue seemed to come later in history, some kind of suspension of privileges was enough to make the parents afraid and want no involvement in the matter.

D. The Reaction of the Man (vv. 24–38)

Seeing that they would get nowhere with the parents, the Pharisees examined the man for the second time. They wanted verification that Jesus was a sinner. But instead, the man refused to be drawn into a theological argument (v. 25), stuck to the facts he knew (that he had received his sight), baited them with the sarcastic question as to whether they wanted the facts again so they could become disciples of Jesus (v. 27), and mounted an attack against their logic by showing that Jesus must be from God if He could open blind eyes (see vv. 30–34). Thus the man convinced himself that Jesus was from God, and he chose Him instead of Moses, whom the Pharisees thought they were following.

The Lord arrived to help His persecuted new follower. This would have been the first occasion that the man had actually seen the Lord. But he would have had no problem identifying who He was by His voice. The Lord's question was straightforward: Do you believe on the Son of Man? (See v. 35 — "Son of Man" may be a better reading than "Son of God" here. This is the title the Lord used more frequently of Himself than any other, and it is the title that links Him to His earthly mission as Savior; see Luke 19:10.) And when the Lord identified Himself as that Savior, the man believed and worshiped Him. He had received not only physical sight, but spiritual sight as well.

E. The Reaction of the Lord (vv. 39–41)

The Light judges those who walk in darkness even though they say they have the truth. It shows up those who say they have spiritual sight as being blind. When the Pharisees asked if they were blind, the Lord said that if they were truly blind — that is, ignorant of spiritual things — they would not be guilty. But because they claimed spiritual insight and knowledge of the Law, they were all the more guilty. They acted in knowledge, not in ignorance, and their acts condemned them.

Our Lord is still offering spiritual sight to blind people. Some disbelieve He is able to do that. Others discredit who He is. Some do not want to be involved, and others openly attack. But a multitude do believe, and they receive His gift of eternal life.

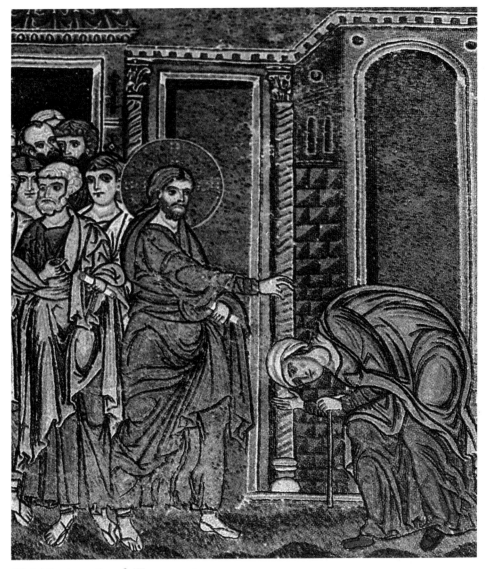

Christ Curing a Curved Woman
Twelfth century; mosaic; Monreale Cathedral, Sicily

The imagery in a Byzantine (twelfth to fifteenth century) church such as Monreale is not just mere adornment or a means of teaching the people, but it is bound up in the fundamental concepts of the building itself. The cathedral represented the universe in its two indivisible aspects, the spiritual (i.e. the sanctuary) and the material (i.e. the naos) or as heaven placed above the terrestrial world. The images spell out this symbolism not only by teaching but also by simply being. Mosaics cover the whole interior of the church of Monreale, with scenes depicting Christ's miracles located on the two aisles on either side of the nave. The style of the mosaic is very linear. The church is in the hills overlooking Palermo and the Benedictine monastery it was built to serve. It was built by King William II (1166–1189) on a large and unprecedented scale.

HYPOCRISY IN ACTION

A Woman Loosed from Her Infirmity

Now He was teaching in one of the synagogues on the Sabbath. And behold, there was a woman who had a spirit of infirmity eighteen years, and was bent over and could in no way raise herself up. But when Jesus saw her, He called her to Him and said to her, "Woman, you are loosed from your infirmity." And He laid His hands on her, and immediately she was made straight, and glorified God. But the ruler of the synagogue answered with indignation, because Jesus had healed on the Sabbath; and he said to the crowd, "There are six days on which men ought to work; therefore come and be healed on them, and not on the Sabbath day." The Lord then answered him and said, "Hypocrite! Does not each one of you on the Sabbath loose his ox or his donkey from the stall, and lead it away to water it? So ought not this woman, being a daughter of Abraham, whom Satan has bound—think of it—for eighteen years, be loosed from this bond on the Sabbath?" And when He said these things, all His adversaries were put to shame; and all the multitude rejoiced for all the glorious things that were done by Him *(Luke 13:10–17).*

Hypocrisy can be defined as "a feigning to be what one is not, an appearance of virtue or religion." Clearly this is the theme of this miracle, for the Lord denounced the ruler of the synagogue as a hypocrite (see Luke 13:15).

Originally, the word *hypocrite* meant "to play a part," as in a Greek drama. Hypocrisy was play-acting and was not necessarily evil. But the concept of hypocrisy also draws from the Hebrew word that means "to be polluted" or "impious." A hypocrite was a godless person (see Job 34:30; Is. 33:14). He opposed God.

When our Lord attacked hypocrites, He was not simply unmasking their pretense of play-acting but also condemning them for their evil ways and opposition to God. For example, "their hypocrisy" in Mark 12:15 is called in the parallel account in Matthew 22:18 "their wickedness" and in Luke 20:23 "their craftiness." Hypocrisy, then, is evil pretense, and the ruler of the synagogue in this story was certainly guilty of it.

I. The Demonstration of Hypocrisy: Luke 13:10–14

The synagogue where this miracle took place is not identified. Likely it was some synagogue in Perea that the Lord visited on His last journey to Jerusalem. Some commentators, however, feel that the incident occurred earlier in His ministry and is inserted here without reference to chronology.

A. The Reason for the Incident: Faithfulness

Though He was turning His face toward Jerusalem to meet betrayal and death, the Lord nevertheless stopped to teach in this synagogue. This place may have been one of the few where His ministry was welcome. The imperfect periphrastic "was teaching" may indicate that His ministry had gone on for several Sabbaths in this particular place. The plural *Sabbaths* may also support this idea.

From the very first of His public ministry the Lord made a habit of attending the synagogue worship (see Luke 4:16), and He continued that practice to the end of His earthly life. His example speaks to individuals who excuse themselves from attending corporate worship because they "get nothing out of the service." No defender of public worship should ever try to make his or her case on the basis of the ability of the preacher! We worship to meet God.

The afflicted woman had also come to the synagogue that day. With her infirmity, that was not an easy undertaking. Her problem was attributed to "a spirit of infirmity," which the Lord clarified as being from Satan (v. 16). As a result, for eighteen years she was bent over and could not straighten herself up. But she did not let this Satanic attack keep her from the corporate worship of God that Sabbath day.

The Lord recognized her problem and, calling to her where she sat in the gallery for women, He announced (a perfect tense, indicating that the miracle was as good as done) her cure, which was consummated as soon as she came to Him and He touched her. The miracle was immediate and total. After eighteen years of being bent over, she was able to stand up straight. Immediately, she burst into praise. "Made straight" occurs only here, Acts 15:16 (of the yet future fulfillment of the Davidic covenant), and Hebrews 12:12 (of encouragement). Nothing is recorded about the woman having faith. In fact, because of her bent over condition, she probably did not even notice the Lord's presence until He called to her.

B. The Result of the Demonstration: Hypocrisy Unmasked

The ruler of the synagogue flared up immediately. He was the one who in-

vited different members of the congregation to lead in prayer and to read the Scriptures. Angry at this display of Christ's power and annoyed at the woman's outburst of praises, he lashed out at Jesus by telling the audience that there were six days in which to work and no healing need be done on the Sabbath.

He demonstrated his hypocrisy in two ways: (1) in pretending to instruct and rebuke the people when in fact he was censuring Christ, and (2) in professing zeal for the Law when in fact he was breaking it by hating the One who healed the woman.

II. The Denunciation of Hypocrisy: Luke 13:15–17

A. The Outline of the Denunciation

The Lord's reply was not only to the ruler of the synagogue but also to other leaders who were also hypocrites (notice the plural in v. 15 and the mention of others who opposed Him in v. 17).

His answer focused on four contrasts: (1) between the ox or ass — dumb animals — and the woman — a daughter of Abraham (perhaps indicating she was a believer, see Luke 19:9); (2) between an inanimate stall (for animals) and Satan, the aggressor; (3) between the few hours between waterings of animals and the eighteen years of affliction of the woman; and (4) between the hypocrisy of exercising an animal on the Sabbath by taking it to a watering place but not wanting to heal a human being.

B. The Outcome of the Denunciation

As usual, there was a division about the Lord and what He had done. The religious leaders behaved as expected and were ashamed, not because they were convinced but because they were confounded by the Lord's reasoning. The people were delighted with what had happened. Many must have known the woman for years and could not help but rejoice with her because of her healing.

The lesson is all too plain. How often religious leaders hypocritically defend their own structures and programs by denouncing what God is doing outside their organizations! Let us never think that God can work only in the way and through the structures we think He should; and let us rejoice in all that He does through the variety of means He chooses.

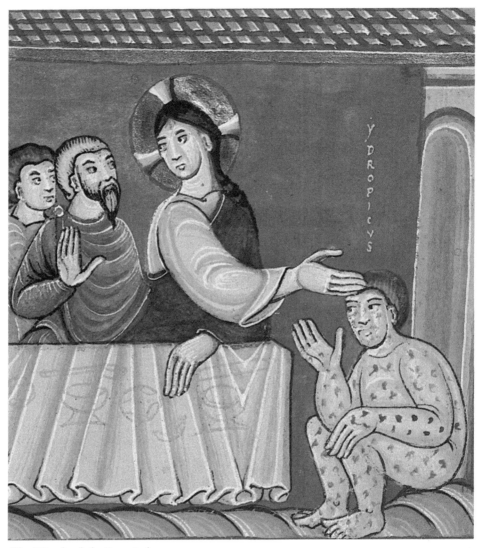

The Miracle of the Dropsical
1035–1040; illuminated manuscript (The Gospel of Echternach); Germanisches National Museum, Nuremberg, West Germany

The scriptorium at Echternach, in what is today Luxembourg, was one of the major centers of illumination during the Ottonian rule of the Holy Roman Empire. The monastery seems to have made the Gospel for itself rather than for imperial patrons. An extensive cycle of New Testament narrative scenes is illustrated in the book; page-width friezes are divided by purple bands inscribed in gold. Part of a page that depicts four other miracles of Christ, this scene shows Christ turning to two of His disciples at the same time He touches the head of the naked sick man. The highly stylized figures represent the divine nature of Christ as the Great Physician. (See also page 102.)

INFLEXIBILITY CAN BE GOOD OR BAD

Healing the Man With Edema

Now it happened, as He went into the house of one of the rulers of the Pharisees to eat bread on the Sabbath, that they watched Him closely. And behold, there was a certain man before him who had dropsy. And Jesus, answering, spoke to the lawyers and Pharisees, saying, "Is it lawful to heal on the Sabbath?" But they kept silent. And He took him and healed him, and let him go. Then He answered them, saying, "Which of you, having a donkey or an ox that has fallen into a pit, will not immediately pull him out on the Sabbath day?" And they could not answer Him regarding these things *(Luke 14:1–6)*.

Inflexible means "firm in will or purpose, unyielding." That can be good or bad, and this miracle demonstrates both aspects. Like the healing of the bent-over woman in the synagogue, this miracle was also done in Perea on the Lord's last journey to Jerusalem (see Luke 13:22).

I. The Inflexibility of Christ

A. Inflexible to Help

Even though the Lord had been constantly rejected and attacked by the Pharisees, and even though this miracle was later in His ministry, He still accepted an invitation to dine at a chief Pharisee's house. This man was a leader or ruler of the Pharisees, which probably means that he was a member of the Sanhedrin, the body that would shortly condemn the Lord. Of course, our Lord knew this when He accepted the invitation, but still He ministered to those who were against Him.

The miracle was done on a Sabbath day. Among the Jewish people, the Sabbath was a feast day, not a fast. To feed the poor on the Sabbath was a religious duty (see Neh. 8:9–11), and Pharisees who could afford it often held semipublic feasts on the Sabbath. Cooking food was forbidden, but food, though cold, was in abundance at a Sabbath meal. This meal was probably one of those ostentatious charitable feasts (note the parable that follows in

vv. 7–14). Other Pharisees and rabbis who were present were carefully watching the Lord (the word can take on the meaning, as here, of watching someone maliciously). Still His enemies hounded Him; still He tried to help them.

B. Inflexible to Heal

Uninvited outsiders could enter such feasts, and probably the afflicted man had come in to get a meal. There is no indication that his presence was prearranged, but once there, the Pharisees saw an opportunity to try to trap Christ again. Verse 2 indicates that suddenly the Lord caught sight of the man right in front of Him. In other words, the Pharisees evidently placed this repulsive-looking individual in a conspicuous place so that Christ could not help but see him. They knew that His good inflexibility would doubtless entice Him to do something about healing the man, and then they could accuse Him of breaking the Law, or at least their interpretation of the Law.

Dropsy, or edema, is an abnormal accumulation of watery fluid in the body which is symptomatic of a deeper and more serious problem. The fluid collects in the tissues and cavities of the body, such as the abdomen or legs and feet, and often is the result of cardiac, renal, or hepatic diseases. When the man was healed, he undoubtedly was relieved not only of the swelling caused by the fluid but also of the disease that produced it.

Like the Lord, we too should be inflexible in serving others by doing what we can to meet their needs. Of course, no one has any greater need than the need of eternal life. So the greatest service we can do for others is to tell them how they may receive the free gift of eternal life. But people have other needs that we can help meet as well; as we have opportunity, we should do good to all people, especially to fellow believers, and not lose heart in doing good (see Gal. 6:9–10).

II. The Inflexibility of the Pharisees

A. Inflexible in Persecuting the Lord

By contrast, the Pharisees were bent on hounding Christ, persecuting Him at every turn, trying to trap Him so that the people would turn against Him. The tense of the word *watched* in verse 1 is an imperfect periphrastic, meaning that they were continually watching Him, and they were doing so maliciously.

B. Inflexible in Perverting the Law

When the Lord saw the trap they set, He accepted the challenge and exposed

their maliciousness. He asked them the direct question, "Is it lawful to heal on the Sabbath day?" The Pharisees remained silent, and their silence condemned them. They could hardly deny that the healing was lawful, but if they admitted it was, then their plot would fail. They did the only thing they could do. They kept still and waited to see what would happen.

The Lord then proceeded to heal the man and dismiss him. Then He turned to the Pharisees to try to show them not only the legality of His act, but more importantly the love displayed in His action.

Christ asked them if they would not rescue their animals if any happened to fall into a pit on the Sabbath. Of course they would, for what owner could possibly think he was violating the Law if he rescued his animal from such danger? The Law said to love one's neighbor as oneself; that made such rescues legal, and the same Law also justified the healing of this man with edema. But what the Pharisees allowed for their own benefit, rescuing their animals on the Sabbath, they did not want to allow for someone else's benefit, as in the case of the man with edema.

The Pharisees had no answer because there was none. So the feast continued.

Our Lord illustrated proper inflexibility; the Pharisees, wrong inflexibility. Some have erroneously equated legalism with inflexibility, but that cannot always be a legitimate equation if there is a proper inflexibility. The motive decides what is legalism. The Lord's motives were unimpeachable and selfless. The Pharisees' motives were self-seeking. Their inflexibility, then, was legalism, and our Lord exposed and condemned it.

The Raising of Lazarus
Vincent van Gogh, after an etching by Rembrandt, 1890; 19″ x 24⅜″; oil on canvas; National Museum Vincent van Gogh, Amsterdam

Van Gogh has been known for his tragic life. Unsuccessful as a missionary, he turned to painting, but only one of his works was sold in the open market during his lifetime. He spent some of his life in and out of asylums and eventually took his life on July 27, 1890, at only 37 years of age. It was while recovering in an asylum that Van Gogh painted this miracle from a copy of Rembrandt's etching. Van Gogh felt he had no right to represent Christ, so his painting retains only the figures of Lazarus and his two sisters. Lazarus is painted with Van Gogh's own features, perhaps indicating a sense of new life as he recovered from his mental confusion. The painting is done in Van Gogh's distinctive style with dynamic brush strokes and strong tones of color. In his spiritual quest, Van Gogh sought to suggest the eternal by the radiance and vibration of color itself.

B. The Disappointment of Mary (vv. 28–32)

Mary, more emotionally demonstrative than Martha, simply came and fell at the Lord's feet. Her confession was similar to her sister's and expressed faith in Christ's power to heal but no more. Not realizing that the Lord could raise her brother then and there, she continued in her disappointment.

C. The Disappointment of Christ (vv. 33–37)

Joined by the mourners, the group moved toward Lazarus's tomb. Two times Christ groaned in His spirit (the word reflects the deepest kind of emotion): the first time in sorrow over the death of His friend, and the second time in sorrow over the doubts of the people concerning Him (vv. 33,38).

III. The Circumstance of Death: John 11:38–44

A. Testing (vv. 38–40)

Here was the ultimate test of faith: the Lord commanded them to remove the stone. Family pride led Martha to object, but the Lord rejected her protest.

B. Thanking (vv. 41–42)

Here was the ultimate proof of faith: Jesus thanked the Father for something not yet accomplished. He did it to strengthen the faith of those who heard His prayer.

C. Triumphing (vv. 43–44)

Here was the ultimate power of faith. Previously, the Lord had declared that the dead would be raised by hearing the voice of the Son of God (see John 5:25). Lazarus heard that voice and came forth. Had the Lord not specifically addressed Lazarus, all the dead might have been raised at that time! John's details about the length of time Lazarus had been dead and the decay that had to have set in make it clear that this act was no resuscitation.

Think what it must have meant to Lazarus to be in paradise four days and then to have to come back to the limitations of an earthly life, eventually to have to die again. But when Lazarus is resurrected again it will be with an eternal body, never to die again. So it is with all believers. The ultimate triumph over death awaits the time of resurrection when we shall receive our bodies of glory.

In this miracle we have seen our Lord as the Lord of all circumstances. In the circumstance of delay, He is the deciding One. In the circumstance of disappointment, He is the dependable One. In the circumstance of death, He is the delivering One.

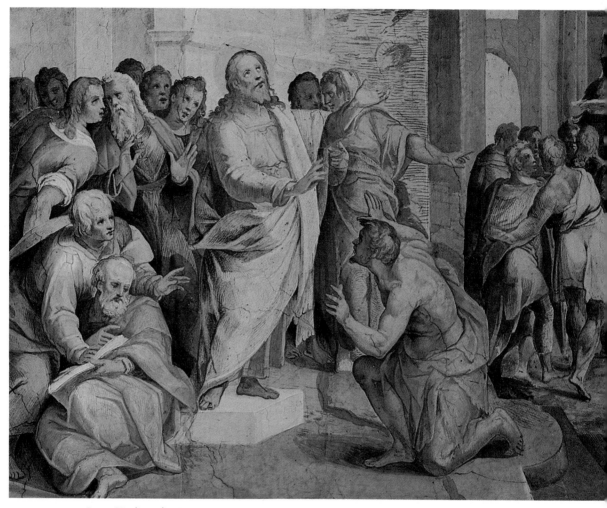

Jesus Healing the Ten Lepers
Lorenzo Sabbatini; Loge of Gregory XIII, Vatican Museum, Rome, Italy (Globe Photos, Inc.)

Sabbatini was born in Bologna around 1530 and died in Rome in 1576. He was the court painter for Pope Gregory XIII. In this picture the miracle of Jesus' healing the ten lepers has already occurred because one of them has returned to fall before Him and give thanks. The others can be seen in the background as they go to the priest as Jesus told them to do. The emotions on the faces of the individuals in the crowd and of the healed leper reflect wonder and astonishment. Christ gazes heavenward to remind us of His source of power.

THE SOCIETY OF THE THANKLESS NINE

Healing Ten Lepers

Now it happened as He went to Jerusalem that He passed through the midst of Samaria and Galilee. Then as He entered a certain village, there met Him ten men who were lepers, who stood afar off. And they lifted up their voices and said, "Jesus, Master, have mercy on us!" So when He saw them, He said to them, "Go, show yourselves to the priests." And so it was that as they went, they were cleansed. Now one of them, when he saw that he was healed, returned, and with a loud voice glorified God, and fell down on his face at His feet, giving Him thanks. And he was a Samaritan. So Jesus answered and said, "Were there not ten cleansed? But where are the nine? Were there not any found who returned to give glory to God except this foreigner?" And He said to him, "Arise, go your way. Your faith has made you well" *(Luke 17:11–19).*

Christians are a thankful people; indeed, thanksgiving is a Christian distinctive. In everything the Christian can give thanks, for God "who did not spare His own Son, but delivered Him up for us all . . ." has "with Him also freely [given] us all things" (Rom. 8:32). And our Father makes all things work together for good to those who love Him (see Rom. 8:28). Christians not only appreciate the blessing of God in things temporal, but they have the promises of God for life eternal.

Since this is true, it should come as no surprise to find the apostle Paul reminding us that it is characteristic of those who have not been redeemed to be unthankful (see Rom. 1:21). But sometimes unthinking Christians also show this trait. This certainly should not be, because those for whom God has done so much should be the most grateful. It is a good thing, then, to look at this miracle that reminds us so pointedly to be thankful.

What is true thanksgiving? In what does it find its basis? How can I know that I am being truly thankful? What difference does it make? All of these questions are answered in the lessons of this miracle of the healing of ten lepers.

It is a familiar story. Jesus was on His way to Jerusalem, and as He passed through Galilee near the border of Samaria, He was accosted by these ten

163

leprous men. In response to their pleas, He healed them all and commanded them to present themselves to the priests as the Mosiac law required. As you may remember, only one of the ten took time to thank the Lord who had performed the miracle, and he was a Samaritan. Then the Lord asked, "Were there not ten cleansed? But where are the nine?" (Luke 17:17). That lone Samaritan illustrated the full meaning of true thanksgiving, and his act of returning to give thanks serves as a reminder to believers today of our privilege to be truly thankful.

I. The Cause of True Thanksgiving

The first thing we are reminded of is the prime reason why we should be thankful to God. When we think of the basis for true thanksgiving, I suppose that most of us turn our thoughts to the material blessings that God has showered upon us. It is right and proper that we should be thankful for these things and recognize that they come from the good hand of God. They constitute an important, though not all-sufficient, basis for true thankfulness.

For instance, surely we are all thankful for life itself, but is it not true that, for the Christian, death in the will of God is far better (see Phil. 1:21)? The older we grow, the more grateful we are for health. But is not sickness often in the will of God (see 2 Cor. 12:7–8)? We are thankful for strength, for we want to serve God with all our strength, but sometimes God makes us weak so that He may manifest His own power through our lives (see 2 Cor. 12:9).

Food is something for which we give thanks at least three times a day. But could we say, as Paul did, that we are thankful for being hungry for His sake (see Phil. 4:12)? Some individuals who have had homes destroyed by wind, war, or other means know especially what it means to be thankful for shelter, but our Lord had no place to lay His head (see Matt. 8:20). We should be just as thankful if God should allow us to follow Christ in that respect.

Do not misunderstand. We are thankful for temporal provisions, but we must learn that there is a deeper, greater, and eternal cause for thanksgiving in the spiritual blessings with which God has graced the believers in Christ. The miracle of the lepers illustrates that better than almost any other. To them death would have been a sweet release. They had no health or strength. The securing of food and shelter was a constant battle. A spiritual miracle of healing was what they most needed.

As was described earlier (see pp. 33–34), leprosy is a heinous disease. Just

as terrible for its victims, however, were the social isolation in which they were forced to live and the connotations of sinfulness that the disease carried. Certainly those who were afflicted with leprosy were no more sinful than their healthy neighbors, though the sin of Adam is ultimately responsible for all sickness. Just as the real need of those ten men was for spiritual healing beyond this horrible disease, so the basic need of all humankind is for cleansing from sin and its consequences.

Our Lord recognized this need, and with five words He offered healing to ten men. But those five words were calculated to test their faith. Implicit in the command to go and show themselves to the priests was the promise that if they went they would be cleansed and the priests would pronounce them so. But first they had to go.

Can you not easily imagine the heated discussion that took place by the road that day? When all the pros and cons had been debated, the matter boiled down to the simple fact that the only way to find out if Jesus' words were true was to obey. Just so, Christianity cannot be put in a test tube and received only if and after the experiment works. Forgiveness of sins comes only to the person who will personally accept the Savior. The sinner must believe his Lord, and then he will find peace and everlasting life. And so they went, and as they went they were cleansed. Imagine then the scene of ecstatic joy and increasing assurance as they progressively examined their bodies. Truly a miracle had been performed.

In this incident we discover the prime reason for the Christian's thanksgiving. This reason does not change with the varying circumstances of life. It is an eternal reason. We are thankful above all else because we are cleansed from sin. This is ultimately the basic reason for being truly thankful anytime. This basis outlasts all others. It is a basis that fixes our attention—as it should—on things eternal. This is the genuine basis for thanksgiving.

II. The Character of True Thanksgiving

True thanksgiving is both an attitude and an action. Both are displayed in the passage before us. The right attitude is to realize the debt incurred and to want to be thankful. All of these men owed thanks, for all had been healed. But only one turned back to give thanks. In so doing he stood against the overwhelming majority of his friends in order to do what was right. No matter what others do, let us who are God's redeemed children never forget to be thankful.

Furthermore, this right attitude was displayed by a Samaritan. Although he may have been a religious man, he was not orthodox, for the religion of the Samaritans was not God-given as Judaism was. Let it never be said of those of us who are evangelical that we are the least thankful. We must not be like the Jewish lepers in this account. Our knowledge of what it means to be redeemed is what generates an attitude of true thankfulness.

A right attitude always evinces itself in right action. Notice that the cured leper prostrated himself before the Lord Jesus. The Person, not the miracle, became the all-important thing in the man's mind. And He should be. While it is right to be grateful for things, the character of true thanksgiving sees beyond the things to the One whose grace has made all things pertaining to life and godliness possible. We reach the epitome of thanksgiving when we direct our gratitude toward the Person simply for who He is. Yet when we contemplate Him, like Paul, we can find no word to describe Him adequately. He is the unspeakable gift—the gift that, literally, "cannot be told throughout" (2 Cor. 9:15). We can never fathom the inexhaustible facets of the character of this Savior whom we have come to know and love. But this we do know, that He is the focal point of all the thanksgiving of our hearts, because of the loveliness of His Person and because God has with Him freely given us all things.

We are also told that the cleansed Samaritan glorified God. To draw attention to Jesus Christ, as the man did, is to glorify God, for the glory of God is the manifestation of any or all of His attributes. In other words, glory is revealed. How is God revealed? He was revealed by the Son who "has declared [or exegeted] Him" (John 1:18). Therefore, when the followers of Christ imitate their Lord, they glorify God by revealing Him. This Samaritan glorified God by both life and lip. His clean body glorified God and his loud voice did likewise (v. 15). This is the character of true thanksgiving—glorifying God by a changed life and a fervent oral testimony to the grace of the One who has made us whole. May God constrain us His people to show forth the praises of Him who has called us out of darkness into His marvelous light (see 1 Pet. 2:9). This is true thanksgiving.

III. The Consequences of True Thanksgiving

The Lord was pleased. What pathetic questions the Savior asked! "Were there not ten cleansed?" "But where are the nine?" The Lord of this universe wanted to be thanked! We know on our human plane of existence how much

we appreciate being thanked for anything, and how grieving it is to be taken for granted. "Therefore by Him let us continually offer the sacrifice of praise to God, that is, the fruit of our lips, giving thanks to His name. . . . for with such sacrifices God is well pleased" (Heb. 13:15–16). To say thank you is an easy thing, but it is not a little thing. True thanksgiving pleases our Lord.

The man was blessed. "Arise, go your way. Your faith has made you well" (v. 19), the Lord told him. In this instance the man who gave thanks received the added blessing of spiritual salvation. All ten had experienced physical healing, but only the one who had returned to give thanks knew the added blessing of being made whole within as well as without.

Thanksgiving always brings added blessing to the one who is thankful. For us who have been redeemed it will increase our understanding of our dependence on the Lord. In turn this realization of dependence brings humility of spirit, for a dependent person cannot be proud. Further, it will cause us to have a proper concept of priorities, for we will realize that "the things which are seen are temporary, but the things which are not seen are eternal" (2 Cor. 4:18).

Not only is it true that the unsaved man is characterized by thanklessness, but we are also told that one of the characteristics of the last days for the church is the same (see 2 Tim. 3:2). May it never be said of those of us who name the name of Christ that we have contributed in any way to this spirit of ingratitude that is sweeping the world today. Instead, we must turn the tide with a continual stream of thanksgiving flowing from our redeemed lives.

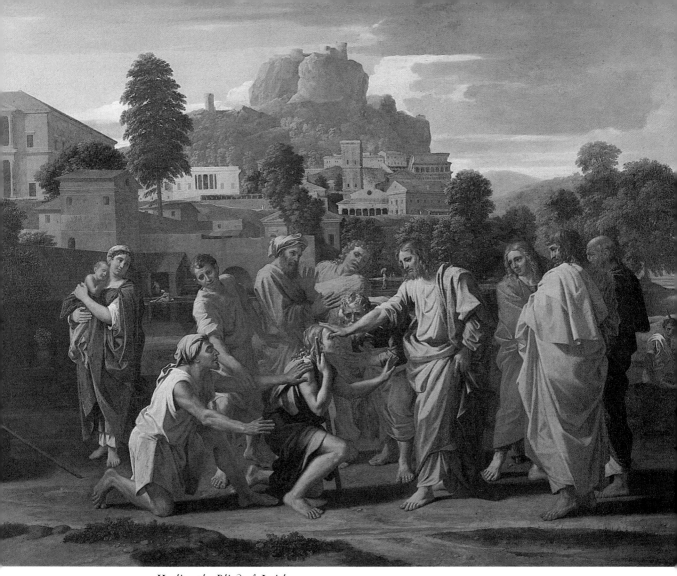

Healing the Blind of Jericho
Nicolas Poussin, 1650; 46⅞″ x 69¼″; oil on canvas; The Louvre, Paris, France (Giraudon/Art Resources, Inc.)

Nicolas Poussin had an innate talent as a teller of stories. This talent is displayed here as the scene captures the moment just before the miracle is to take place. Poussin's interest in the psychology of the figures is shown in the varied attitudes of the spectators. Yet all eyes are on the hand of Christ. The first blind man seems confident as he kneels before Jesus, while the second stretches his hands forward in expectation. Three bystanders show a mixture of interest and unbelief while the fourth, an old man, bends down to take a closer look at the event. Christ's companions on the right wait with a sense of faith while a woman holding a child to the left looks on curiously. The landscape behind the figures is built up layer by layer toward the towering fortress of Jericho, corresponding to the interrelationship of the figures, thus pictorially forming a coherent whole to this narrative.

THE SAVIOR AND HIS SALVATION

Giving Sight to Bartimaeus and His Friend

Then it happened, that as He was coming near Jericho, that a certain blind man sat by the road begging. And hearing a multitude passing by, he asked what it meant. So they told him that Jesus of Nazareth was passing by. And he cried out, saying, "Jesus, Son of David, have mercy on me!" Then those who went before warned him that he should be quiet; but he cried out all the more, "Son of David, have mercy on me!" So Jesus stood still and commanded him to be brought to Him. And when he had come near, He asked him, saying, "What do you want Me to do for you?" And he said, "Lord, that I may receive my sight." Then Jesus said to him, "Receive your sight; your faith has saved you." And immediately he received his sight, and followed Him, glorifying God. And all the people, when they saw it, gave praise to God *(Luke 18:35–43; see also Matt. 20:29–34; Mark 10:46–52).*

New Testament Jericho, about a mile and three quarters south of the Old Testament site, was the winter resort and capital for Herod the Great and his successors. The king carried out an extensive building program at this location that was blessed with an ample supply of water and a warm winter climate. Zacchaeus, a chief tax collector of the area, became a wealthy man from the taxes levied on products of that region (see Luke 19:2).

But where wealth is, so there are beggars. Jericho had not only its Herods and Zacchaeuses but also its Bartimaeuses. Two such blind beggars became the objects of this miracle.

On the surface, the accounts seem to differ greatly, so much so that some commentators declare they are irreconcilable. Matthew said that the Lord healed two blind men as He left Jericho. Mark and Luke mentioned only one blind man and said that the miracle was done as the Lord entered Jericho. Two questions emerge from the three accounts: (1) How many were healed, one or two? and (2) When did the healing occur, as the Lord entered or left Jericho?

As to the number of blind men healed, obviously there were two. Mark and Luke focused on only one of the men, Bartimaeus, but neither writer stated that

169

there was only one healed. If either had stated that, there would be a clear contradiction, since Matthew declared that there were two. However, the silence of one writer (Mark or Luke) does not indicate a contradiction in the statement of another (Matthew). Evidently, Bartimaeus was the more aggressive of the two, and likely he became a believer and well-known member of the Christian church, while the other unnamed man may not have. So Bartimaeus is remembered, and Mark's and Luke's attention naturally centered on him.

As to where the miracle occurred, two explanations have been offered. One suggests that the blind men pleaded with the Lord as He entered Jericho (Mark and Luke), but they were not healed until the Lord left the city later (Matthew). Another suggests that since there were two Jerichos (the old and the new cities) the miracle could have taken place as the Lord left old Jericho (Matthew) and approached new Jericho (Mark and Luke). Whichever suggestion seems better, no reason exists to consider the accounts to be contradictory.

I. The Sinner

Bartimaeus and his friend illustrate the sinner and his need.

A. His Heritage

Bartimaeus's name means "son of Timaeus," which may be derived from the Aramaic meaning "son of the unclean." If that is true, his name itself labels the situation of all born into this world. We are children of wrath, sons of Adam, unacceptable in God's holy sight. No one has even a little saving merit in God's sight. Like Bartimaeus, all humankind stands unacceptable and condemned before God, totally out of phase with God who is Light.

B. His Hopelessness

Blindness is not easily cured! In all the Old Testament there is no account of any blind person receiving his or her sight. No disciples of the Lord were involved in restoring sight to a blind person. Only Ananias's involvement in Paul's regaining his temporary loss of sight is somewhat analogous but still different from what Christ did when He gave sight to people. Only the Lord restored sight to the permanently blind, and there are more recorded miracles of the Lord in this category than any other (see Matt. 9:27–31; 12:22; 15:30; 21:14; Mark 8:22–26; 10:46–52; Luke 7:21). The reason is simply that the Old Testament predicted this miraculous healing would be a function of the Messiah

(see Is. 29:18; 35:5; 42:7); these sight-giving miracles clearly point out Jesus of Nazareth as the promised Messiah.

Jewish exorcists could cast out demons. The Pool of Bethesda was said to have curative powers. But only Christ could open blind eyes. Without Him Bartimaeus's case was truly hopeless, and so is every sinner's. The sight of eternal life can come only through Christ and no one else.

Perhaps Bartimaeus understood at least a glimmer of this truth, for he addressed the Lord as the "Son of David." This was a messianic title, recalling the promises of the Davidic covenant (see 2 Sam. 7:8–16; Is. 9:7; cf. Mark 12:35–37). On Bartimaeus's lips it showed his acknowledgment of Jesus as the Messiah.

C. His Hindrances

Quite simply, the hindrances were people. Many in the crowd told Bartimaeus to be quiet when he persisted in trying to get Jesus' attention. They were contemptuous of him, regarding his outbursts as indecent. Why should a beggar trouble the Master, especially when He was on His way to a triumphal entry into Jerusalem?

But their rebuke only made Bartimaeus cry out the more. All three writers note that he simply continued (an imperfect tense) to yell. This was his chance, and he was not going to let the crowd cause him to miss it.

Well-meaning people can hinder the unsaved from coming to Christ—even the closest members of one's family or sincere friends. But if you sense a need, do not be put off by anyone until you reach the Lord with that problem. Bartimaeus would not have been saved that day had he listened to the crowd.

II. The Savior

A. The Savior Invites

The Lord invited the two blind men to come to Him. But He did it through some of those following Him. He told them to call the two men. Now, too, His invitation to the lost comes through others. How shall they hear without a preacher (see Rom. 10:14)? Without doubt the omnipotent Christ could do it alone, but He chooses to use people to invite others to Himself.

B. The Savior Inquires

In response to the word that the Lord was calling for him, Bartimaeus cast aside his cloak and came to Jesus. This action shows his eagerness and his

faith; normally, a blind man would want to keep his cloak within reach for easy retrieval. But coming to the Lord was more important. And when he came, the Lord made him articulate his faith by asking what he wanted Him to do. The response was clear and precise: he wanted his sight restored. It was an open confession of his faith in the Lord's ability to do just that.

III. The Salvation

A. It Was Immediate

Immediately, Bartimaeus regained his sight. Spiritual salvation is not a process: one is either born again or not. The spiritual life is an ongoing process, but the new life itself comes at a moment of time. There may be growth in understanding before that moment, but every person alive stands on one side or the other of having eternal life.

B. It Was Complete

Bartimaeus did not have some sight at first, followed by gradual improvement later. His sight came immediately and completely. In Christ our salvation is complete; in our experience it is incomplete. Our position is perfect; our practice is imperfect. We are fully accepted sons and daughters at the moment of faith; we are also newborn babes in need of growth at that same moment.

C. It Was through Faith

Bartimaeus's faith saved him. Clearly, this word means the physical restoration of his sight, but *saved* may have a double meaning here by also referring to his spiritual salvation. After all, he had confessed Jesus as the Messiah. Salvation is always and only through faith. The whole package is the gift of God (see Eph. 2:8); yet it is our faith that saves (see Rom. 4:5). He gives it, and we do it. Both are true statements.

D. It Was Followed by Service

The beggar became the follower, joining the others going to Jerusalem to become eyewitnesses of the events of Passion week. Christ did not ask if Bartimaeus would follow Him as a condition of his healing or his salvation, but once he was healed, it was the natural thing to do. Following is a consequence, not a condition of salvation. As we follow, we must be aggressive in our resolve to do God's will.

Lord, I know thy grace is nigh me,
Though thyself I cannot see;
Jesus, Master pass not by me;
Son of David! pity me.

While I sit in weary blindness,
Longing for the blessed light,
Many taste thy loving kindness,
"Lord, I would receive my sight."

I would see thee, and adore thee,
And thy word the power can give.
Hear the sightless soul implore thee,
Let me see thy face and live.

Ah, what touch is this that thrills me?
What this burst of strange delight?
Lo, the rapturous vision fills me!
This is Jesus! This is sight!

Room, ye saints that throng behind Him,
Let me follow in the way;
I will teach the blind to find Him
Who can turn their night to day.

— H. D. Ganse

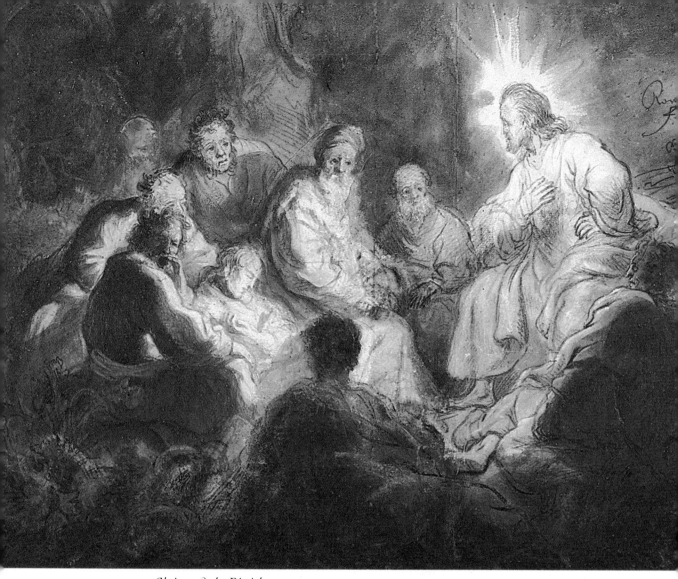

Christ and the Disciples
Rembrandt, 1634; drawing; 13⅞″ x 18¾″; Teylers Museum, Haarlem, Noord Holland

A master at treating the Gospel stories with tenderness in his works, Rembrandt exhibits this ability in this drawing of Christ and His disciples. They come to life as real men in this intimate gathering illuminated by the light of a fire. The largest figure, surrounded by a halolike light, Christ is instructing His disciples and they reflect various emotions as they listen to Him. On the left, one disciple has his hand to his mouth as if calling to others who have not yet joined the group.

HYPOCRISY

Withering the Fig Tree

Now the next day, when they had come out from Bethany, He was hungry. And seeing from afar a fig tree having leaves, He went to see if perhaps He would find something on it. And when He came to it, He found nothing but leaves, for it was not the season for figs. In response Jesus said to it, "Let no one eat fruit from you ever again." And His disciples heard it. . . .

Now in the morning, as they passed by, they saw the fig tree dried up from the roots. And Peter, remembering, said to Him, "Rabbi, look! The fig tree which You cursed has withered away." So Jesus answered and said to them, "Have faith in God. For assuredly, I say to you, whoever says to this mountain, 'Be removed and be cast into the sea,' and does not doubt in his heart, but believes that those things he says will come to pass, he will have whatever he says. Therefore I say to you, whatever things you ask when you pray, believe that you receive them, and you will have them.

"And whenever you stand praying, if you have anything against anyone, forgive him, that your Father in heaven may also forgive you your trespasses. But if you do not forgive, neither will your Father in heaven forgive your trespasses" *(Mark 11:12–14,20–26; see also Matt. 21:18–22).*

It was Holy Week. The triumphal entry was only the Sunday before. But on Monday, the Lord would cleanse the temple again, alienating some who had acclaimed Him the day before. He was on His way to Jerusalem, having spent the night outside the city, perhaps in the home of Mary, Martha, and Lazarus, or perhaps outdoors.

As the group approached Jerusalem, the Lord caught sight of a fig tree whose luxuriant green foliage was visible a long way off. Matthew noted that it was a solitary fig tree growing by the wayside, evidently belonging to no one and eye-catching because of its leaves. Not a tall tree — since fig trees grow only about twenty-five feet high — its widespreading branches provided welcome shade. Its fruit was eaten both fresh and dried as well as being made into cakes. Two or even three crops a year could be harvested. The fruit appears at the same time as the leaves, and sometimes even before.

The season for figs was June, more than a month away. So Mark's comment

that it was not the season for figs was true, but the abundance of leaves on this tree held out a promise that there would be figs too. Finding nothing but leaves, the Lord announced the death sentence on that tree. Immediately it began to die, and by the next morning when the disciples passed that way again it had dried up from the roots.

No symbolic significance is specifically stated in the text by either writer, but it takes no special insight to recognize the beautiful but fruitless tree as an illustration of hypocrisy. In particular, the hypocrisy of the nation Israel must have been in His mind—that nation so privileged by God with knowledge of Him far beyond what any other people had, and yet a people that, for the most part, were rejecting their Messiah. Their spiritual privileges did not bear the fruit of repentance in recognizing and accepting their Messiah and Savior.

I. The Characteristics of Hypocrisy

A. Hypocrisy Is Attractive

The green foliage would have caught anyone's eye, so attractive it was. And just because it was so lush, one expected fruit to be there also. Hypocrites look great and act greatly.

B. Hypocrisy Is Barren

Hypocrisy offers nothing more than fruitlessness in the midst of a display that promises fruit. Hypocrisy is always barren, offering no fruit. And fruit is what is expected. A hypocrite's life can only bring disappointment to others.

C. Hypocrisy Is Cheating

The Lord wanted some food, but He got nothing. The Lord wanted Israel to accept Him, but He got rejection. The world wants to see reality in Christians, but often they only get a hoax. Hypocrites are cheaters. Hypocrisy is not only fruitlessness but also falsehood.

II. The Condemnation of Hypocrisy

A. It Is Just

No display of temper was this, but a solemn reminder that the just reward of all hypocrisy is condemnation. For the Jewish people, soon to crucify their Messiah, it was more than just. Their privileges had been many; their punishment was just.

B. It Is Total

The tree totally withered. Just so, all false professions and all pretenses will wither at the time of judgment. In that day our Lord will judge the motives of our hearts. We can put forth leaves of hypocrisy to attempt to cover up the barrenness of our hearts, but all things are naked and open before the eyes of Him before whom we shall give our report. Sometimes persistent hypocrisy will bring loss of any further opportunity to bear fruit in this life.

III. The Contrast to Hypocrisy

After the cleansing of the Temple on that Monday, the group retired from the city for the night. On their way into the city on Tuesday, as they passed by the place where the fig tree had been they found it withered. It was then that the Lord taught them about faith, fellowship, and forgiveness—all opposites of hypocrisy. All of them were surprised at this display of His power when they saw the tree withered, and the Lord used it as an opportunity to teach them.

The mountain that could be moved by faith was undoubtedly the Mount of Olives nearby, but, of course, Jesus was using it to represent any obstacle. Faith is the key, but faith has to be rightly placed. Faith in God believes Him for what He desires to do. This promise is no blank check to which God has already signed His name for us simply to fill in for any amount anytime. The appropriate amount of request and the proper dating of the request have to be filled in by faith before God can cash the check. And the believer who is in the closest fellowship with his Lord will know what to ask, when to ask it, and in faith will await God's answer.

The most important requirement for such fellowship and faith is forgiveness. Not salvation forgiveness but family forgiveness. Fellowship, or lack of it, with others of God's children affects our fellowship with our heavenly Father. As we forgive one another, our fellowship with the Father is cleared, and we can pray discerning His will. It is then that we will avoid the barrenness of hypocrisy and bear the true fruit of the Spirit of God.

Scenes from the Life of Christ — The Betrayal
Madonna Master, ca. 1310–1330; illuminated manuscript (the Psalter of Robert De Lisle); The British Library, London, England

This miniature is taken from a lavishly illustrated Psalter owned by the wealthy baron, Robert De Lisle, who renounced everything to join a Franciscan order. Most scholars consider the book to be a masterpiece of fourteenth-century English illumination. Unlike many pages that depict only one scene, this page has six. One is from the infancy cycle, two are of miracles of Christ, and three are from the passion cycle (that is, they relate to Christ's suffering, death, and resurrection). The crowded scene of the betrayal depicts Judas's giving the ill-fated kiss to Jesus and Peter's cutting off the ear of the high priest's servant, Malchus. The gestures and facial expressions range from the soldiers' glee to Peter's sadness, Christ's resignation, Judas's sinister intent, and Malchus's helplessness. Since earlier manuscripts rarely displayed emotions on the figures, their use here points to a growing interest in their psychological aspects.

"A TIME TO HEAL"

Healing Malchus's Ear

When those around Him saw what was going to happen, they said to Him, "Lord, shall we strike with the sword?" And one of them struck the servant of the high priest and cut off his right ear. But Jesus answered and said, "Permit even this." And He touched his ear and healed him *(Luke 22:49–51; see also Matt. 26:51–54; Mark 14:46–47; John 18:10–11).*

Though all four Gospel writers narrated this story, only Luke recorded the actual miracle of restoring Malchus's ear to normalcy. His being a doctor undoubtedly accounts for this detail. John is the only writer who revealed the name of the high priest's servant as being Malchus. Perhaps this was because John was well known to the high priest and thus to his household staff, including Malchus (see John 18:16). All four writers identified Malchus as *the* servant of the high priest, the presence of the definite article possibly indicating that he was an important servant. Perhaps he was delegated to be present when Christ was seized and arrested. Certainly, he never forgot his experience that night.

I. The Cause of the Miracle

Humanly speaking, it was Peter's impetuosity that gave rise to the occasion for the miracle. Why was Peter so impetuous? Because of his character and because of a conversation he had with Christ.

Peter was like a pendulum swinging from one extreme to another. It was Peter who jumped in the Lake of Galilee to walk on the water to Christ (see Matt. 14:28). It was Peter who scoffed at the revelation of Christ's coming death (see Matt. 16:22). It was Peter who assured the temple tax collectors that the Master would pay, even though He had not consulted the Lord first (see Matt. 17:24–27). It was Peter who assured the Lord that he would never desert Him (see Matt. 26:33). It was Peter who, misunderstanding the meaning of

having his feet washed, wanted the Lord to wash his hands and face too (see John 13:9). And here it was Peter who impetuously drew his sword to defend his Master and cut off Malchus's ear.

The conversation Peter had with the Lord took place in the Upper Room that same evening of the arrest. There the Lord had given new instructions to the disciples (see Luke 22:35–38). Earlier in His ministry Christ had commissioned the twelve disciples to go to Jewish people only (see Matt. 10:5–6). On that occasion He clearly instructed them not to take any provisions along nor to defend themselves against any opposition. But at the close of His ministry He issued entirely different orders (see Luke 22:35–38). This He did in order to prepare them for their future ministry after His death and resurrection. Now, He said, they should take provisions with them, including a sword for self-defense. Then, quoting from Isaiah 53:12, He reminded them that He was going to be despised and that they could expect the same treatment. Therefore, a sword would not only be appropriate but sometimes necessary.

Peter, of course, heard these orders. Clearly, he had understood. His only mistake was that he jumped the gun. These new instructions applied only after the Crucifixion, but Peter tried to put them into practice too soon. The Lamb of God must first be slain. He could not be defended and thus spared from dying. Peter, ever impetuous, tried and only got an ear before the Lord stopped him.

Viewing this theologically, one may say that Peter failed to understand the sweep of the whole plan of God. He did not fail to hear the change in procedures (no provisions before, now provisions), but he tried to put instructions, which were still for the future, into operation before the proper time. A similar mistake is being made today by Christians who try to put into operation now ethics that apply to the coming Kingdom. Today the church lives in a hostile world. Its ethical requirements focus mainly, though not exclusively, on helping and relating to the body of Christ (see Gal. 6:10). But in the coming Kingdom all people will live in a friendly, righteous world, and ethical principles will be concerned with all humankind.

II. The Character of the Miracle

Some interesting characteristics of this miracle stand out. (1) There was no request for it; our Lord just did it. (2) It was performed on an enemy of the Lord, one who was part of the group arresting Him. In fact, Malchus must have been in the front of the group or he would not have been struck. Apparently, he was not just a neutral observer standing at the edge of the crowd that

had come to see Christ taken. (3) The miracle was done to correct a mistake on Peter's part, and it clearly demonstrated that Christ would not retaliate against those who put Him to death.

III. The Consequences of the Miracle

A. To Malchus

Malchus was healed. All the accounts use the diminutive form of the word *ear*, which is different from the usual word. It is the word that in the Septuagint (Greek) translation of Deuteronomy 15:17 means "the lobe of the ear." Apparently, Peter only nicked Malchus's ear and cut off the lobe. And that is what Christ touched in order to restore it.

What effect did this healing have on Malchus? The Scriptures do not tell us, but it is interesting to speculate. After the tremendous events of that night and the next day's crucifixion and the following Sunday's resurrection, did Malchus become a believer? That should have been the result, but the heart of man is unalterably opposed to God. There exists a strong possibility that the miracle had no effect on his spiritual condition. The Lord warned that even if someone rises from the dead (which He did), people will not repent (see Luke 16:30–31).

B. To the Crowd

The miracle seemed not to faze the crowd at all. Probably many people did not even know what had happened. But those who did should have been startled at the power of the One they were trying to arrest. They should have asked how they could ever hope to take captive someone like that.

C. To Peter

The immediate consequence to Peter was that a relative of Malchus identified Peter as being with Christ at the time of His arrest. This assertion led to Peter's denying that he knew the Lord (see John 18:26–27). Peter also learned his lesson, for there is no record that he used a sword again, though it might have been in order for him to do so. After Pentecost he allowed himself to be imprisoned for his faith (see Acts 4:3; 12:4). The pendulum became a rock.

D. To Us

Balance is the key idea for followers of Christ today. Providing for the servant of God is entirely in order. The life of faith does not exclude purses and swords (though only in self-defense, never to commit murder). Insisting on rights may be proper (see Acts 16:37). But it also may be necessary to suffer wrong, as did our Lord, and not to insist on our rights as He did not (see 1 Pet. 2:21–23). He must guide us in each situation.

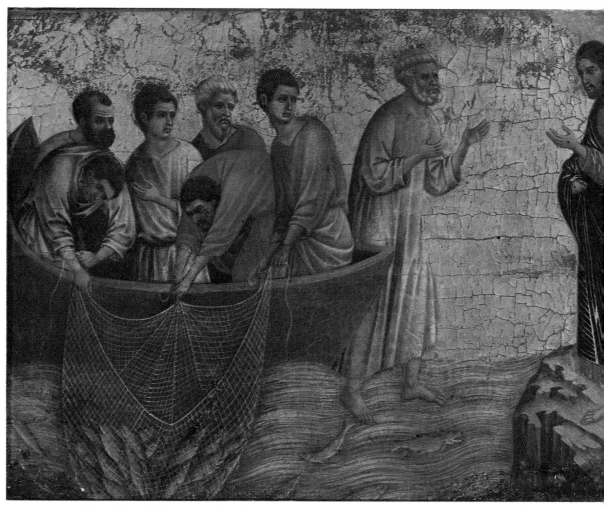

Apparition of Christ in Lake Tiberius
Duccio Di Buoninsegna; tempera; 12⅕″ x 18⁷⁄₁₀″; Museo Opera del Duomo, Siena, Italy (Scala/Art Resources, Inc.)

Duccio (1255?–1319) was an Italian painter of the Sienese school. He is generally recognized as one of the first to have given Siena a lyrical school of painting and thus to have initiated a fresh interpretation of the Byzantine tradition. In this transformation his figures assumed a three-dimensional character, instead of the more typical flat, frozen figures of earlier works. These qualities are evident in this painting. As they haul in an enormous amount of fish, the disciples recognize their Master. Two disciples are bent over with the weight of the net, which is strained to the utmost by the huge catch. The Lord beckons from the shore, and Peter jumps from the boat to greet Him.

THE SECRET OF REVIVAL—
THE DISCIPLES' FINAL EXAM

The Miraculous Catch of Fish

After these things Jesus showed Himself again to the disciples at the Sea of Tiberias, and in this way He showed Himself: Simon Peter, Thomas called Didymus, Nathanael of Cana in Galilee, the sons of Zebedee, and two others of His disciples were together. Simon Peter said to them, "I am going fishing." They said to him, "We are going with you also." They went out and immediately got into the boat, and that night they caught nothing. But when the morning had now come, Jesus stood on the shore; yet the disciples did not know that it was Jesus. Then Jesus said to them, "Children, have you any food?" They answered Him, "No." And He said to them, "Cast the net on the right side of the boat, and you will find some." So they cast, and now they were not able to draw it in because of the multitude of fish. Therefore that disciple whom Jesus loved said to Peter, "It is the Lord!" Now when Simon Peter heard that it was the Lord, he put on his outer garment (for he had removed it), and plunged into the sea. But the other disciples came in the little boat (for they were not far from land, but about two hundred cubits), dragging the net with fish. Then, as soon as they had come to land, they saw a fire of coals there, and fish laid on it, and bread. Jesus said to them, "Bring some of the fish which you have just caught." Simon Peter went up and dragged the net to land, full of large fish, one hundred and fifty-three; and although there were so many, the net was not broken. Jesus said to them, "Come and eat breakfast." Yet none of the disciples dared ask Him, "Who are You?"—knowing that it was the Lord. Jesus then came and took the bread and gave it to them, and likewise the fish. This is now the third time Jesus showed Himself to His disciples after He was raised from the dead.

So when they had eaten breakfast, Jesus said to Simon Peter, "Simon, son of Jonah, do you love Me more than these?" He said to Him, "Yes, Lord; You know that I love You." He said to him, "Feed My lambs." He said to him again a second time, "Simon, son of Jonah, do you love Me?" He said to Him, "Yes, Lord; You know that I love You." He said to him, "Tend my sheep." He said to him the third time, "Simon, son of Jonah, do you love Me?" Peter was grieved because He said to him the third time, "Do you love Me?" And he said to Him, "Lord, You know all things; You know that I love You." Jesus said to him, "Feed My sheep" *(John 21:1–17).*

Revival and evangelism are different things. Evangelism is concerned with winning people to Christ, while revival means to become active or flourishing again. Those outside the church need evangelizing; those inside the church need reviving.

Revival meetings seldom produce revival; they are usually evangelistic. For-

mulas for revival seldom result in revival, though they may bring some surface or temporary changes. Campaigns come and go, and their results quickly disappear.

What, then, is the secret of revival? How can the church be active and flourish continually? How can a Christian be active and flourish continually? Revival of the church depends on revival of those persons who belong to the church.

In relation to this miracle Christ gave His disciples a final examination. It consisted of three questions, and the correct answers to those questions give the way to revival.

I. Will You Obey Me?

This matter of obedience was something Peter had to learn the hard way. He was at loose ends. He and all the disciples had forsaken the Lord at the most critical moment of His life. Then came the electrifying news that Jesus had come back from the dead. One of His first appearances had been to Peter in order to restore their relationship (see Luke 24:34). Later the Lord had appeared to the disciples as a group, so Peter had seen Him several times. But he was still at loose ends. The Lord had told the two Marys to tell the disciples that they would see Him in Galilee (see Matt. 28:10), so Peter and six of the other disciples had gone there to meet Him. But Jesus had not shown up.

Who knows what thoughts were going through their minds? What did these appearances of Jesus mean? What would they do now? Would the Lord appear again? Was their service finished? Perhaps they should sharpen up their fishing abilities again. After all, they would have to make a living for themselves somehow. Or perhaps they were just nervous, waiting and wondering. At any rate, Peter made a spur-of-the-moment decision.

"I'm going fishing," he said. The others grabbed at the idea. "We're coming with you," they replied. They set out that evening on the familiar waters of the Lake of Galilee where they had often fished before. Peter was still their leader, but this time he was leading them astray. They all should have waited on the shore for the Lord as He had commanded. Peter's words in verse 3 may indicate that he intended to go back to fishing as an occupation, returning to the life he had left three years before right there on those same shores (see Luke 5:1–11).

So they fished. They fished all night but caught nothing. Do you suppose Peter remembered that other night the same thing happened? He had caught

nothing the night before the Lord called him to follow Him three years before. Perhaps his own words went through his mind again and again this night: "Depart from me, for I am a sinful man, O Lord!" (Luke 5:8).

Morning came and Jesus stood on the shore, but Peter did not recognize Him. The man, a stranger to them at that point, told them to cast the net on the right side of the ship, which they did. After all, any suggestion could only improve the results they were having! And when they did, they suddenly caught a lot of fish. Then John recognized the Lord. Quickly, they came to land, were invited to breakfast, hauled in the fish, and counted the catch.

Though I have told the story of verses 1–14 in narrative form, do not miss the lessons about obedience. Revival can never come if we do not obey the commands of Christ. The disciples were supposed to wait for the Lord, not go fishing. Of course, fishing is an innocent activity; indeed on this occasion it might have been rationalized as a beneficial activity for the nervous disciples. But innocent or even good things are no substitute for obedience. When they did obey and cast their nets on the right side of the boat, the disciples were successful. No research could have discovered any significance to the right side as opposed to the left side. Surely, the disciples had tried both sides of the boat during that long night. But there is always greatest significance in doing exactly what the Lord commands when He commands it.

II. Do You Love Me?

When breakfast was finished, Peter was given his own exam. An air of solemnity surrounded it, for Christ used Peter's full name in addressing him. Then came the first question: Do you love Me?

It was a very special question, for the Lord asked it three times. Three times Peter had denied the Lord; now three times he was asked to affirm his love for Him. Restoration or revival must always begin by going back to the place where fellowship began to be lost. Even the fire around which they had just breakfasted must have reminded Peter of the fire at the high priest's house where Peter had stoutly affirmed, "I do not know Him" (Luke 22:57).

"Do you love *Me*?" the Lord asked. Not, Do you love the work? Nor, Do you love the church? Not, Do you love the Word? But, Do you love Me? Important and proper as love for these other things is, they can never substitute for love for the Person of the Lord. Imagine a couple affirming their love for each other by acclaiming the mate's cooking or ability to earn money or integrity or con-

duct or whatever. What a husband or wife wants to hear is that the other loves him or her. Do you love *Me*?

It was also a very specific question. It was not a question of sentimental silliness or emotional feeling or intellectual reasoning, but a question of a clearly defined attitude toward the Lord. The use of two different words for "love" in verses 15–17 has been the subject of much discussion. The Lord used *agapaō* in His questions in verses 15 and 16 and *phileō* in verse 17. Peter used *phileō* in all his replies.

Some commentators say that the Lord tried to pull Peter to the highest concept of love (represented by *agapaō*) and that when He could not, He condescended to Peter's lower concept of love (represented by *phileō*). But these words do not indicate a higher and lower form of love (as, for example, "love" in contrast to "like"). Nor do they contrast divine love and human love. The words are interchangeable. Notice John 3:35 and 5:20 where the Father is said to love the Son; both words are used to indicate that love. Obviously, *phileō* cannot be human love in contrast to *agapaō* as divine love, if the Father loves the Son with *phileō* love. If there is a difference in the meaning of the words, it may lie along these lines: *agapaō* love is a reverent love, an esteem for the one loved (see Rev. 12:11), while *phileō* includes the emphasis of deep emotion and passion. In using both words, the Lord was asking Peter if he loved Him with every facet of love a person can have. In responding with the word *phileō,* Peter was expressing his passionate love for the Lord. Peter had been forgiven for terrible treason, and his passion for Christ was unbounded.

So if there is significance to the use of both words in the text, it is to emphasize the fullness of the question to Peter and to us: Do we love Christ with every kind of love a person can have? Is our love for our Lord intelligent as well as emotional? Is it passionate as well as reasoned? Is it as multifaceted as love can be?

It is a searching question. Why is it that we often cannot fully love people here on earth? Often it is because we see imperfections in them. But with the Lord, there are no imperfections. If we cannot fully and truly love Him, the fault must be in us. Thus, in order to answer the question honestly, we have to look at ourselves to see what may be hindering a full love relationship with the perfect Lord. When you say, "I love you, Lord, with all my heart, with all my soul, with all my mind, and with all my strength," then any area you are holding back by loving self will surface. And when those areas of self-love are con-

fessed, true and full love for Him will be experienced. Try it, you'll love Him!

There was a second question in Christ's examination of Peter that morning. It was this: How much do you love Me? "Do you love Me more than these?" (John 21:15).

The words "more than these" have three possible interpretations. One is, "Do you love Me more than these other disciples do?" Peter had boasted that even if all the other disciples defected, he would not (see Matt. 26:33). The Lord may have been asking Peter if his love exceeded everyone else's. That is a good question. We often measure ourselves by others and are satisfied if we do as well as others do. Christ asks for a love that is unique, not measured by anyone else's, but measured only by its purity and fervency for Him.

Second, Christ may have meant, "Do you love Me more than you love the other disciples? More than Andrew who led you to Christ? More than you love your wife or parents or children or anyone else?" "He who loves father or mother more than Me is not worthy of Me. And he who loves son or daughter more than Me is not worthy of Me" (Matt. 10:37). Many family problems are due simply to the fact that someone in the home is loved more than Christ is.

Third, Christ may have meant, "Do you love Me more than you love these things?" What things? Anything. More than boats or fishing tackle? More than fishing itself? More than a successful business and security? More than fame and acclaim? More than anything. Of course, sinful things eclipse our love for Christ, but good things sometimes can do the same. "All that is in the world . . . is not of the Father but is of the world" (1 John 2:16).

How much do you love Him? More than anyone else in the world does? More than you love anyone else in the world? More than you love anything in the world?

III. Will You Serve Me?

Actions speak louder than words. The proof of our profession of love is in our practice. Peter was given specific instructions for service that morning.

Some say that love frees one from commands. Not so, for the Lord said, "If you love Me, keep My commandments" (John 14:15). There is no conflict between love and obedience. Love is obedient, and obedience proves love.

How will love for Christ be expressed? By feeding His lambs (v. 15), by shepherding His sheep (v. 16), and by feeding His sheep (v. 17). How do we do

these things? Not by extending His kingdom, promoting a program, or increasing numbers, but by building up the quality of members of the body of Christ. How do we do that? By acting like a shepherd and doing what needs to be done to lambs and to more mature sheep.

Feeding means providing spiritual food. It means helping others to understand the Word of God, for that is the spiritual food of the believer. To do this, of course, requires that you first know the Word. You cannot feed others if you have no food to give them. Feeding, of course, will bring revival, for the Christian who himself is feeding on the Bible in order to be able to feed others will be flourishing in his own soul.

Too often we forget that it is the Word of God that changes lives. The Word sanctifies (see John 17:17) and builds up the flock (see Acts 20:32). It is the Word of God that comforts (see 1 Thess. 4:15) and convicts (see Heb. 4:12). Full knowledge of its "strong meat" makes one skillful in living righteously (see Heb. 5:11–14).

But we are also to shepherd other believers. A shepherd's duties include other things besides feeding, though they do include that (see Ps. 23:2). A shepherd must be strong and selfless, for he has to protect his charges from the weather, from fierce animals, and from thieves (see Amos 3:12; John 10:10). Paul warned that ". . . savage wolves will come in among you, not sparing the flock. Also from among yourselves men will rise up, speaking perverse things, to draw away the disciples after themselves" (Acts 20:29–30). Shepherds must also retrieve sheep that go astray (see Matt. 18:12). Shepherding Christians will seek to restore those who get trapped by sin (see Gal. 6:1).

This kind of service is the essence of a part of the Great Commission— "teaching them to observe all things that I have commanded you" (Matt. 28:20). And that Commission, like these commands, is for all believers. All are priests and members of one another. People who love Him more than anything will show that love in feeding and caring for others.

That morning Peter declared, "Yes, Lord, You know that I love You." Can you say that?

Hark, my soul, it is the Lord;
'Tis thy Savior, hear His Word;
Jesus speaks, and speaks to thee
Say, poor sinner, lov'st thou me?

I delivered thee when bound,
And, when bleeding, healed thy wound;
Sought thee wandering, set thee right,
Turned thy darkness into light.

Can a woman's tender care
Cease toward the child she bear?
Yes, she may forgetful be;
Yet, will I remember thee.

Mine is an unchanging love,
Higher than the heights above,
Deeper than the depths beneath,
Free and faithful, strong as death.

Thou shalt see my glory soon,
When the work of grace is done;
Partner of my throne shalt be;
Say, O Christian, lov'st thou me?

Lord, it is my chief complaint
That my love is weak and faint;
Yet I love thee, and adore:
Oh for grace to love thee more.

— William Cowper (1768)

BECAUSE HE LIVES

Our journey is complete, yet it goes on.

I said at the outset that the purpose of the miracles of our Lord was to reveal and to teach. What have we seen, and what have we learned?

Hopefully, we have seen the Lord in new ways. No portrait of the Lord during His days on earth exists; yet we can "see" Him through His character as revealed in these miracle stories.

Above everything, we see Him as the Lord God of this world. In His miracles we see Him as Lord over nature, Lord over life, Lord over death, Lord over sickness, Lord over sin, and Lord over Satan. The miracles are clear and eloquent evidence that Jesus of Nazareth possessed powers that belong only to God and therefore that He is God Himself.

Some of His miracles in particular supported His claim to be Israel's Messiah and God. As Peter declared in His day of Pentecost message, Jesus of Nazareth was a Man "attested by God to you by miracles, wonders, and signs which God did through Him in your midst, as you yourselves also know," and He was Israel's Messiah and the Lord God (Acts 2:22,36). Giving sight to the blind, you remember, was recognized as a function of the Messiah. The Gospels record five of the occasions on which our Lord did that, proof enough that He was Israel's promised Messiah.

"Who can forgive sins but God alone?" the scribes demanded (Mark 2:7). Accepting the challenge, the Lord forgave the paralytic's sins, gave outward evidence that He had done so by healing his paralysis, and thus proved Himself to be God.

Raising the dead also proves conclusively that Jesus is God. This is Paul's argument in Romans 1:4. Jesus was "declared to be the Son of God . . . by the resurrection from the dead." This certainly refers to His own resurrection from the dead, and it may also include as proof the three people He raised from the dead during His earthly ministry (the widow of Nain's son, Jairus's daughter, and Lazarus). Those three were brought back to life and had to go through the experience of death again; He raised Himself in a glorified body over which death has no dominion (see Rom. 6:9). He is God.

In addition, the Lord's miracles reveal facets of His character such as au-

thority (over demons, His disciples, the scribes and Pharisees, diseases, nature) and compassion (for human suffering in sickness, bereavement, hunger). They show His impatience with Pharisaic legalism and His great patience with the slow-to-learn disciples. They show His willingness to serve and not to insist on His rights (see Matt. 17:24–27). The first miracle shows His sociability (see John 2:2). Many show His tenderness with people. Together, all the miracles show that the Lord is worthy of our trust (John 5:36; 10:25,38; 14:11).

Not only do the miracles of our Lord teach us about His person and power, but they also expose our human inadequacies and need for help from an all-sufficient Savior.

All the miracles of physical healings remind us that we are subject to defects, infirmities, diseases, and handicaps. Our Lord certainly did not heal all those who were so afflicted in His day, nor does He in our day. But the fact that He healed some, and healed them completely, shows His power over the bodies He created. If He chooses not to heal, we may still know His power to sustain us in the difficulty.

The two miracles of feeding thousands of people remind us that we are incapable of providing the necessities of life apart from the providence of God. Our dependence is not on food chains and their stores, but on God who supplies through various means our needs. We need to remember to pray, "Give us this day our daily bread."

Miracles in which the Lord asserted His authority over Satan and his demons remind us that we need His power today to fight against "principalities, against powers, against the rulers of the darkness of this age, against spiritual hosts of wickedness in the heavenly places" (Eph. 6:12). The risen Christ lives in us today (see Gal. 2:20), and He is greater in power and authority than Satan and his demons (see 1 John 4:4), and He "will never leave you nor forsake you" (Heb. 13:5).

The three resurrections from the dead portray our Lord as "the resurrection and the life" (John 11:25). While those three returned to this life to die again, they preview the new kind of undying life to which all believers will be raised by the Lord. Jesus assured Martha and us that though we die physically we shall live spiritually and eternally. And, of course, His greatest miracle, His own resurrection from the dead, seals that guarantee.

Because the tomb is empty, our Lord lives, and He lives in the lives of His children (see Gal. 2:20). What does that mean for us in this day?

It means more than anything else that we can experience the sufficiency of

our Lord in all aspects of life. It does not mean exemption from trials or sickness or attacks, but it assures us that the grace of our living Lord is sufficient in all circumstances (see 2 Cor. 12:9).

It does not mean release from the limitations of our humanity, but it does mean that we can exhibit Christlikeness through our attitudes and our actions.

It does not necessarily mean that His power will be unleashed to right all the wrongs to which we are exposed in this life, but it does mean that we can find grace to help in time of need (see Heb. 4:16).

It does not mean relief from tests and temptations, but it does mean He will walk with us through those tests so we can bear them (see 1 Cor. 10:13).

It does not necessarily mean He will give the same signs and perform the same wonders He did while He was here on earth, nor that we will perform them, but it does mean we can rely on His power to accomplish all His desires in our lives and in this world.

Because *He* lives, we know Him to be powerful yet tender, authoritative yet compassionate, commanding yet patient, conquering yet loving.

Because He *lives*, we know that Christ is alive and active through His people today.

This is the Lord who saves all who put their trust in Him. This is the Lord who cares for His own through every circumstance of life. This is the Lord whom we love and serve forever.